# Just Kids

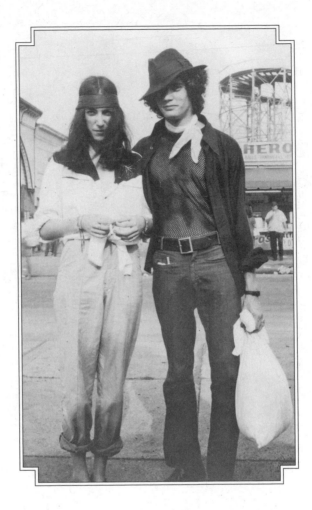

# Just Kids

❖

## Patti Smith

An Imprint of HarperCollinsPublishers

HarperCollins books may be purchased for educational, business, or sales promotional use. For information, please write: Special Markets Department, HarperCollins Publishers, 10 East 53rd Street, New York, NY 10022.

A hardcover edition of this book was published in 2010 by Ecco, an imprint of HarperCollins Publishers.

FIRST ECCO PAPERBACK EDITION PUBLISHED 2010

Designed by Mary Austin Speaker

Library of Congress Cataloging-in-Publication Data

Smith, Patti.
Just kids / by Patti Smith.
    p.  cm.
ISBN: 978-0-06-093622-8 (pbk.)
1. Smith, Patti. 2. Mapplethorpe, Robert. 3. Chelsea Hotel—Biography. 4. Women rock musicians—United States—Biography. 5. Photographers—United States—Biography. 6. Women poets—20th century—Biography. 7. Poets, American—20th century—Biography. 8. Artists—New York (State)—New York—Biography. 9. Musicians—New York (State)—New York—Biography. 10. New York (N.Y.)—Biography. I. Title.
ML420.S672.A3   2010          2010279646

11 12 13 14 OV/RRD 10 9 8

# Contents

*Much has been said about Robert, and more will be added. Young men will adopt his gait. Young girls will wear white dresses and mourn his curls. He will be condemned and adored. His excesses damned or romanticized. In the end, truth will be found in his work, the corporeal body of the artist. It will not fall away. Man cannot judge it. For art sings of God, and ultimately belongs to him.*

# Foreword

I WAS ASLEEP WHEN HE DIED. I HAD CALLED THE HOSPITAL to say one more good night, but he had gone under, beneath layers of morphine. I held the receiver and listened to his labored breathing through the phone, knowing I would never hear him again.

Later I quietly straightened my things, my notebook and fountain pen. The cobalt inkwell that had been his. My Persian cup, my purple heart, a tray of baby teeth. I slowly ascended the stairs, counting them, fourteen of them, one after another. I drew the blanket over the baby in her crib, kissed my son as he slept, then lay down beside my husband and said my prayers. He is still alive, I remember whispering. Then I slept.

I awoke early, and as I descended the stairs I knew that he was dead. All was still save the sound of the television that had been left on in the night. An arts channel was on. An opera was playing. I was drawn to the screen as Tosca declared, with power and sorrow, her passion for the painter Cavaradossi. It was a cold March morning and I put on my sweater.

I raised the blinds and brightness entered the study. I smoothed the heavy linen draping my chair and chose a book of paintings by Odilon Redon, opening it to the image of the head of a woman floating in a small sea. *Les yeux clos*. A universe not yet scored contained beneath the pale lids. The phone rang and I rose to answer.

It was Robert's youngest brother, Edward. He told me that he had given Robert one last kiss for me, as he had promised. I stood motionless, frozen; then slowly, as in a dream, returned to my chair. At that moment, Tosca began the great aria "Vissi d'arte." *I have lived for love, I have lived for Art*. I closed my eyes and folded my hands. Providence determined how I would say goodbye.

# Monday's
# Children

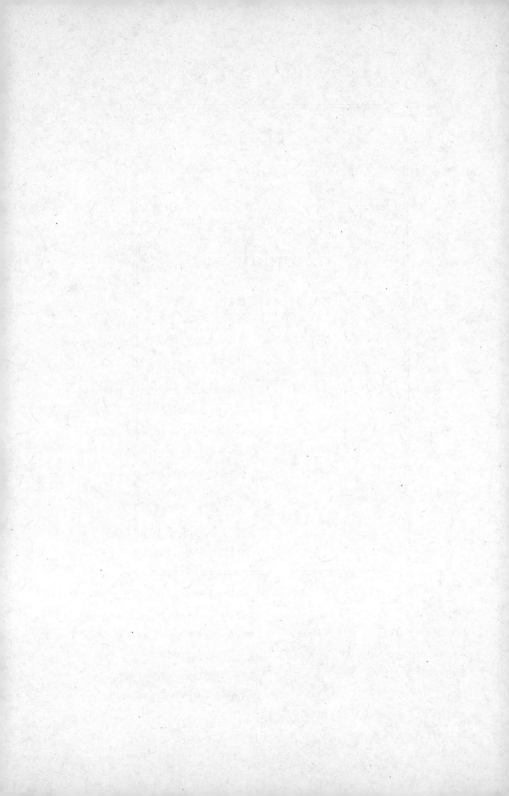

WHEN I WAS VERY YOUNG, MY MOTHER TOOK ME FOR walks in Humboldt Park, along the edge of the Prairie River. I have vague memories, like impressions on glass plates, of an old boathouse, a circular band shell, an arched stone bridge. The narrows of the river emptied into a wide lagoon and I saw upon its surface a singular miracle. A long curving neck rose from a dress of white plumage.

*Swan*, my mother said, sensing my excitement. It pattered the bright water, flapping its great wings, and lifted into the sky.

The word alone hardly attested to its magnificence nor conveyed the emotion it produced. The sight of it generated an urge I had no words for, a desire to speak of the swan, to say something of its whiteness, the explosive nature of its movement, and the slow beating of its wings.

The swan became one with the sky. I struggled to find words to describe my own sense of it. *Swan*, I repeated, not entirely satisfied, and I felt a twinge, a curious yearning, imperceptible to passersby, my mother, the trees, or the clouds.

★

I was born on a Monday, in the North Side of Chicago during the Great Blizzard of 1946. I came along a day too soon, as babies born on New Year's Eve left the hospital with a new refrigerator. Despite my mother's effort to hold me in, she went into heavy labor as the taxi crawled along Lake Michigan through a vortex of snow and wind. By my father's account, I arrived a long skinny thing with bronchial pneumonia, and he kept me alive by holding me over a steaming washtub.

My sister Linda followed during yet another blizzard in 1948. By necessity I was obliged to measure up quickly. My mother took in ironing as I sat on the stoop of our rooming house waiting for the iceman and the last of the horse-drawn wagons. He gave me slivers of ice wrapped in brown paper. I would slip one in my pocket for my baby sister, but when I later reached for it, I discovered it was gone.

When my mother became pregnant with my brother, Todd, we left our cramped quarters in Logan Square and migrated to Germantown, Pennsylvania. For the next few years we lived in temporary housing set up for servicemen and their children—whitewashed barracks overlooking an abandoned field alive with wildflowers. We called the field The Patch, and in summertime the grown-ups would sit and talk, smoke cigarettes, and pass around jars of dandelion wine while we children played. My mother taught us the games of her childhood: Statues, Red Rover, and Simon Says. We made daisy chains to adorn our necks and crown our heads. In the evenings we collected fireflies in mason jars, extracting their lights and making rings for our fingers.

My mother taught me to pray; she taught me the prayer her mother taught her. *Now I lay me down to sleep, I pray the Lord my soul*

*to keep.* At nightfall, I knelt before my little bed as she stood, with her ever-present cigarette, listening as I recited after her. I wished nothing more than to say my prayers, yet these words troubled me and I plagued her with questions. What is the soul? What color is it? I suspected my soul, being mischievous, might slip away while I was dreaming and fail to return. I did my best not to fall asleep, to keep it inside of me where it belonged.

Perhaps to satisfy my curiosity, my mother enrolled me in Sunday school. We were taught by rote, Bible verses and the words of Jesus. Afterward we stood in line and were rewarded with a spoonful of comb honey. There was only one spoon in the jar to serve many coughing children. I instinctively shied from the spoon but I swiftly accepted the notion of God. It pleased me to imagine a presence above us, in continual motion, like liquid stars.

Not contented with my child's prayer, I soon petitioned my mother to let me make my own. I was relieved when I no longer had to repeat the words *If I should die before I wake, I pray the Lord my soul to take* and could say instead what was in my heart. Thus freed, I would lie in my bed by the coal stove vigorously mouthing long letters to God. I was not much of a sleeper and I must have vexed him with my endless vows, visions, and schemes. But as time passed I came to experience a different kind of prayer, a silent one, requiring more listening than speaking.

My small torrent of words dissipated into an elaborate sense of expanding and receding. It was my entrance into the radiance of imagination. This process was especially magnified within the fevers of influenza, measles, chicken pox, and mumps. I had them all and with each I was privileged with a new level of awareness. Lying deep within myself, the symmetry of a snowflake spinning above me, intensifying through my lids, I seized a most worthy souvenir, a shard of heaven's kaleidoscope.

My love of prayer was gradually rivaled by my love for the book. I would sit at my mother's feet watching her drink coffee and smoke cigarettes with a book on her lap. Her absorption intrigued me. Though not yet in nursery school, I liked to look at her books, feel their paper, and lift the tissues from the frontispieces. I wanted to know what was in them, what captured her attention so deeply. When my mother discovered that I had hidden her crimson copy of Foxe's *Book of Martyrs* beneath my pillow, with hopes of absorbing its meaning, she sat me down and began the laborious process of teaching me to read. With great effort we moved through Mother Goose to Dr. Seuss. When I advanced past the need for instruction, I was permitted to join her on our overstuffed sofa, she reading *The Shoes of the Fisherman* and I *The Red Shoes*.

I was completely smitten by the book. I longed to read them all, and the things I read of produced new yearnings. Perhaps I might go off to Africa and offer my services to Albert Schweitzer or, decked in my coonskin cap and powder horn, I might defend the people like Davy Crockett. I could scale the Himalayas and live in a cave spinning a prayer wheel, keeping the earth turning. But the urge to express myself was my strongest desire, and my siblings were my first eager coconspirators in the harvesting of my imagination. They listened attentively to my stories, willingly performed in my plays, and fought valiantly in my wars. With them in my corner, anything seemed possible.

In the months of spring, I was often ill and so condemned to my bed, obliged to hear my comrades at play through the open window. In the months of summer, the younger ones reported bedside how much of our wild field had been secured in the face of the enemy. We lost many a battle in my absence and my weary troops would gather around my bed and I would offer a benediction from the child soldier's bible, *A Child's Garden of Verses* by Robert Louis Stevenson.

In the winter, we built snow forts and I led our campaign, serving

as general, making maps and drawing out strategies as we attacked and retreated. We fought the wars of our Irish grandfathers, the orange and the green. We wore the orange yet knew nothing of its meaning. They were simply our colors. When attention flagged, I would draw a truce and visit my friend Stephanie. She was convalescing from an illness I didn't really understand, a form of leukemia. She was older than I, perhaps twelve to my eight. I didn't have much to say to her and was perhaps little comfort, yet she seemed to delight in my presence. I believe that what really drew me to her was not my good heart, but a fascination with her belongings. Her older sister would hang up my wet garments and bring us cocoa and graham crackers on a tray. Stephanie would lie back on a mound of pillows and I would tell tall tales and read her comics.

I marveled at her comic-book collection, stacks of them earned from a childhood spent in bed, every issue of *Superman*, *Little Lulu*, *Classic Comics*, and *House of Mystery*. In her old cigar box were all the talismanic charms of 1953: a roulette wheel, a typewriter, an ice skater, the red Mobil winged horse, the Eiffel Tower, a ballet slipper, and charms in the shape of all forty-eight states. I could play with them endlessly and sometimes, if she had doubles, she would give one to me.

I had a secret compartment near my bed, beneath the floorboards. There I kept my stash—winnings from marbles, trading cards, religious artifacts I rescued from Catholic trash bins: old holy cards, worn scapulars, plaster saints with chipped hands and feet. I put my loot from Stephanie there. Something told me I shouldn't take presents from a sick girl, but I did and hid them away, somewhat ashamed.

I had promised to visit her on Valentine's Day, but I didn't. My duties as general to my troop of siblings and neighboring boys were very taxing and there was heavy snow to negotiate. It was a harsh winter that year. The following afternoon, I abandoned my post to sit with her and have cocoa. She was very quiet and begged me to stay even as she drifted off to sleep.

I rummaged through her jewel box. It was pink and when you opened it a ballerina turned like a sugarplum fairy. I was so taken with a particular skating pin that I slipped it in my mitten. I sat frozen next to her for a long time, leaving silently as she slept. I buried the pin amongst my stash. I slept fitfully through the night, feeling great remorse for what I had done. In the morning I was too ill to go to school and stayed in bed, ridden with guilt. I vowed to return the pin and ask her to forgive me.

The following day was my sister Linda's birthday, but there was to be no party for her. Stephanie had taken a turn for the worse and my father and mother went to a hospital to give blood. When they returned my father was crying and my mother knelt down beside me to tell me Stephanie had died. Her grief was quickly replaced with concern as she felt my forehead. I was burning with fever.

Our apartment was quarantined. I had scarlet fever. In the fifties it was much feared since it often developed into a fatal form of rheumatic fever. The door to our apartment was painted yellow. Confined to bed, I could not attend Stephanie's funeral. Her mother brought me her stacks of comic books and her cigar box of charms. Now I had everything, all her treasures, but I was far too ill to even look at them. It was then that I experienced the weight of sin, even a sin as small as a stolen skater pin. I reflected on the fact that no matter how good I aspired to be, I was never going to achieve perfection. I also would never receive Stephanie's forgiveness. But as I lay there night after night, it occurred to me that it might be possible to speak with her by praying to her, or at least ask God to intercede on my behalf.

Robert was very taken with this story, and sometimes on a cold, languorous Sunday he would beg me to recount it. "Tell me the Stephanie story," he would say. I would spare no details on our long mornings beneath the covers, reciting tales of my childhood, its sorrow and magic,

as we tried to pretend we weren't hungry. And always, when I got to the part where I opened the jewelry box, he would cry, "Patti, no . . ."

We used to laugh at our small selves, saying that I was a bad girl trying to be good and that he was a good boy trying to be bad. Through the years these roles would reverse, then reverse again, until we came to accept our dual natures. We contained opposing principles, light and dark.

I was a dreamy somnambulant child. I vexed my teachers with my precocious reading ability paired with an inability to apply it to anything they deemed practical. One by one they noted in my reports that I daydreamed far too much, was always somewhere else. Where that somewhere was I cannot say, but it often landed me in the corner sitting on a high stool in full view of all in a conical paper hat.

I would later make large detailed drawings of these humorously humiliating moments for Robert. He delighted in them, seeming to appreciate all the qualities that repelled or alienated me from others. Through this visual dialogue my youthful memories became his.

★

I was unhappy when we were evicted from The Patch and had to pack up to begin a new life in southern New Jersey. My mother gave birth to a fourth child whom we all pitched in to raise, a sickly though sunny little girl named Kimberly. I felt isolated and disconnected in the surrounding swamps, peach orchards, and pig farms. I immersed myself in books and in the design of an encyclopedia that only got as far as the entry for Simón Bolívar. My father introduced me to science fiction and for a time I joined him in investigating UFO activity in the skies over the local square-dance hall, as he continually questioned the source of our existence.

When I was barely eleven, nothing pleased me more than to take long walks in the outlying woods with my dog. All about were jack-in-the-pulpits, punks, and skunk cabbage, rising from the red clay earth. I would find a good place for some solitude, to stop and rest my head against a fallen log by a stream rushing with tadpoles.

With my brother, Todd, serving as loyal lieutenant, we'd crawl on our bellies over the dusty summer fields near the quarries. My dutiful sister would be stationed to bandage our wounds and provide much-needed water from my father's army canteen.

On one such day, limping back to the home front beneath the anvil of the sun, I was accosted by my mother.

"Patricia," my mother scolded, "put a shirt on!"

"It's too hot," I moaned. "No one else has one on."

"Hot or not, it's time you started wearing a shirt. You're about to become a young lady." I protested vehemently and announced that I was never going to become anything but myself, that I was of the clan of Peter Pan and we did not grow up.

My mother won the argument and I put on a shirt, but I cannot exaggerate the betrayal I felt at that moment. I ruefully watched my mother performing her female tasks, noting her well-endowed female body. It all seemed against my nature. The heavy scent of perfume and the red slashes of lipstick, so strong in the fifties, revolted me. For a time I resented her. She was the messenger and also the message. Stunned and defiant, with my dog at my feet, I dreamed of travel. Of running away and joining the Foreign Legion, climbing the ranks and trekking the desert with my men.

I drew comfort from my books. Oddly enough, it was Louisa May Alcott who provided me with a positive view of my female destiny. Jo, the tomboy of the four March sisters in *Little Women*, writes to help support her family, struggling to make ends meet during the Civil War. She fills page after page with her rebellious

scrawl, later published in the literary pages of the local newspaper. She gave me the courage of a new goal, and soon I was crafting little stories and spinning long yarns for my brother and sister. From that time on, I cherished the idea that one day I would write a book.

In the following year my father took us on a rare excursion to the Museum of Art in Philadelphia. My parents worked very hard, and taking four children on a bus to Philadelphia was exhausting and expensive. It was the only such outing we made as a family, marking the first time I came face-to-face with art. I felt a sense of physical identification with the long, languorous Modiglianis; was moved by the elegantly still subjects of Sargent and Thomas Eakins; dazzled by the light that emanated from the Impressionists. But it was the work in a hall devoted to Picasso, from his harlequins to Cubism, that pierced me the most. His brutal confidence took my breath away.

My father admired the draftsmanship and symbolism in the work of Salvador Dalí, yet he found no merit in Picasso, which led to our first serious disagreement. My mother busied herself rounding up my siblings, who were sliding the slick surfaces of the marble floors. I'm certain, as we filed down the great staircase, that I appeared the same as ever, a moping twelve-year-old, all arms and legs. But secretly I knew I had been transformed, moved by the revelation that human beings create art, that to be an artist was to see what others could not.

I had no proof that I had the stuff to be an artist, though I hungered to be one. I imagined that I felt the calling and prayed that it be so. But one night, while watching *The Song of Bernadette* with Jennifer Jones, I was struck that the young saint did not ask to be called. It was the mother superior who desired sanctity, even as Bernadette, a humble peasant girl, became the chosen one. This worried me. I wondered

if I had really been called as an artist. I didn't mind the misery of a vocation but I dreaded not being called.

I shot up several inches. I was nearly five eight and barely a hundred pounds. At fourteen, I was no longer the commander of a small yet loyal army but a skinny loser, the subject of much ridicule as I perched on the lowest rung of high school's social ladder. I immersed myself in books and rock and roll, the adolescent salvation of 1961. My parents worked at night. After doing our chores and homework, Toddy, Linda, and I would dance to the likes of James Brown, the Shirelles, and Hank Ballard and the Midnighters. With all modesty I can say we were as good on the dance floor as we were in battle.

I drew, I danced, and I wrote poems. I was not gifted but I was imaginative and my teachers encouraged me. When I won a competition sponsored by the local Sherwin-Williams paint store, my work was displayed in the shopwindow and I had enough money to buy a wooden art box and a set of oils. I raided libraries and church bazaars for art books. It was possible then to find beautiful volumes for next to nothing and I happily dwelt in the world of Modigliani, Dubuffet, Picasso, Fra Angelico, and Albert Ryder.

My mother gave me *The Fabulous Life of Diego Rivera* for my sixteenth birthday. I was transported by the scope of his murals, descriptions of his travels and tribulations, his loves and labor. That summer I got a job in a nonunion factory, inspecting handlebars for tricycles. It was a wretched place to work. I escaped into daydreams as I did my piecework. I longed to enter the fraternity of the artist: the hunger, their manner of dress, their process and prayers. I'd brag that I was going to be an artist's mistress one day. Nothing seemed more romantic to my young mind. I imagined myself as Frida to Diego, both muse and maker. I dreamed of meeting an artist to love and support and work with side by side.

<✦>

Robert Michael Mapplethorpe was born on Monday, November 4, 1946. Raised in Floral Park, Long Island, the third of six children, he was a mischievous little boy whose carefree youth was delicately tinged with a fascination with beauty. His young eyes stored away each play of light, the sparkle of a jewel, the rich dressing of an altar, the burnish of a gold-toned saxophone or a field of blue stars. He was gracious and shy with a precise nature. He contained, even at an early age, a stirring and the desire to stir.

The light fell upon the pages of his coloring book, across his child's hands. Coloring excited him, not the act of filling in space, but choosing colors that no one else would select. In the green of the hills he saw red. Purple snow, green skin, silver sun. He liked the effect it had on others, that it disturbed his siblings. He discovered he had a talent for sketching. He was a natural draftsman and secretly he twisted and abstracted his images, feeling his growing powers. He was an artist, and he knew it. It was not a childish notion. He merely acknowledged what was his.

The light fell upon the components of Robert's beloved jewelry kit, upon the bottles of enamel and tiny brushes. His fingers were nimble. He delighted in his ability to piece together and decorate brooches for his mother. He wasn't concerned that this was a girl's pursuit, that a jewelry-making kit was a traditional Christmas gift for a girl. His older brother, a whiz at sports, would snicker at him as he worked. His mother, Joan, chain-smoked, and admired the sight of her son sitting at the table, dutifully stringing yet another necklace of tiny Indian beads for her. They were precursors of the necklaces he would later adorn himself with, having broken from his father, leaving his Catholic, commercial, and military options behind in the wake of LSD and a commitment to live for art alone.

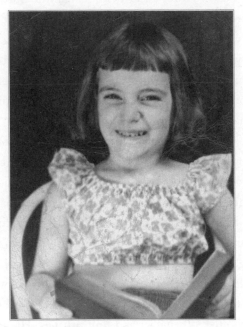

*Bible school, Philadelphia*

*First Holy Communion, Floral Park, Long Island*

It was not easy for Robert to make this break. Something within him could not be denied, yet he also wanted to please his parents. Robert rarely spoke of his youth or his family. He always said he had a good upbringing, that he was safe and well provided for in practical terms. But he always suppressed his real feelings, mimicking the stoic nature of his father.

His mother dreamed of him entering the priesthood. He liked being an altar boy, but enjoyed it more for his entrance into secret places, the sacristy, forbidden chambers, the robes and the rituals. He didn't have a religious or pious relationship with the church; it was aesthetic. The thrill of the battle between good and evil attracted him, perhaps because it mirrored his interior conflict, and revealed a line that he might yet need to cross. Still, at his first holy communion, he stood proud to have accomplished this sacred task, reveling in being the center of attention. He wore a huge Baudelairean bow and an armband identical to the one worn by a very defiant Arthur Rimbaud.

There was no sense of culture or bohemian disorder in his parents' house. It was neat and clean and a model of postwar middle-class sensibilities, the magazines in the magazine rack, jewelry in the jewelry box. His father, Harry, could be stern and judgmental and Robert inherited these qualities from him, as well as his strong, sensitive fingers. His mother gave him her sense of order and her crooked smile that always made it seem as if he had a secret.

A few of Robert's drawings were hung on the wall in the hallway. While he lived at home he did his best to be a dutiful son, even choosing the curriculum his father demanded—commercial art. If he discovered anything on his own, he kept it to himself.

Robert loved to hear of my childhood adventures, but when I asked about his, he would have little to say. He said that his family never talked much, read, or shared intimate feelings. They had no

communal mythology; no tales of treason, treasure, and snow forts. It was a safe existence but not a fairy-tale one.

"You're my family," he would say.

-<+>-

W hen I was a young girl, I fell into trouble.
In 1966, at summer's end, I slept with a boy even more callow than I and we conceived instantaneously. I consulted a doctor who doubted my concern, waving me off with a somewhat bemused lecture on the female cycle. But as the weeks passed, I knew that I was carrying a child.

I was raised at a time when sex and marriage were absolutely synonymous. There was no available birth control and at nineteen I was still naïve about sex. Our union was so fleeting; so tender that I was not altogether certain we consummated our affection. But nature with all her force would have the final word. The irony that I, who never wanted to be a girl nor grow up, would be faced with this trial did not escape me. I was humbled by nature.

The boy, who was only seventeen, was so inexperienced that he could hardly be held accountable. I would have to take care of things on my own. On Thanksgiving morning I sat on the cot in the laundry room of my parents' house. This was where I slept when I worked summers in a factory, and the rest of the year while I attended Glassboro State Teachers College. I could hear my mother and father making coffee and the laughter of my siblings as they sat around the table. I was the eldest and the pride of the family, working my way through college. My father was concerned that I was not attractive enough to find a husband and thought that the teaching profession would afford me security. It would be a great blow to him if I did not complete my studies.

I sat for a long time looking at my hands resting on my stomach. I had relieved the boy of responsibility. He was like a moth struggling within a cocoon and I couldn't bring myself to disturb his unwieldy emergence into the world. I knew there was nothing he could do. I also knew I was incapable of tending to an infant. I had sought the assistance of a benevolent professor who had found an educated couple longing for a child.

I surveyed my quarters: a washer and dryer, a large wicker basket overflowing with unwashed linens, my father's shirts folded on the ironing board. There was a small table where I had arranged my drawing pencils, sketchbook, and copy of *Illuminations*. I sat readying myself to face my parents, praying beneath my breath. For a brief moment I felt as if I might die; and just as quickly I knew everything would be all right.

It is impossible to exaggerate the sudden calm I felt. An overwhelming sense of mission eclipsed my fears. I attributed this to the baby, imagining it empathized with my situation. I felt in full possession of myself. I would do my duty and stay strong and healthy. I would never look back. I would not return to the factory or to teachers college. I would be an artist. I would prove my worth, and with my new resolve I rose and approached the kitchen.

I was dismissed from college, but I no longer cared. I knew I was not destined to be a schoolteacher, though I believed it to be an admirable occupation. I continued to live in my laundry room.

My compatriot from college, Janet Hamill, bolstered my morale. She had lost her mother and came to stay with my family. I shared my little quarters with her. Both of us harbored lofty dreams but also a common love of rock and roll, spending long evenings discoursing on the Beatles versus the Rolling Stones. We had stood in line for hours

at Sam Goody's to purchase *Blonde on Blonde*, combing Philadelphia in search of a scarf like the one Bob Dylan wore on the cover. We lit candles for him when he had his motorcycle accident. We lay in the high grass listening to "Light My Fire" wafting from the radio of Janet's battered car parked by the side of the road with the doors open. We cut our long skirts to the mini-lengths of Vanessa Redgrave's in *Blow-Up* and searched for greatcoats in thrift stores like those worn by Oscar Wilde and Baudelaire.

Janet remained my trusted friend through my term, but as my pregnancy progressed, I had to find refuge elsewhere. Judgmental neighbors made it impossible for my family, treating them as if they were harboring a criminal. I found a surrogate family, also called Smith, farther south by the sea. A painter and his wife, a potter, kindly took me in. They had a little boy and theirs was a disciplined but loving environment of macrobiotic food, classical music, and art. I was lonely but Janet visited me when she could. I had a small amount of pocket money. Every Sunday I would take a long walk to a deserted beach café to have a coffee and a jelly doughnut, two things forbidden in a home regimented by healthy food. I savored these small indulgences, slipping a quarter in the jukebox and listening to "Strawberry Fields" three times in a row. It was my private ritual and the words and voice of John Lennon provided me with strength when I faltered.

After the Easter holidays my parents came for me. My labor coincided with the full moon. They drove me to the hospital in Camden. Due to my unwed status, the nurses were very cruel and uncaring, and left me on a table for several hours before informing the doctor that I had gone into labor. They ridiculed me for my beatnik appearance and immoral behavior, calling me "Dracula's daughter" and threatening to cut my long black hair. When my doctor arrived, he was very angry. I could hear him yelling at the nurses that I was having a breech

birth and I should not have been left alone. Through an open window, while I lay in labor, I could hear boys singing a cappella songs through the night. Four-part harmony on the street corners of Camden, New Jersey. As the anesthesia took effect, the last thing I remember was the doctor's concerned face and the whispers of attendants.

My child was born on the anniversary of the bombing of Guernica. I remember thinking of the painting, a weeping mother holding her dead child. Although my arms would be empty and I wept, my child would live, was healthy, and would be well cared for. I trusted and believed that with all my heart.

On Memorial Day I took a bus to Philadelphia to visit the Joan of Arc statue near the Museum of Art. It had not been there when I first went with my family as a young girl. How beautiful she looked astride her horse, raising her banner toward the sun, a teenage girl who delivered her imperiled prince to his throne in Reims and struggled to free her country, only to be betrayed and burned at the stake on this day. Young Joan whom I had known through books and the child whom I would never know. I vowed to both of them that I would make something of myself, then headed back home, stopping in Camden at the Goodwill store to buy a long gray raincoat.

—◄◆►—

On that same day, in Brooklyn, Robert dropped acid. He cleared his work area, arranging his drawing pad and pencils on a low table with a pillow to sit on. He placed a fresh sheet of clay coat on the table. He knew he might not be able to draw once the acid peaked, but he wanted his tools by him in case he needed them. He had tried working on acid before, but it drew him toward the negative spaces, areas he would normally have the self-control to avoid.

Often the beauty he beheld was a deception, the results aggressive and unpleasing. He didn't contemplate the meaning of this. It was just so.

At first the LSD seemed benign and he was disappointed, as he had ingested more than usual. He had passed through the phase of anticipation and nervous agitation. He loved that feeling. He traced the thrill and fear blossoming in his stomach. He used to experience it as an altar boy as he stood behind the velvet curtains in his small robe holding the processional cross, readying to march.

It occurred to him that nothing was going to happen.

He adjusted a gilded frame above the mantel. He noticed the blood coursing through the veins crossing his wrist and the bright edges of his cuff. He noticed the room in planes, sirens and dogs, the walls in their pulse. He became aware that he was clenching his teeth. He noticed his own breath like the breath of a collapsing god. A terrible lucidity came over him; a stop-motion force dropping him to his knees. A string of remembrances stretched like taffy—accusing faces of fellow cadets, holy water flooding the latrine, classmates passing like indifferent dogs, his father's disapproval, expulsion from ROTC, and his mother's tears, bleeding with his own loneliness the apocalypse of his world.

He tried to rise. His legs were completely asleep. He managed to stand and rubbed his legs. The veins of his hands were unusually prominent. He took off his shirt soaked in light and damp, sloughing away the prison of skins.

He looked down at the piece of paper on his table. He could see the work there, though it was not yet drawn. He crouched down again and worked confidently in the last rays of afternoon light. He completed two drawings, spidery and amorphous. He wrote the words he had seen and felt the gravity of what he had written: *Destruction of the universe. May 30 '67.*

It's good, he thought, somewhat ruefully. For no one would see what he had seen, no one would understand. He was accustomed to this feeling. He'd had it all his life, but in the past he tried to make up for it, as if it were his fault. He compensated for this with a sweet nature, seeking approval from his father, from his teachers, from his peers.

He wasn't certain whether he was a good or bad person. Whether he was altruistic. Whether he was demonic. But he was certain of one thing. He was an artist. And for that he would never apologize. He leaned against a wall and smoked a cigarette. He felt swathed in clarity, a little shaken, but he knew it was merely physical. There was another sensation brewing he had no name for. He felt in control. He would no longer be a slave.

As night fell, he noticed he was thirsty. He craved chocolate milk. One place would be open. He felt for his change, turned the corner, and headed toward Myrtle Avenue, grinning in the dark.

★

In the spring of 1967 I assessed my life. I had brought the child healthy into the world and placed her under the protection of a loving and educated family. I had dropped out of teachers' college, having not the discipline, the focus, nor the money I needed to continue. I was holding a temporary minimum-wage job in a textbook factory in Philadelphia.

My immediate concern was where to go next, and what to do when I got there. I held to the hope that I was an artist, though I knew I would never be able to afford art school and had to make a living. There was nothing to keep me home, no prospects and no sense of community. My parents had raised us in an atmosphere of religious dialogue, of compassion, of civil rights, but the general

feel of rural South Jersey was hardly pro-artist. My few comrades had moved to New York to write poetry and study art and I felt very much alone.

I had found solace in Arthur Rimbaud, whom I had come upon in a bookstall across from the bus depot in Philadelphia when I was sixteen. His haughty gaze reached mine from the cover of *Illuminations*. He possessed an irreverent intelligence that ignited me, and I embraced him as compatriot, kin, and even secret love. Not having the ninety-nine cents to buy the book, I pocketed it.

Rimbaud held the keys to a mystical language that I devoured even as I could not fully decipher it. My unrequited love for him was as real to me as anything I had experienced. At the factory where I had labored with a hard-edged, illiterate group of women, I was harassed in his name. Suspecting me of being a Communist for reading a book in a foreign language, they threatened me in the john, prodding me to denounce him. It was within this atmosphere that I seethed. It was for him that I wrote and dreamed. He became my archangel, delivering me from the mundane horrors of factory life. His hands had chiseled a manual of heaven and I held them fast. The knowledge of him added swagger to my step and this could not be stripped away. I tossed my copy of *Illuminations* in a plaid suitcase. We would escape together.

I had my plan. I would seek out friends who were studying at the Pratt Institute in Brooklyn. I figured if I placed myself in their environment I could learn from them. When I was laid off in late June from my job in the textbook factory, I took this as a sign to head out. Employment in South Jersey was hard to come by. I was on a waiting list at the Columbia Records pressing plant in Pitman and the Campbell Soup Company in Camden, but the thought of either job made me nauseous. I had enough money for a one-way ticket. I planned to hit all the bookstores in the city. This seemed ideal work

to me. My mother, who was a waitress, gave me white wedgies and a fresh uniform in a plain wrapper.

"You'll never make it as a waitress," she said, "but I'll stake you anyway." It was her way of showing her support.

It was a Monday morning on July 3. I maneuvered the tearful good-byes and walked the mile to Woodbury and caught the Broadway bus to Philadelphia, passing through my beloved Camden and nodding respectfully to the sad exterior of the once-prosperous Walt Whitman Hotel. I felt a pang abandoning this struggling city, but there was no work for me there. They were closing the great shipyard and soon everyone would be looking for jobs.

I got off at Market Street and stopped in Nedick's. I slipped a quarter in the jukebox, played two sides by Nina Simone, and had a farewell doughnut and coffee. I crossed over to Filbert Street to the bus terminal across from the bookstall that I had haunted for the last few years. I paused before the spot where I had pocketed my Rimbaud. In its place was a battered copy of *Love on the Left Bank* with grainy black-and-white shots of Paris nightlife in the late fifties. The photographs of the beautiful Vali Myers, with her wild hair and kohl-rimmed eyes, dancing on the streets of the Latin Quarter deeply impressed me. I did not swipe the book, but kept her image in mind.

It was a big blow that the fare to New York had nearly doubled since last I'd traveled. I was unable to buy my ticket. I went into a phone booth to think. It was a real Clark Kent moment. I thought of calling my sister although I was too ashamed to return home. But there, on the shelf beneath the telephone, lying on thick yellow pages, was a white patent purse. It contained a locket and thirty-two dollars, almost a week's paycheck at my last job.

Against my better judgment, I took the money but I left the purse on the ticket counter in the hopes that the owner would at least retrieve the locket. There was nothing in it that revealed her identity. I can only thank, as I have within myself many times through the years, this unknown benefactor. She was the one who gave me the last piece of encouragement, a thief's good-luck sign. I accepted the grant of the small white purse as the hand of fate pushing me on.

At twenty years old, I boarded the bus. I wore my dungarees, black turtleneck, and the old gray raincoat I had bought in Camden. My small suitcase, yellow-and-red plaid, held some drawing pencils, a notebook, *Illuminations*, a few pieces of clothing, and pictures of my siblings. I was superstitious. Today was a Monday; I was born on Monday. It was a good day to arrive in New York City. No one expected me. Everything awaited me.

I immediately took the subway from Port Authority to Jay Street and Borough Hall, then to Hoyt-Schermerhorn and DeKalb Avenue. It was a sunny afternoon. I was hoping my friends might put me up until I could find a place of my own. I went to the brownstone at the address I had, but they had moved. The new tenant was polite. He motioned toward a room at the rear of the flat and suggested that his roommate might know the new address.

I walked into the room. On a simple iron bed, a boy was sleeping. He was pale and slim with masses of dark curls, lying bare-chested with strands of beads around his neck. I stood there. He opened his eyes and smiled.

When I told him of my plight, he rose in one motion, put on his huaraches and a white T-shirt, and beckoned me to follow him.

I watched him as he walked ahead, leading the way with a light-footed gait, slightly bowlegged. I noticed his hands as he tapped his fingers against his thigh. I had never seen anyone like him. He deliv-

ered me to another brownstone on Clinton Avenue, gave a little fare-well salute, smiled, and was on his way.

The day wore on. I waited for my friends. As fortune would have it, they did not return. That night, having nowhere to go, I fell asleep on their red stoop. When I awoke, it was Independence Day, my first away from home with the familiar parade, veterans' picnic, and fire-works display. I felt a restless agitation in the air. Packs of children threw firecrackers that exploded at my feet. I would spend that day much as I spent the next few weeks, looking for kindred souls, shelter, and, most urgently, a job. Summer seemed the wrong time to find a sympathetic student. Everyone was less than eager to provide me with a helping hand. Everyone was struggling, and I, the country mouse, was just an awkward presence. Eventually I went back to the city and slept in Central Park, not far from the statue of the Mad Hatter.

Along Fifth Avenue, I left applications at shops and bookstores. I would often stop before a grand hotel, an alien observer to the Proustian lifestyle of the privileged class, exiting sleek black cars with exquisite brown-and-gold-patterned trunks. It was another side of life. Horse-drawn carriages were stationed between the Paris Theatre and the Plaza Hotel. In discarded newspapers I would search out the evening's entertainment. Across from the Metropolitan Opera I watched the people enter, sensing their anticipation.

The city was a real city, shifty and sexual. I was lightly jostled by small herds of flushed young sailors looking for action on Forty-second Street, with its rows of X-rated movie houses, brassy women, glittering souvenir shops, and hot-dog vendors. I wandered through Kino parlors and peered through the windows of the magnificent sprawling Grant's Raw Bar filled with men in black coats scooping up piles of fresh oysters.

The skyscrapers were beautiful. They did not seem like mere corporate shells. They were monuments to the arrogant yet phil-

anthropic spirit of America. The character of each quadrant was invigorating and one felt the flux of its history. The old world and the emerging one served up in the brick and mortar of the artisan and the architects.

I walked for hours from park to park. In Washington Square, one could still feel the characters of Henry James and the presence of the author himself. Entering the perimeters of the white arch, one was greeted by the sounds of bongos and acoustic guitars, protest singers, political arguments, activists leafleting, older chess players challenged by the young. This open atmosphere was something I had not experienced, simple freedom that did not seem to be oppressive to anyone.

I was beat and hungry, roaming with a few belongings wrapped in a cloth, hobo style, a sack without a stick—my suitcase stashed in Brooklyn. It was a Sunday and I took a day off from searching for work. Through the night I had gone back and forth to the end of the line at Coney Island, snatching bits of sleep when I could. I got off the F train at the Washington Square station and walked down Sixth Avenue. I stopped to watch the boys shooting hoops near Houston Street. It was there I met Saint, my guide, a black Cherokee with one foot in the street and the other in the Milky Way. He suddenly appeared, as vagabonds will sometimes find one another.

I swiftly clocked him, inside and out, and perceived he was okay. It seemed natural talking with him, though I didn't normally talk to strangers.

"Hey, sister. What's your situation?"

"On earth or in the universe?"

He laughed and said, "All right!"

I sized him up while he was looking at the sky. He had a Jimi Hendrix look, tall, slim, and soft-spoken, though a bit ragged. He posed no threat, uttered no sexual innuendos, no mention of the physical plane, except the most basic.

"You hungry?"

"Yes."

"Come on."

The street of cafés was just waking up. He stopped at a few places on MacDougal Street. He greeted the fellows setting up for the new day. "Hey, Saint," they would say, and he'd shoot the shit while I stood a few feet away. "Got anything for me?" he asked.

The cooks knew him well and gave him offerings in brown paper bags. He returned the favor with anecdotes of his travels from the heartland to Venus. We walked to the park, sat on a bench, and divided his take: loaves of day-old bread and a head of lettuce. He had me remove the top layers of the lettuce as he broke the bread in half. Some of the lettuce was still crisp inside.

"There's water in the lettuce leaves," he said. "The bread will satisfy your hunger."

We piled the best leaves on the bread and happily ate.

"A real prison breakfast," I said.

"Yeah, but we are free."

And that summed it up. He slept for a while in the grass and I just sat quietly with no fear. When he awoke, we searched around until he found a patch of earth without grass. He got a stick and drew a celestial map. He gave me some lessons on man's place in the universe, then the inner universe.

"You follow this?"

"It's normal stuff," I said.

He laughed for a long time.

Our unspoken routine filled my next few days. At night we'd go our separate ways. I would watch him stroll away. He would often be barefoot, his sandals slung over his shoulder. I marveled how anyone, even in summer, would have the courage and stealth to roam barefoot in the city.

JUST KIDS

We would go find our own sleep outposts. We never spoke about where we slept. In the morning I would find him in the park and we'd make the rounds, "getting vitals," as he said. We'd eat pita bread and celery stalks. On the third day I found two quarters embedded in the grass in the park. We had coffee, toast and jam, and split an egg at the Waverly Diner. Fifty cents was real money in 1967.

That afternoon, he gave me a long recap of man and the universe. He seemed content with me as a pupil, though he was more distracted than usual. Venus, he had told me, was more than a star. "I'm waiting to go home," he said.

It was a beautiful day and we sat in the grass. I guess I dozed off. He wasn't there when I awoke. There was a piece of red chalk he used for drawing on the sidewalk. I pocketed it and went my way. The next day I half waited for him to return. But he didn't. He had given me what I needed to keep going.

I wasn't sad, because every time I thought of him I'd smile. I imagined him jumping on a boxcar on a celestial course to the planet he embraced, appropriately named for the goddess of love. I wondered why he devoted so much time to me. I reasoned it was because we were both wearing long coats in July, the brotherhood of *La Bohème*.

★

I grew more desperate to find a job and started a second-level search in boutiques and department stores. I was quick to comprehend I wasn't dressed right for this line of work. Even Capezio's, a store for classic dance attire, wouldn't take me, though I had cultivated a good beatnik ballet look. I canvassed Sixtieth and Lexington and as a last resort left an application at Alexander's, knowing I would never really work there. Then I began to walk downtown, absorbed in my own condition.

It was Friday, July 21, and unexpectedly I collided with the sorrow of an age. John Coltrane, the man who gave us *A Love Supreme*, had died. Scores of people were gathering across from St. Peter's Church to say goodbye. Hours passed. People were sobbing as the love cry of Albert Ayler spirited the atmosphere. It was if a saint had died, one who had offered up healing music yet was not permitted to heal himself. Along with many strangers, I experienced a deep sense of loss for a man I had not known save through his music.

Later I walked down Second Avenue, Frank O'Hara territory. Pink light washed over rows of boarded buildings. New York light, the light of the abstract expressionists. I thought Frank would have loved the color of the fading day. Had he lived, he might have written an elegy for John Coltrane like he did for Billie Holiday.

I spent the evening checking out the action on St. Mark's Place. Long-haired boys scatting around in striped bell-bottoms and used military jackets flanked with girls wrapped in tie-dye. There were flyers papering the streets announcing the coming of Paul Butterfield and Country Joe and the Fish. "White Rabbit" was blaring from the open doors of the Electric Circus. The air was heavy with unstable chemicals, mold, and the earthy stench of hashish. The fat of candles burned, great tears of wax spilling onto the sidewalk.

I can't say I fit in, but I felt safe. No one noticed me. I could move freely. There was a roving community of young people, sleeping in the parks, in makeshift tents, the new immigrants invading the East Village. I wasn't kin to these people, but because of the free-floating atmosphere, I could roam within it. I had faith. I sensed no danger in the city, and I never encountered any. I had nothing to offer a thief and didn't fear men on the prowl. I wasn't of interest to anyone, and that worked in my favor for the first few weeks of July when I bummed around, free to explore by day, sleeping where I could at night. I sought door wells, subway cars, even a graveyard. Startled to

awake beneath the city sky or being shaken by a strange hand. Time to move along. Time to move along.

When it got really rough, I would go back to Pratt, occasionally bumping into someone I knew who would let me shower and sleep a night. Or else I would sleep in the hall near a familiar door. That wasn't much fun, but I had my mantra, "I'm free, I'm free." Although after several days, my other mantra, "I'm hungry, I'm hungry," seemed to be in the forefront. I wasn't worried, though. I just needed a break and I wasn't going to give up. I dragged my plaid suitcase from stoop to stoop, trying not to wear out my unwelcome.

It was the summer Coltrane died. The summer of "Crystal Ship." Flower children raised their empty arms and China exploded the H-bomb. Jimi Hendrix set his guitar in flames in Monterey. AM radio played "Ode to Billie Joe." There were riots in Newark, Milwaukee, and Detroit. It was the summer of *Elvira Madigan*, the summer of love. And in this shifting, inhospitable atmosphere, a chance encounter changed the course of my life.

It was the summer I met Robert Mapplethorpe.

Just Kids

I T WAS HOT IN THE CITY, BUT I STILL WORE MY RAINCOAT.
It gave me confidence as I hit the streets looking for work, my
only résumé a stint in a factory, vestiges of an incomplete education,
and an immaculately starched waitress uniform. I landed a job in a lit-
tle Italian restaurant called Joe's on Times Square. Three hours into
my first shift, after spilling a tray of veal Parmigiana on a customer's
tweed suit, I was relieved of my duties. Knowing I would never
make it as a waitress, I left my uniform—only slightly soiled—with
the matching wedgies in a public bathroom. My mother had given
them to me, a white uniform with white shoes, investing in them her
own hopes for my well-being. Now they were like wilted lilies, left
in a white sink.

Negotiating the thick psychedelic atmosphere of St. Mark's
Place, I was not prepared for the revolution under way. There
was an air of vague and unsettling paranoia, an undercurrent of
rumors, snatched fragments of conversation anticipating future
revolution. I just sat there trying to figure it all out, the air thick

with pot smoke, which may account for my dreamy recollections. I clawed through a thick web of the culture's consciousness that I hadn't known existed.

I had lived in the world of my books, most of them written in the nineteenth century. Though I was prepared to sleep on benches, in subways and graveyards, until I got work, I was not ready for the constant hunger that gnawed at me. I was a skinny thing with a high metabolism and a strong appetite. Romanticism could not quench my need for food. Even Baudelaire had to eat. His letters contained many a desperate cry for want of meat and porter.

I needed a job. I was relieved when I was hired as a cashier in the uptown branch of Brentano's bookstore. I would have preferred manning the poetry section over ringing up sales of ethnic jewelry and crafts, but I liked looking at trinkets from faraway countries: Berber bracelets, shell collars from Afghanistan, and a jewel-encrusted Buddha. My favorite object was a modest necklace from Persia. It was made of two enameled metal plaques bound together with heavy black and silver threads, like a very old and exotic scapular. It cost eighteen dollars, which seemed like a lot of money. When things were quiet I would take it out of the case and trace the calligraphy etched upon its violet surface, and dream up tales of its origins.

Shortly after I started working there, the boy I had briefly met in Brooklyn came into the store. He looked quite different in his white shirt and tie, like a Catholic schoolboy. He explained that he worked at Brentano's downtown branch and had a credit slip he wanted to use. He spent a long time looking at everything, the beads, the small figurines, the turquoise rings.

Finally he said, "I want this." It was the Persian necklace.

"Oh, it's my favorite too," I answered. "It reminds me of a scapular."

"Are you a Catholic?" he asked me.

"No, I just like Catholic things."

"I was an altar boy." He grinned at me. "I loved to swing the frankincense censer."

I was happy because he had selected the piece I singled out, yet sad to see it go. When I wrapped it and handed it to him, I said impulsively, "Don't give it to any girl but me."

I was immediately embarrassed, but he just smiled and said, "I won't."

After he left I looked at the empty place where it had lain on a piece of black velvet. By the next morning a more elaborate piece had taken its place, but it lacked the simple mystery of the Persian necklace.

By the end of my first week I was very hungry and still had nowhere to go. I took to sleeping in the store. I would hide in the bathroom while the others left, and after the night watchman locked up I would sleep on my coat. In the morning it would appear I had gotten to work early. I hadn't a dime and rummaged through employees' pockets for change to buy peanut butter crackers in the vending machine. Demoralized by hunger, I was shocked when there was no envelope for me on payday. I had not understood that the first week's pay was withheld, and I went back to the cloakroom in tears.

When I returned to my counter, I noticed a guy lurking around, watching me. He had a beard and was wearing a pinstripe shirt and one of those jackets with suede patches on the elbows. The supervisor introduced us. He was a science-fiction writer and he wanted to take me out to dinner. Even though I was twenty, my mother's warning not to go anywhere with a stranger reverberated in my consciousness. But the prospect of dinner weakened me, and I accepted. I hoped the guy, being a writer, would be okay, though he seemed more like an actor playing a writer.

We walked down to a restaurant at the base of the Empire State Building. I had never eaten at a nice place in New York City. I tried to order something that wasn't too expensive and chose swordfish, $5.95, the cheapest thing on the menu. I can still see the waiter setting the plate before me with a big wad of mashed potatoes and a slab of overdone swordfish. Even though I was starving, I could hardly enjoy it. I felt uncomfortable and had no idea how to handle the situation, or why he wanted to eat with me. It seemed like he was spending a lot of money on me and I got to worrying what he would expect in return.

After the meal we walked all the way downtown. We went east to Tompkins Square Park and sat on a bench. I was conjuring lines of escape when he suggested we go up to his apartment for a drink. This was it, I thought, the pivotal moment my mother had warned me about. I was looking around desperately, unable to answer him, when I saw a young man approaching. It was as if a small portal of future opened, and out stepped the boy from Brooklyn who had chosen the Persian necklace, like an answer to a teenage prayer. I immediately recognized his slightly bowlegged gait and his tousled curls. He was dressed in dungarees and a sheepskin vest. Around his neck hung strands of beaded necklaces, a hippie shepherd boy. I ran up to him and grabbed his arm.

"Hello, do you remember me?"

"Of course," he smiled.

"I need help." I blurted, "Will you pretend you're my boyfriend?"

"Sure," he said, as if he wasn't surprised by my sudden appearance.

I dragged him over to the science-fiction guy. "This is my boyfriend," I said breathlessly. "He's been looking for me. He's really mad. He wants me to come home now." The guy looked at us both quizzically.

"Run," I cried, and the boy grabbed my hand and we took off, through the park across to the other side.

Out of breath, we collapsed on someone's stoop. "Thank you, you saved my life," I said. He accepted this news with a bemused expression.

"I never told you my name, it's Patti."

"My name is Bob."

"Bob," I said, really looking at him for the first time. "Somehow you don't seem like a Bob to me. Is it okay if I call you Robert?"

The sun had set over Avenue B. He took my hand and we wandered the East Village. He bought me an egg cream at Gem Spa, on the corner of St. Mark's Place and Second Avenue. I did most of the talking. He just smiled and listened. I told him childhood stories, the first of many: of Stephanie, The Patch, and the square-dance hall across the road. I was surprised at how comfortable and open I felt with him. He told me later that he was tripping on acid.

I had only read about LSD in a small book called *Collages* by Anaïs Nin. I wasn't aware of the drug culture that was blooming in the summer of '67. I had a romantic view of drugs and considered them sacred, reserved for poets, jazz musicians, and Indian rituals. Robert didn't seem altered or strange in any way I might have imagined. He radiated a charm that was sweet and mischievous, shy and protective. We walked around until two in the morning and finally, almost simultaneously, revealed that neither one of us had a place to go. We laughed about that. But it was late and we were both tired.

"I think I know somewhere we can stay," he said. His last roommate was out of town. "I know where he hides his key; I don't think he would mind."

We got the subway out to Brooklyn. His friend lived in a little place on Waverly, near the Pratt campus. We went through an alleyway

where he found the key hidden beneath a loose brick, and let ourselves into the apartment.

We both fell shy when we entered, not so much because we were alone together as that it was someone else's place. Robert busied himself making me comfortable and then, in spite of the late hour, asked if I would like to see his work that was stored in a back room.

Robert spread it out over the floor for me to see. There were drawings, etchings, and he unrolled some paintings that reminded me of Richard Poussette-Dart and Henri Michaux. Multifarious energies radiated through interweaving words and calligraphic line. Energy fields built with layers of word. Paintings and drawings that seemed to emerge from the subconscious.

There were a set of discs intertwining the words EGO LOVE GOD, merging them with his own name; they seemed to recede and expand over his flat surfaces. As I stared at them, I was compelled to tell him of my nights as a child seeing circular patterns radiating on the ceiling.

He opened a book on Tantric art.

"Like this?" he asked.

"Yes."

I recognized with amazement the celestial circles of my childhood. A mandala.

I was particularly moved by the drawing he had done on Memorial Day. I had never seen anything like it. What also struck me was the date: Joan of Arc's feast day. The same day I had promised to make something of myself before her statue.

I told him this, and he responded that the drawing was symbolic of his own commitment to art, made on the same day. He gave it to me without hesitation and I understood that in this small space of time we had mutually surrendered our loneliness and replaced it with trust.

We looked at books on Dada and Surrealism and ended the night

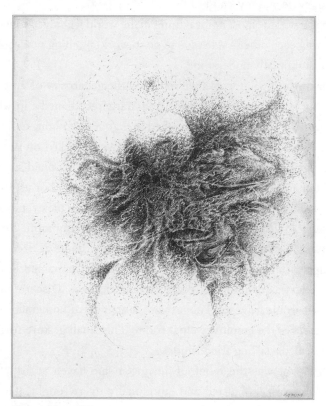

*Memorial Day, 1967*

immersed in the slaves of Michelangelo. Wordlessly we absorbed the thoughts of one another and just as dawn broke fell asleep in each other's arms. When we awoke he greeted me with his crooked smile, and I knew he was my knight.

As if it was the most natural thing in the world we stayed together, not leaving each other's side save to go to work. Nothing was spoken; it was just mutually understood.

For the following weeks we relied on the generosity of Robert's friends for shelter, notably Patrick and Margaret Kennedy, in whose apartment on Waverly Avenue we had spent our first night. Ours was an attic room with a mattress, Robert's drawings tacked on the wall and his paintings rolled in a corner and I with only my plaid suitcase. I'm certain it was no small burden for this couple to harbor us, for we had meager resources, and I was awkward socially. In the evenings we were lucky to share the Kennedys' table. We pooled our money, every cent going toward our own place. I worked long hours at Brentano's and skipped lunches. I befriended another employee, named Frances Finley. She was delightfully eccentric and discreet. Discerning my plight, she would leave me Tupperware containers of homemade soup on the table of the employee cloakroom. This small gesture fortified me and sealed a lasting friendship.

Perhaps it was the relief of having a safe haven at last, for I seemed to crash, exhausted and emotionally overwrought. Though I never questioned my decision to give my child up for adoption, I learned that to give life and walk away was not so easy. I became for a time moody and despondent. I cried so much that Robert affectionately called me Soakie.

Robert was infinitely patient with my seemingly inexplicable melancholy. I had a loving family and could have returned home. They would have understood, but I didn't want to go back with my head bowed. They had their own struggles and I now had a companion

I could rely on. I had told Robert everything about my experience, though there was no possible way of hiding it. I was so small-hipped that carrying a child had literally opened the skin of my belly. Our first intimacy revealed the fresh red scars crisscrossing my abdomen. Slowly, through his support, I was able to conquer my deep self-consciousness.

When we had finally saved enough money, Robert looked for a place for us to live. He found an apartment in a three-story brick building on a tree-lined street around the corner from the Myrtle el and within walking distance of Pratt. We had the entire second floor, with windows facing east and west, but its aggressively seedy condition was out of my range of experience. The walls were smeared with blood and psychotic scribbling, the oven crammed with discarded syringes, and the refrigerator overrun with mold. Robert cut a deal with the landlord, agreeing to clean and paint it himself provided we pay only one month's deposit, instead of the required two. The rent was eighty dollars a month. We paid one hundred and sixty dollars to move into 160 Hall Street. We regarded the symmetry as favorable.

Ours was a small street with low ivy-covered brick garages converted from former stables. It was just a short walk to the diner, the phone booth, and Jake's art supply store, where St. James Place began.

The staircase up to our floor was dark and narrow, with an arched niche carved into the wall, but our door opened onto a small, sunny kitchen. From the windows above the sink you could see a huge white mulberry tree. The bedroom faced the front with ornate medallions on the ceiling that boasted the original turn-of-the-century plasterwork.

Robert had assured me he would make it a good home and, true to his word, he labored to make it ours. The first thing he did was to wash and scrub the crusted stove with steel wool. He waxed the floors, cleaned the windows, and whitewashed the walls.

Our few possessions were heaped in the center of our future bed-
room. We slept on our coats. On trash night we scavenged the streets
and magically found all we needed. A discarded mattress in the lamp-
light, a small bookcase, repairable lamps, earthenware bowls, images
of Jesus and the Madonna in ornate crumbling frames, and a thread-
bare Persian rug for my corner of our world.

I scrubbed the mattress with baking soda. Robert rewired the
lamps, adding vellum shades tattooed with his own designs. He was
good with his hands, still the boy who had made jewelry for his mother.
He worked for some days restringing a beaded curtain, and hung it at
the entrance of our bedroom. At first I was a little skeptical about the
curtain. I had never seen such a thing but it eventually harmonized
with my own gypsy elements.

I went back to South Jersey and retrieved my books and clothing.
While I was gone Robert hung his drawings and draped the walls with
Indian cloth. He dressed the mantel with religious artifacts, candles,
and souvenirs from the Day of the Dead, arranging them as if sacred
objects on an altar. Finally he prepared a study area for me with a little
worktable and the frayed magic carpet.

We combined our belongings. My few records were filed in the
orange crate with his. My winter coat hung next to his sheepskin vest.

My brother gave us a new needle for our record player, and my
mother made us meatball sandwiches wrapped in tinfoil. We ate them
and happily listened to Tim Hardin, his songs becoming our songs,
the expression of our young love. My mother also sent along a parcel
of sheets and pillowcases. They were soft and familiar, possessing
the sheen of years of wear. They reminded me of her as she stood in
the yard assessing with satisfaction the wash on the line as it fluttered
in the sun.

My treasured objects were mingled with the laundry. My work
area was a jumble of manuscript pages, musty classics, broken toys,

and talismans. I tacked pictures of Rimbaud, Bob Dylan, Lotte Lenya, Piaf, Genet, and John Lennon over a makeshift desk where I arranged my quills, my inkwell, and my notebooks—my monastic mess.

When I came to New York I had brought a few colored pencils and a wood slate to draw on. I had drawn a girl at a table before a spread of cards, a girl divining her fate. It was the only drawing I had to show Robert, which he liked very much. He wanted me to experience working with fine paper and pencils, and shared his materials with me. We would work side by side for hours, in a state of mutual concentration.

We hadn't much money but we were happy. Robert worked part-time and took care of the apartment. I did the laundry and made our meals, which were very limited. There was an Italian bakery we frequented, off Waverly. We would choose a nice loaf of day-old bread or a quarter pound of their stale cookies offered at half-price. Robert had a sweet tooth, so the cookies often won out. Sometimes the woman behind the counter would give us extra and fill the small brown paper sack to the brim with yellow and brown pinwheels, shaking her head and murmuring friendly disapproval. Most likely she could tell it was our dinner. We would add take-out coffee and a carton of milk. Robert loved chocolate milk but it was more expensive and we would deliberate whether to spend the extra dime.

We had our work and one other. We didn't have the money to go to concerts or movies or to buy new records, but we played the ones we had over and over. We listened to my *Madame Butterfly* as sung by Eleanor Steber. *A Love Supreme. Between the Buttons.* Joan Baez and *Blonde on Blonde.* Robert introduced me to his favorites—Vanilla Fudge, Tim Buckley, Tim Hardin—and his *History of Motown* provided the backdrop for our nights of communal joy.

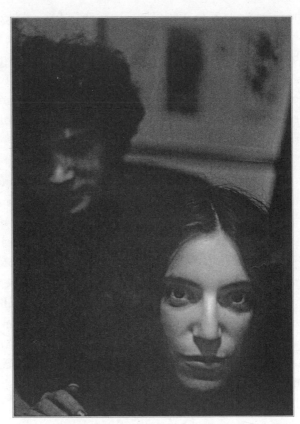

*First portrait, Brooklyn*

One Indian summer day we dressed in our favorite things, me in my beatnik sandals and ragged scarves, and Robert with his love beads and sheepskin vest. We took the subway to West Fourth Street and spent the afternoon in Washington Square. We shared coffee from a thermos, watching the stream of tourists, stoners, and folksingers. Agitated revolutionaries distributed antiwar leaflets. Chess players drew a crowd of their own. Everyone coexisted within the continuous drone of verbal diatribes, bongos, and barking dogs.

We were walking toward the fountain, the epicenter of activity, when an older couple stopped and openly observed us. Robert enjoyed being noticed, and he affectionately squeezed my hand.

"Oh, take their picture," said the woman to her bemused husband, "I think they're artists."

"Oh, go on," he shrugged. "They're just kids."

The leaves were turning burgundy and gold. There were carved pumpkins on the stoops of the brownstones on Clinton Avenue.

We took walks at night. Sometimes we could see Venus above us. It was the shepherd's star and the star of love. Robert called it our blue star. He practiced forming the *t* of Robert into a star, signing in blue so that I would remember.

I was getting to know him. He had absolute confidence in his work and in me, yet he worried incessantly about our future, how we would survive, about money. I felt we were too young to have such cares. I was happy just being free. The uncertainty of the practical side of our life haunted him, though I did my best to stay his worries.

He was searching, consciously or unconsciously, for himself. He was in a fresh state of transformation. He had shed the skin of

his ROTC uniform, and in its wake his scholarship, his commercial path, and his father's expectations of him. At seventeen he had been infatuated with the prestige of the Pershing Rifles, their brass buttons, highly polished boots, braids and ribbons. It was the uniform that attracted him, just as the robes of an altar boy had drawn him to the altar. But his service was to art, not to church or country. His beads, dungarees, and sheepskin vest represented not a costume but an expression of freedom.

After work, I would meet him downtown and we would walk through the yellow filtered light of the East Village, past the Fillmore East and the Electric Circus, the places we had passed on our first walk together.

It was exciting just to stand in front of the hallowed ground of Birdland that had been blessed by John Coltrane, or the Five Spot on St. Mark's Place where Billie Holiday used to sing, where Eric Dolphy and Ornette Coleman opened the field of jazz like human can openers.

We couldn't afford to go inside. On other days, we would visit art museums. There was only enough money for one ticket, so one of us would go in, look at the exhibits, and report back to the other.

On one such occasion, we went to the relatively new Whitney Museum on the Upper East Side. It was my turn to go in, and I reluctantly entered without him. I no longer remember the exhibit, but I do recall peering through one of the museum's unique trapezoidal windows, seeing Robert across the street, leaning against a parking meter, smoking a cigarette.

He waited for me, and as we headed toward the subway he said, "One day we'll go in together, and the work will be ours."

Some evenings later Robert surprised me and took me to our first movie. Someone at work had given him two tickets to a preview of *How I Won the War*, directed by Richard Lester. John Lennon had an important role as a soldier called Gripweed. I was excited

to see John Lennon but Robert slept with his head on my shoulder throughout the movie.

Robert was not especially drawn to film. His favorite movie was *Splendor in the Grass*. The only other movie we saw that year was *Bonnie and Clyde*. He liked the tagline on the poster: "They're young. They're in love. They rob banks." He didn't fall asleep during that movie. Instead, he wept. And when we went home he was unnaturally quiet and looked at me as if he wanted to convey all he was feeling without words. There was something of us that he saw in the movie but I wasn't certain what. I thought to myself that he contained a whole universe that I had yet to know.

On November fourth, Robert turned twenty-one. I gave him a heavy silver ID bracelet I found in a pawnshop on Forty-second Street. I had it engraved with the words *Robert Patti blue star*. The blue star of our destiny.

We spent a quiet night looking at our art books. My collection included de Kooning, Dubuffet, Diego Rivera, a Pollock monograph, and a small pile of *Art International* magazines. Robert had large coffee table books he had acquired from Brentano's on Tantric art, Michelangelo, Surrealism, and erotic art. We added used catalogs on John Graham, Gorky, Cornell, and Kitaj that we acquired for less than a dollar.

Our most prized books were on William Blake. I had a very pretty facsimile of *Songs of Innocence and of Experience*, and I often read it to Robert before we went to sleep. I also had a vellum edition of Blake's collected writings, and he had the Trianon Press edition of Blake's *Milton*. We both admired the likeness of Blake's brother Robert, who died young, pictured with a star at his foot. We adopted Blake's palette as our own, shades of rose, cadmium, and moss, colors that seemed to generate light.

One evening in late November Robert came home a bit shaken. There were some etchings for sale at Brentano's. Among them was a print pulled from an original plate from *America: A Prophecy*, watermarked with Blake's monogram. He had taken it from its portfolio, sliding it down his pant leg. Robert was not one to steal; he hadn't the nervous system for theft. He did it on impulse because of our mutual love of Blake. But toward the end of the day he lost courage. He imagined they were on to him and ducked into the bathroom, slid it out of his trousers, shredded it, and flushed it down the toilet.

I noticed his hands were shaking as he told me. It had been raining and droplets trickled down from his thick curls. He had on a white shirt, damp and sodden against his skin. Like Jean Genet, Robert was a terrible thief. Genet was caught and imprisoned for stealing rare volumes of Proust and rolls of silk from a shirt maker. Aesthetic thieves. I imagined his sense of horror and triumph as bits of Blake swirled into the sewers of New York City.

We looked down at our hands, each holding on to the other. We took a deep breath, accepting our complicity, not in theft, but in the destruction of a work of art.

"At least they'll never get it," he said.

"Who are they?" I asked.

"Anyone who isn't us," he answered.

Robert got laid off from Brentano's. He spent his unemployed days in the continual transformation of our living space. When he painted the kitchen, I was so happy that I prepared us a special meal. I made couscous with anchovies and raisins, and my specialty: lettuce soup. This delicacy consisted of chicken bouillon garnished with lettuce leaves.

But soon after Robert was laid off, I also got fired. I had failed to charge a Chinese customer any tax on a very expensive Buddha.

"Why should I pay the tax?" he said. "I am not an American."

I had no answer to this, so I didn't charge him. My judgment cost

me my job, but I was not sorry to leave. The best thing about the place had been the Persian necklace and meeting Robert, who, true to his word, had not given the necklace to another girl. On our first night together at Hall Street he gave me the cherished necklace, wrapped in violet tissue and tied with black satin ribbon.

★

The necklace was passed back and forth through the years. Ownership was based on who needed it the most. Our mutual sense of code manifested in many little games. The most unshakable was called One Day–Two Day. The premise was simply that one of us always had to be vigilant, the designated protector. If Robert took a drug, I needed to be present and conscious. If I was down, he needed to stay up. If one was sick, the other healthy. It was important that we were never self-indulgent on the same day.

In the beginning I faltered, and he was always there with an embrace or words of encouragement, coercing me to get out of myself and into my work. Yet he also knew that I would not fail if he needed me to be the strong one.

Robert got a full-time job as a window trimmer at FAO Schwarz. They were hiring for the holidays and I got a temporary position at the cash register. It was Christmastime but it was less than magical behind the scenes at the famous toy store. The pay was very low, the hours were long, and the atmosphere was dispiriting. The employees were not allowed to talk to one another, nor share coffee breaks. We found a few moments, secretly meeting by the Nativity scene spread on a platform of hay. It was there I rescued a tiny Nativity lamb from a waste bin. Robert promised to do something with it.

He liked the boxes of Joseph Cornell and often transformed insignificant bits of jetsam, colored string, paper lace, discarded rosaries, scrap, and

pearls into a visual poem. He would stay awake late into the night, sewing, cutting, gluing, and then adding touches of gouache. When I awoke there would be a finished box for me, like a valentine. Robert made a wooden manger for the little lamb. He painted it white with a bleeding heart and we added sacred numbers entwining like vines. Spiritually beautiful, it served as our Christmas tree. We placed our gifts for one another around it.

We worked quite late Christmas Eve, then got a bus at Port Authority to South Jersey. Robert was extremely nervous about meeting my family, because he was so estranged from his own. My father picked us up at the bus station. Robert gave my brother, Todd, one of his drawings, a bird rising from a flower. We had made handmade cards and brought books for my youngest sibling, Kimberly.

To stay his nerves, Robert decided to take acid. I would never have considered taking any drug in the presence of my parents, but it seemed more natural for Robert. My whole family took a liking to him and noticed nothing unusual except his continuous smile. In the course of the evening, Robert was examining my mother's expansive knickknack collection, dominated by cows of every description. He was particularly attracted to a marbleized candy dish with a purple cow lid. Perhaps it was the swirl of the glaze in his LSD-induced state, but he couldn't stop staring at it.

On Christmas evening we said goodbye, and my mother gave Robert a shopping bag filled with her traditional gift to me: art books and biographies. "There's something in there for you." She winked at Robert. When we got in the bus on the way back to Port Authority, Robert looked in the bag and found the purple cow candy dish wrapped in a gingham kitchen towel. He was delighted with it, so much so that years later, after he died, it was found displayed among his most valu-. able Italian vases.

For my twenty-first birthday, Robert made me a tambourine, tattooing the goatskin with astrological signs and tying multicolored

ribbons to its base. He put on Tim Buckley singing "Phantasmagoria in Two," then he knelt down and handed me a small book on the tarot that he had rebound in black silk. Inside it he inscribed a few lines of poetry, portraying us as the gypsy and the fool, one creating silence; one listening closely to the silence. In the clanging swirl of our lives, these roles would reverse many times.

The following night was New Year's Eve, our first together. We made new vows. Robert decided he would apply for a student loan and return to Pratt, not to study commercial art as his father wished, but to devote his energies to art alone. He wrote me a note to say we would create art together and we would make it, with or without the rest of the world.

For my part, I made a silent promise to help him achieve his goal by providing for his practical needs. I had quit the toy store after the holidays and was out of work for a short while. This set us back a little but I refused to be confined to a cashier's booth. I was determined to find a better-paying and more satisfying job and felt lucky to be hired at the Argosy Book Store on Fifty-ninth Street. They dealt in old and rare books, prints, and maps. There were no salesgirl openings, but the old man in charge, perhaps beguiled by my enthusiasm, took me on as an apprentice restorer. I sat at my dark heavy table, cluttered with eighteenth-century Bibles, linen strips, archival tape, rabbit glue, beeswax, and binder's needles, completely overwhelmed. Unfortunately I had no aptitude for such a task, and most reluctantly he had to let me go.

I returned home rather sad. It was going to be a hard winter. Robert was depressed working full-time at FAO Schwarz. Working as a window trimmer sparked his imagination and he made installation sketches. But he did less and less drawing. We lived on day-old bread and Dinty Moore beef stew. We hadn't the money to go anywhere, had no television, telephone, or radio. We had our record player,

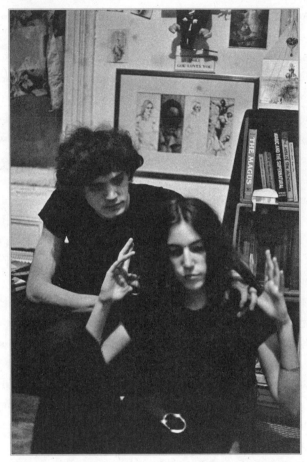

*Hall Street, Brooklyn, 1968*

though, and drew back the arm so a chosen record would play over and over as we slept.

★

I needed to get another job. My friend Janet Hamill had been hired at Scribner's Bookstore, and once again, as she had done in college, she found a way of giving me a helping hand by sharing her good fortune. She spoke to her superiors, and they offered me a position. It seemed like a dream job, working in the retail store of the prestigious publisher, home to writers like Hemingway and Fitzgerald, and their editor, the great Maxwell Perkins. Where the Rothschilds bought their books, where paintings by Maxfield Parrish hung in the stairwell.

Scribner's was housed in a beautiful landmark building at 597 Fifth Avenue. The glass-fronted Beaux Arts–style exterior had been designed by Ernest Flagg in 1913. There was a two-and-a-half-story space behind a lavish expanse of glass and iron, under a vaulted ceiling lined with clerestory windows. Each day I rose, dutifully dressed, and made the three subway changes to Rockefeller Center. My uniform for Scribner's was taken from Anna Karina in *Bande à part*: dark sweater, plaid skirt, black tights, and flats. I was positioned at the phone desk, which was manned by the kindhearted and supportive Faith Cross.

I felt lucky to be associated with such a historic bookstore. My salary was higher, and I had Janet as a confidante. I was rarely bored, and when I got restless, I wrote on the back of Scribner's stationery, like Tom in *The Glass Menagerie*, scribbling poems on the inside of cardboard boxes.

Robert was increasingly despondent. The hours were long and the pay was less than his part-time job at Brentano's had been. When he came home he was exhausted and dispirited and for a time stopped creating.

I implored him to quit. His job and scant paycheck were not worth the sacrifice. After nights of discussion, he reluctantly agreed. In return, he worked diligently, always anxious to show me what he had accomplished while I was at Scribner's. I had no regrets taking on the job as breadwinner. My temperament was sturdier. I could still create at night and I was proud to provide a situation allowing him to do his work without compromise.

At night, after trudging through the snow, I found him waiting for me in our apartment, ready to rub my hands to make them warm. He seemed always in motion, heating water on the stove, unlacing my boots, hanging up my coat, always with one eye on the drawing he was working on. He would stop for a moment if he noticed something. Most of the time, it seemed as if the piece was fully formed in his mind. He was not one for improvising. It was more a question of executing something he saw in a flash.

Existing in silence all day, he was eager to hear my stories of the bookstore's eccentric customers, of Edward Gorey with his big tennis shoes or Katharine Hepburn wearing Spencer Tracy's cap covered with a green silk head scarf or the Rothschilds with their long black coats. Afterward, we would sit on the floor and eat spaghetti while examining his new work. I was attracted to Robert's work because his visual vocabulary was akin to my poetic one, even if we seemed to be moving toward different destinations. Robert always would tell me, "Nothing is finished until you see it."

Our first winter together was a harsh one. Even with my better salary from Scribner's, we had very little money. Often we'd stand in the cold on the corner of St. James Place in eyeshot of the Greek diner and Jake's art supply store, debating how to spend our few dollars—a toss-up between grilled cheese sandwiches and art supplies. Sometimes, unable to distinguish the greater hunger, Robert would keep nervous watch in the diner while I, filled with the spirit of

Genet, pocketed the much-needed brass sharpener or colored pencils. I had a more romantic view of the artist's life and sacrifices. I had once read that Lee Krasner had lifted art supplies for Jackson Pollock. I don't know if it was true, but it served as inspiration. Robert fretted over not being able to provide for us. I told him not to worry, that committing to great art is its own reward.

At night we played the records we liked to draw to on our battered player. Sometimes we played a game called Record of the Night. The album cover of the chosen record would be prominently displayed on the mantel. We played the disc over and over, the music informing the trajectory of the evening.

It did not bother me to work in obscurity. I was hardly more than a student. Yet Robert, though shy, nonverbal, and seemingly out of step with those around him, was very ambitious. He held Duchamp and Warhol as models. High art and high society; he aspired to them both. We were a curious mix of *Funny Face* and Faust.

One cannot imagine the mutual happiness we felt when we sat and drew together. We would get lost for hours. His ability to concentrate for long periods infected me, and I learned by his example, working side by side. When we would take a break, I would boil water and make some Nescafé.

After a particularly good stretch of work, we would stroll along Myrtle Avenue, searching for Mallomars, splurging on Robert's favorite treat, a marshmallow cookie covered in dark chocolate.

Although we spent most of our time together, we weren't isolated. Our friends would come to visit. Harvey Parks and Louis Delsarte were painters; sometimes they worked on the floor next to us. Louis did portraits of us both, Robert with an Indian necklace and one of me with closed eyes. Ed Hansen shared his wisdom and collages and Janet Hamill read us her poems. I would show my drawings and tell stories about them, like Wendy entertaining the lost children

of Neverland. We were a crew of misfits, even within the liberal terrain of an art school. We often joked that we were a "losers' salon."

On special nights, Harvey, Louis, and Robert would share a joint and play hand drums. Robert had his own set of tablas. And they accompanied themselves by reciting from Timothy Leary's *Psychedelic Prayers*, one of the few books Robert actually read. Occasionally I would read their cards, deriving meanings from a mix of Papus and my own intuition. These were nights like none I had experienced in South Jersey, whimsical and filled with love.

A new friend entered my life. Robert introduced me to Judy Linn, a fellow graphics student, and we liked each other right away. Judy lived around the corner, on Myrtle Avenue, over the Laundromat where I washed our clothes. She was pretty and intelligent with an offbeat sense of humor, like a young Ida Lupino. She eventually pursued photography, spending years perfecting her darkroom techniques. In time I became her subject and she produced some of the earliest images of Robert and me.

On Valentine's Day, Robert gave me an amethyst geode. It was pale violet and nearly the size of a half grapefruit. He submerged it in water and we looked at the glowing crystals. When I was a kid I had dreamed of being a geologist. I recounted how I spent hours looking for rock specimens, wearing an old hammer tied around my waist. "No, Patti, no," he laughed.

My gift to him was an ivory heart with a cross carved in the center. Something in this object provoked a rare childhood tale from him, and he told me how he and the other altar boys would secretly rummage through the priests' private closet and drink the vestment wine. The wine didn't interest him; it was the funny feeling in his stomach that excited him, the thrill of doing something forbidden.

In the beginning of March, Robert got a temporary job as an usher for the newly opened Fillmore East. He reported for duty in an orange jumpsuit. He was looking forward to seeing Tim Buckley.

But when he came home he was more excited by someone else. "I saw someone who's going to be really big," he said. It was Janis Joplin.

We didn't have the money to go to concerts, but before Robert left the Fillmore he got me a pass to see the Doors. Janet and I had devoured their first album and I felt almost guilty seeing them without her. But I had a strange reaction watching Jim Morrison. Everyone around me seemed transfixed, but I observed his every move in a state of cold hyperawareness. I remember this feeling much more clearly than the concert. I felt, watching Jim Morrison, that I could do that. I can't say why I thought this. I had nothing in my experience to make me think that would ever be possible, yet I harbored that conceit. I felt both kinship and contempt for him. I could feel his self-consciousness as well as his supreme confidence. He exuded a mixture of beauty and self-loathing, and mystic pain, like a West Coast Saint Sebastian. When anyone asked how the Doors were, I just said they were great. I was somewhat ashamed of how I had responded to their concert.

In *Poems a Penny Each*, James Joyce wrote a line that dogged me— *the signs that mock me as I go*. It came in my mind some weeks after the Doors concert, and I mentioned it to Ed Hansen. I always liked Ed. He was small though sturdy, and with his brown overcoat, light brown hair, elfin eyes, and wide mouth, he reminded me of the painter Soutine. He was shot in the lung on DeKalb Avenue by a pack of wild children yet maintained a childlike quality himself.

He said nothing of the Joyce quote but one night brought me a record by the Byrds. "This song is going to be important to you," he said as he touched the needle to "So You Want to Be a Rock 'N' Roll Star." Something in the song excited and unnerved me but I couldn't divine his intention.

On a wintry night in 1968 someone came to our door and told us Ed was in trouble. Robert and I went out to find him. I grabbed my black lamb toy that Robert had given to me. It was his black sheep boy to black sheep girl present. Ed was something of a black sheep himself, so I took it along as a comforting talisman.

Ed was perched high up on a crane; he wouldn't come down. It was a cold, clear night, and as Robert talked to him, I climbed up the crane and gave him the lamb. He was shivering. We were the rebels without a cause and he was our sad Sal Mineo. Griffith Park in Brooklyn.

Ed followed me down, and Robert took him home.

"Don't worry about the lamb," he said when he returned. "I'll find you another."

We lost contact with Ed but a decade later he was with me in an unexpected way. As I approached the microphone with my electric guitar to sing the opening line "So you want to be a rock 'n' roll star," I remembered his words. Small prophecies.

◄-◄-►-►

There were days, rainy gray days, when the streets of Brooklyn were worthy of a photograph, every window the lens of a Leica, the view grainy and immobile. We gathered our colored pencils and sheets of paper and drew like wild, feral children into the night, until, exhausted, we fell into bed. We lay in each other's arms, still awkward but happy, exchanging breathless kisses into sleep.

The boy I had met was shy and inarticulate. He liked to be led, to be taken by the hand and enter wholeheartedly another world. He was masculine and protective, even as he was feminine and submissive. Meticulous in his dress and demeanor, he was also capable of a frightening disorder within his work. His

own worlds were solitary and dangerous, anticipating freedom, ecstasy, and release.

Sometimes I would awaken and find him working in the dim light of votive candles. Adding touches to a drawing, turning the work this way and that, he would examine it from every angle. Pensive, preoccupied, he'd look up and see me watching him and he'd smile. That smile broke through anything else he was feeling or experiencing—even later, when he was dying, in mortal pain.

In the war of magic and religion, is magic ultimately the victor? Perhaps priest and magician were once one, but the priest, learning humility in the face of God, discarded the spell for prayer.

Robert trusted in the law of empathy, by which he could, by his will, transfer himself into an object or a work of art, and thus influence the outer world. He did not feel redeemed by the work he did. He did not seek redemption. He sought to see what others did not, the projection of his imagination.

He thought his own process drudgery because he saw the finished outcome so quickly. He was drawn to sculpture but felt the medium to be obsolete. Still, he spent hours studying the *Slaves* of Michelangelo, wishing to access the feeling of working with the human form without the labor of the hammer and chisel.

He sketched out an idea for an animation depicting us in a Tantric Garden of Eden. He needed nude pictures of us to make cutouts for the geometric garden that bloomed in his mind. He asked a classmate, Lloyd Ziff, to take the nude photographs, but I wasn't happy about it. I didn't particularly relish posing as I was still somewhat self-conscious about the scars on my stomach.

The images were rigid and not as Robert had envisioned. I had an old 35mm camera and I suggested he take the photographs, but he didn't have the patience for developing and printing. He used so many photographic images from other sources I thought he could

get the results he sought shooting them himself. "I wish I could just project everything on the paper," he said. "By the time I'm halfway through I'm already on to something else." The Garden was abandoned.

Robert's early work was clearly drawn from his experiences with LSD. His drawings and small constructions had the dated charm of the Surrealists and the geometric purity of Tantric art. Slowly his work took a turn toward the Catholic: the lamb, the Virgin, and the Christ.

He took down the Indian cloths from the walls and dyed our old sheets black and violet. He stapled them to the wall and hung crucifixes and religious prints upon them. We had no difficulty finding framed portraits of saints in junk heaps or in Salvation Army stores. Robert would remove the lithographs and hand-color or work them into a large drawing, collage, or construction.

But Robert, wishing to shed his Catholic yoke, delved into another side of the spirit, reigned over by the Angel of Light. The image of Lucifer, the fallen angel, came to eclipse the saints he used in his collages and varnished onto boxes. On one small wooden box, he applied the face of Christ; inside, a Mother and Child with a tiny white rose; and in the inner lid, I was surprised to find the face of the Devil, with his extended tongue.

I would return home to find Robert in brown monk's cloth, a Jesuit robe he had found in a thrift store, poring over pamphlets on alchemy and magic. He asked me to bring him books slanted toward the occult. At first he didn't read these books so much as utilize their pentagrams and satanic images, deconstructing and refiguring them. He was not evil, though as darker elements infused his work, he became more silent.

He grew interested in creating visual spells, which might serve to call up Satan, like one would a genie. He imagined if he could make a pact that accessed Satan's purest self, the self of the light, he would

recognize a kindred soul, and that Satan would grant him fame and fortune. He did not have to ask for greatness, for the ability to be an artist, because he believed he already had that.

"You're looking for shortcuts," I said.

"Why should I take the long road?" he answered.

Sometimes, during lunch break at Scribner's, I would go to St. Patrick's to visit the young Saint Stanislaus. I would pray for the dead, whom I seemed to love as much as the living: Rimbaud, Seurat, Camille Claudel, and the mistress of Jules Laforgue. And I would pray for us.

Robert's prayers were like wishes. He was ambitious for secret knowledge. We were both praying for Robert's soul, he to sell it and I to save it.

Later he would say that the Church led him to God, and LSD led him to the universe. He also said that art led him to the devil, and sex kept him with the devil.

Some of the signs and portents were too painful to acknowledge. One night at Hall Street I stood at the entrance of our bedroom while Robert slept and had a vision of him stretched on a rack, his white shirt crumbling as he turned to dust before my eyes. He woke up and felt my horror. "What did you see?" he cried.

"Nothing," I answered, turning away, choosing not to accept what I had seen. Though I would someday hold his ashes in my hand.

★

Robert and I hardly fought, but we would bicker like children—usually over managing our small income. My salary was sixty-five dollars a week and Robert would find the occasional odd job. With rent at eighty dollars a month, plus utilities, every penny had to be accounted for. Subway tokens were twenty cents apiece and I needed ten a week. Robert smoked cigarettes and they were thirty-five cents a pack. My

weakness for using the phone booth in the diner was the most prob-
lematic. He couldn't comprehend my deep attachment to my siblings.
A handful of coins on the telephone could mean one less meal. My
mother sometimes slipped a dollar bill in her cards or letters. This
seemingly small gesture represented many coins from her waitress tip
jar and it was always appreciated.

We liked to go to the Bowery, examining tattered silk dresses,
frayed cashmere overcoats, and used motorcycle jackets. On Orchard
Street we would hunt out inexpensive but interesting materials for a
new work: sheets of Mylar, wolf skins, obscure hardware. We spent
hours at Pearl Paint on Canal Street and then took a subway to Coney
Island to walk along the boardwalk and share a Nathan's hot dog.

My table manners appalled Robert. I could see it in the cast of his
eyes, the turn of his head. When I ate with my hands, he thought it
drew too much attention, even while he'd be sitting in the booth bare-
chested, wearing several beaded necklaces and an embroidered sheep-
skin vest. Our nitpicking usually evolved into laughter, especially when
I'd point out such discrepancies. We continued these diner arguments
throughout our long friendship. My manners never got any better but
his attire went through some extremely flamboyant changes.

In those days, Brooklyn was very much an outer borough, and
seemed far removed from the action in "The City." Robert loved to go to
Manhattan. He felt alive when he crossed the East River, and it was there
he later went through rapid transformations, personally and artistically.

I lived in my own world, dreaming about the dead and their van-
ished centuries. As a young girl I had spent hours copying the ele-
gant script forming the words of the Declaration of Independence.
Handwriting had always fascinated me. Now I was able to integrate
this obscure skill into my own drawings. I became fascinated with
Islamic calligraphy, and sometimes I would take the Persian necklace
out of its tissue wrapping and set it before me when I was drawing.

I was promoted at Scribner's from the phone desk to sales. That year, the big sellers were Adam Smith's *The Money Game* and Tom Wolfe's *Electric Kool-Aid Acid Test*, summing up the polarization of everything that was rampant in our country. I identified with neither. I felt disconnected from all that was outside the world that Robert and I had created between us.

In my low periods, I wondered what was the point of creating art. For whom? Are we animating God? Are we talking to ourselves? And what was the ultimate goal? To have one's work caged in art's great zoos—the Modern, the Met, the Louvre?

I craved honesty, yet found dishonesty in myself. Why commit to art? For self-realization, or for itself? It seemed indulgent to add to the glut unless one offered illumination.

Often I'd sit and try to write or draw, but all of the manic activity in the streets, coupled with the Vietnam War, made my efforts seem meaningless. I could not identify with political movements. In trying to join them I felt overwhelmed by yet another form of bureaucracy. I wondered if anything I did mattered.

Robert had little patience with these introspective bouts of mine. He never seemed to question his artistic drives, and by his example, I understood that what matters is the work: the string of words propelled by God becoming a poem, the weave of color and graphite scrawled upon the sheet that magnifies His motion. To achieve within the work a perfect balance of faith and execution. From this state of mind comes a light, life-charged.

Picasso didn't crawl in a shell when his beloved Basque country was bombed. He reacted by creating a masterpiece in *Guernica* to remind us of the injustices committed against his people. When I had extra money I'd go to the Museum of Modern Art and sit before *Guernica*, spending long hours considering the fallen horse and the eye of the bulb shining over the sad spoils of war. Then I'd get back to work.

That spring, only days before Palm Sunday, Martin Luther King was gunned down at the Lorraine Hotel in Memphis. There was a picture in the paper of Coretta Scott King comforting her young daughter, her face wet with tears behind her widow's veil. I felt sick at heart, just as I did as a teenage girl watching Jacqueline Kennedy in her flowing black veil, standing with her children as her husband's body passed in a horse-drawn caisson. I tried to speak of my feelings in a drawing or poem but I couldn't. It seemed whenever I wanted to express injustice I never had the right lines.

Robert had bought me a white dress for Easter, but he gave it to me on Palm Sunday to assuage my sadness. It was a tattered Victorian tea dress of handkerchief linen. I adored it and wore it in our apartment, a fragile armor against the ominous portents of 1968.

My Easter dress was not suited to wear to the Mapplethorpe family dinner, nor was anything else we had amongst our few pieces of clothing.

I was fairly independent of my parents. I loved them but was not concerned about how they may have felt about my and Robert's life together. But Robert was not so free. He was still their Catholic son, unable to tell them we were living together out of wedlock. He had been warmly welcomed in my parents' house but worried I would not be welcome in his.

At first Robert thought it would be best if he slowly introduced me in phone calls to his parents. Then he decided to tell them we had eloped to Aruba and had gotten married. A friend of his was traveling in the Caribbean and Robert wrote his mother a letter, his friend postmarking it from Aruba.

I felt this elaborate deception unnecessary. I thought he should just tell them the truth, really believing they would eventually accept us as we were. "No," he would say desperately. "They're strict Catholics."

It wasn't until we visited his parents that I understood his concern. His father greeted us with icy silence. I couldn't comprehend a man not embracing his son.

The entire family was grouped around the dining room table—his older sister and brother and their spouses and his four younger siblings. The table was set, everything in place for a perfect meal. His father barely looked at me, and said nothing to Robert except, "You should cut your hair. You look like a girl."

Robert's mother, Joan, did her best to offer some sense of warmth. After dinner, she slipped Robert some money from her apron pocket and took me into her room, where she opened her jewelry box. Looking at my hand, she took out a gold ring. "We didn't have enough money for a ring," I said.

"You should wear one on your left ring finger," she told me, pressing it into my hand.

Robert was very tender toward Joan when Harry wasn't around. Joan had spirit. She laughed easily, chain-smoked, and obsessively cleaned house. I realized Robert got his sense of order not entirely from the Catholic Church. Joan favored Robert and seemed to have a secret pride in Robert's chosen path. Robert's father had wanted him to be a commercial artist, but he refused. He was driven to prove his father wrong.

The family hugged and congratulated us as we left. Harry stood in the background. "I don't believe they're married at all," he was heard to say.

Robert was cutting out sideshow freaks from an oversized paperback on Tod Browning. Hermaphrodites, pinheads, and Siamese twins were scattered everywhere. It threw me, for I couldn't see a connection between these images and Robert's recent preoccupation with magic and religion.

As always, I found ways to keep in step with him through my own drawings and poems. I drew circus characters and told stories about them, of Hagen Waker the nocturnal tightrope walker, Balthazar the Donkey-Faced Boy, and Aratha Kelly with his moon-shaped head. Robert had no more explanation of why he was drawn to freaks than I had in creating them.

It was in that spirit that we would go to Coney Island to visit the sideshows. We had looked for Hubert's on Forty-second Street, which had featured Snake Princess Wago and a flea circus, but it had closed in 1965. We did find a small museum that had body parts and human embryos in specimen jars, and Robert got fixated on the idea to use something of that sort in an assemblage. He asked around where he might find something of that sort, and a friend told him about the ruins of the old City Hospital on Welfare (later Roosevelt) Island.

On a Sunday we traveled there with our friends from Pratt. There were two points on the island that we visited. The first was a sprawling nineteenth-century building that had the aura of a madhouse; it was the Smallpox Hospital, the first place in America to receive victims of contagion. Separated only by barbed wire and broken glass, we imagined dying of leprosy and the plague.

The other ruins were what were left of the old City Hospital, with its forbidding institutional architecture, finally to be demolished in 1994. When we entered it, we were struck by the silence and an odd medicinal smell. We went from room to room and saw shelves of medical specimens in their glass jars. Many were broken, vandalized by visiting rodents. Robert combed each room until he found what he was looking for, an embryo swimming in formaldehyde within a womb of glass.

We all had to agree that Robert would most likely make great use of it. He clutched the precious find on the journey home. Even in his silence, I could feel his excitement and anticipation, imagining how he could make it work as art. We left our friends on Myrtle Avenue.

Just as we turned the corner to Hall Street, the glass jar slipped inexplicably from his hands and shattered on the sidewalk, just steps from our door.

I saw his face. He was so deflated that neither of us could say anything. The purloined jar had sat on a shelf for decades, undisturbed. It was almost as if he had taken its life. "Go upstairs," he said. "I'll clean it up." We never mentioned it again. There was something about that jar. The shards of heavy glass seemed to foreshadow the deepening of our days; we didn't speak of it but each of us seemed inflicted with a vague internal restlessness.

In early June, Valerie Solanas shot Andy Warhol. Although Robert tended not to be romantic about artists, he was very upset about it. He loved Andy Warhol and considered him our most important living artist. It was as close to hero worship as he ever got. He respected artists like Cocteau and Pasolini, who merged life and art, but for Robert, the most interesting of them was Andy Warhol, documenting the human mise-en-scène in his silver-lined Factory.

I didn't feel for Warhol the way Robert did. His work reflected a culture I wanted to avoid. I hated the soup and felt little for the can. I preferred an artist who transformed his time, not mirrored it.

Soon after, one of my customers and I fell into a discussion about our political responsibilities. It was an election year and he represented Robert Kennedy. The California primary was pending and we agreed to meet again afterward. I was excited about the prospect of working for someone with the ideals I cherished and who promised to end the war in Vietnam. I saw Kennedy's candidacy as a way in which idealism could be converted into meaningful political action, that something might be achieved to truly help those in need.

Still shaken by the Warhol shooting, Robert stayed home to do

a tribute drawing for Andy. I went home to see my father. He was a
wise and fair man and I wanted his opinion about Robert Kennedy. We sat
together on the couch watching the primary returns, which were favor-
able. My father winked at me, taking pleasure in the promise of our young
candidate and my own enthusiasm. In the intermittent hours we followed
a late news feed from California to the East Coast. I was filled with pride
as I slept but the following morning everything had changed. He had won
the primary for the Democratic nomination for president and his jubilant
smile seemed a light on earth. But he was shot down as he walked through
the kitchen of the Ambassador Hotel. My father and I once again sat on
the couch, holding hands, waiting for hours for news of his condition.

Senator Robert F. Kennedy was dead.

"Daddy, Daddy," I sobbed, burying my face in his shoulder.

My father put his arm around me. He didn't say a thing. I guess he
had already seen it all. But it seemed to me that the world outside was
unraveling, and, increasingly, my own world as well.

I came home and there were cutouts of statues, the torsos and
buttocks of the Greeks, the *Slaves* of Michelangelo, images of sailors,
tattoos, and stars. To keep up with him, I read Robert passages from
*Miracle of the Rose*, but he was always a step ahead. While I was read-
ing Genet, it was as if he was becoming Genet.

He discarded his sheepskin vest and beads and found a sailor's
uniform. He had no love of the sea. In his sailor dress and cap, he res-
onated a Cocteau drawing or the world of Genet's Robert Querelle.
He had no interest in war, but the relics and rituals of war attracted
him. He admired the stoic beauty of the Japanese kamikaze pilots who
laid out their clothing—meticulously folded shirt, a white silk scarf—
to be donned before battle.

I liked to participate in his fascinations. I found him a peacoat and a
pilot's silk scarf, though for me, my perception of World War II was fil-
tered through the Bomb and *The Diary of Anne Frank*. I acknowledged

his world as he willingly entered mine. At times, however, I felt mystified and even upset by a sudden transformation. When he covered the walls and medallion ceiling of our bedroom with Mylar, I felt shut out because it seemed more for him than me. He had hopes it would be stimulating but in my eyes it had the distorted effect of a funhouse mirror. I mourned the dismantling of the romantic chapel in which we slept.

He was disappointed I didn't like it. "What were you thinking?" I asked him.

"I don't think," he insisted. "I feel."

Robert was good to me, yet I could tell he was somewhere else. I was accustomed to him being quiet, but not silently brooding. Something was bothering him, something that was not about money. He never ceased to be affectionate to me, but he just seemed troubled.

He slept through the day and worked through the night. I would awake to find him staring at the bodies chiseled by Michelangelo tacked in a row on the wall. I would have preferred an argument to silence but it wasn't his way. I could no longer decipher his moods.

I noticed that at night there was no music. He withdrew from me and paced about, unfocused, not fully realizing his work. Half-finished montages of freaks, saints, and sailors littered the floor. It was unlike him to leave his work in that state. It was something that he had always admonished me for. I felt powerless to penetrate the stoic darkness surrounding him.

His agitation mounted as he became increasingly unsatisfied with his work. "The old imagery doesn't work for me," he would say. One Sunday afternoon he took a soldering iron to the groin of a Madonna. After he was done, he just shrugged it off. "It was a moment of insanity," he said.

There came a time when Robert's aesthetic became so consuming that I felt it was no longer our world, but his. I believed in him, but he had transformed our home into a theater of his own design. The vel-

vet backdrop of our fable had been replaced with metallic shades and black satin. The white mulberry tree was draped in heavy net. I paced while he slept, ricocheting like a dove skidding the lonely confines of a Joseph Cornell box.

-<-+->-

Our wordless nights made me restless. Something in the change of the weather marked a change in myself as well. I felt a longing, a curiosity, and a vibrancy that seemed to stifle as I walked in the evenings after work from the subway to Hall Street. I began to stop at Janet's on Clinton more often, but if I stayed too long, Robert would get uncharacteristically annoyed, and increasingly possessive. "I waited all day for you," he would say.

Slowly I began to spend more time with old friends in the Pratt area, especially the painter Howard Michels. He was the boy I was looking for on the day I met Robert. He had moved to Clinton with the artist Kenny Tisa, but at that time he was on his own. His huge paintings resonated the physical power of the Hans Hofmann School and his drawings, though unique, were reminiscent of those of Pollock and de Kooning.

In my hunger for communication I turned to him. I began to visit him frequently on the way home from work. Howie, as he was known, was articulate, passionate, well read, and politically active. It was a relief to converse with someone about everything from Nietzsche to Godard. I admired his work and looked forward to the kinship we shared in these visits. But as time passed I was less than candid with Robert about the nature of our growing intimacy.

In retrospect, the summer of 1968 marked a time of physical awakening for both Robert and me. I had not yet comprehended that Robert's conflicted behavior related to his sexuality. I knew he

deeply cared for me, but it occurred to me that he had tired of me physically. In some ways I felt betrayed, but in reality it was I who betrayed him.

I fled our little home on Hall Street. Robert was devastated, yet still could not offer any explanation for the silence that engulfed us.

I could not easily cast off the world Robert and I shared. I wasn't certain where to go next, so when Janet offered to share a sixth-floor walk-up on the Lower East Side, I accepted. This arrangement, though painful for Robert, was much preferred to my living alone or moving in with Howie.

As distraught as Robert was over my leave-taking, he helped me move my things into the new apartment. For the first time, I had my own room, to arrange as I pleased, and I began a new series of drawings. Leaving my circus animals behind, I became my own subject, producing self-portraits that emphasized a more feminine, earthy side of myself. I took to wearing dresses and waving my hair. I waited for my painter to come, but most often he didn't.

Robert and I, unable to break our bonds, continued to see one another. Even as my relationship with Howie waxed and waned, he implored me to return. He wanted us to get back together as if nothing had happened. He was ready to forgive me, yet I wasn't repentant. I wasn't willing to go backward, especially since Robert still seemed to be harboring an inner turmoil that he refused to voice.

In early September, Robert appeared out of the blue at Scribner's. Dressed in a long oxblood leather trench coat, belted at the waist, he looked both handsome and lost. He had returned to Pratt and applied for a student loan, buying the coat and a ticket to San Francisco with some of the money.

He said he wanted to talk to me. We went outside and stood on the corner of Forty-eighth and Fifth Avenue. "Please come back," he said, "or I'm leaving for San Francisco."

I couldn't imagine why he would go there. His explanation was disjointed, vague. Liberty Street, there was someone who knew the ropes, a place on Castro.

He grabbed my hand. "Come with me. There's freedom there. I have to find out who I am."

The only thing I knew about San Francisco was the great earthquake and Haight-Ashbury. "I'm already free," I said.

He stared at me with a desperate intensity. "If you don't come, I'll be with a guy. I'll turn homosexual," he threatened.

I just looked at him, not understanding at all. There was nothing in our relationship that had prepared me for such a revelation. All of the signs that he had obliquely imparted I had interpreted as the evolution of his art. Not of his self.

I was less than compassionate, a fact I came to regret. His eyes looked as if he had been working all night on speed. Wordlessly he handed me an envelope.

I watched him walk away and disappear into the crowd.

The first thing that struck me was that he had written his letter on Scribner's stationery. His handwriting, usually so deliberate, was fraught with contradiction; it went from neat and precise to a childlike scrawl. But even before I read the words, the thing that deeply moved me was the simple heading: "Patti—What I think—Robert." I had asked, even begged him so many times before I left to tell me what he was thinking about, what was on his mind. He had no words for me.

I realized, looking at these sheets of paper, that he had gone deep within himself on my account and had attempted to express the inexpressible. Imagining the anguish that drew him to write this letter brought me to tears.

"I open doors, I close doors," he wrote. He loved no one, he loved everyone. He loved sex, he hated sex. Life is a lie, truth is a

lie. His thoughts ended with a healing wound. "I stand naked when I draw. God holds my hand and we sing together." His manifesto as an artist.

I let the confessional aspects fall away, and I accepted those words as a communion wafer. He had cast the line that would seduce me, ultimately bind us together. I folded the letter and put it back in the envelope, not knowing what would happen next.

★

The walls were covered with drawings. I emulated Frida Kahlo, creating a suite of self-portraits, each containing a shard of poetry that tracked my fragmented emotional state. I imagined her great suffering that made my own seem small. One evening I was mounting the stairs to the apartment and Janet met me halfway. "We've been robbed," she cried. I followed her up the stairs. I reasoned that we owned very little that would interest a thief. I went into my room. The thieves, frustrated by our lack of sellable goods, had torn down most of my drawings. The few still intact were covered with mud and boot prints.

Deeply shaken, Janet decided it was time to leave the apartment and move in with her boyfriend. East of Avenue A in the East Village was still a danger zone, and since I had promised Robert I wouldn't stay there alone, I went back to Brooklyn. I found a two-room flat on Clinton Avenue, a block from the stoop I had slept on the summer before. I tacked up the surviving drawings on the wall. Then, on impulse, I walked over to Jake's Art Supplies and bought some oils, brushes, and canvas. I decided I was going to paint.

I had watched Howie paint when I was with him. His process was physical and abstract in a way that Robert's was not, and I recalled

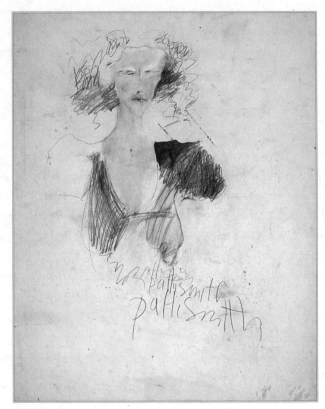

Self Portrait, *Brooklyn, 1968*

my own young ambitions, seized with the desire to pick up a brush myself. Taking my camera to MoMA, I searched for inspiration. I took a series of black-and-white portraits of de Kooning's *Woman I*, and had them developed. Taping them to the wall, I began her portrait. It amused me to do a portrait of a portrait.

Robert was still in San Francisco. He had written that he missed me, and that he had accomplished his mission, discovering new things about himself. Even as he spoke to me of his experiences with other men, he assured me he loved me.

My reaction to his admission was more emotional than I had anticipated. Nothing in my experience had prepared me for this. I felt I had failed him. I had thought a man turned homosexual when there was not the right woman to save him, a misconception I had developed from the tragic union of Rimbaud and the poet Paul Verlaine. Rimbaud regretted to the end of his life that he could not find a woman with whom he could share his full being, both physically and intellectually.

In my literary imagination, homosexuality was a poetic curse, notions I had gleaned from Mishima, Gide, and Genet. I knew nothing of the reality of homosexuality. I thought it irrevocably meshed with affectation and flamboyance. I had prided myself on being nonjudgmental, but my comprehension was narrow and provincial. Even in reading Genet, I saw his men as a mystical race of thieves and sailors. I didn't fully comprehend their world. I embraced Genet as a poet.

We were evolving with different needs. I needed to explore beyond myself and Robert needed to search within himself. He explored the vocabulary of his work, and as his components shifted and morphed, he was in effect creating a diary of his internal evolution, heralding the emergence of a suppressed sexual identity. He had never given me any indication in his behavior that I would have interpreted as homosexual.

I realized that he had tried to renounce his nature, to deny his desires, to make things right for us. For my part, I wondered if I should have been able to dispel these drives. He had been too shy and respectful and afraid to speak of these things, but there was no doubting he still loved me, and I him.

When Robert returned from San Francisco, he seemed both triumphant and troubled. It was my hope that he would come back transformed, and he did, but not in the way I imagined. He seemed to glow, more like his old self, and was more affectionate to me than ever. Even though he had experienced a sexual awakening, he still hoped that we could find some way of continuing our relationship. I wasn't sure I could come to terms with his new sense of self, nor he with mine. As I wavered, he met someone, a boy named Terry, and he embarked on his first male affair.

Whatever physical encounters he had experienced in San Francisco were random and experimental. Terry was a real boyfriend, kind and handsome, with wavy brown hair. A narcissistic air surrounded them, in their matching belted coats and knowing glances. They were a mirror image, though not so much in physical resemblance as in body language, in sync. I felt a mixture of understanding and envy for their intimacy and the secrets I imagined they shared.

Robert had met Terry through Judy Linn. Terry, soft-spoken and empathetic, accepted Robert's caring for me, and treated me with warmth and compassion. Through Terry and Robert, I observed that homosexuality was a natural way of being. But as the feelings between Terry and Robert deepened, and the intermittent relationship with my painter diffused, I found myself completely alone and conflicted.

Robert and Terry visited me often, and though there was nothing negative between the three of us, something snapped in me. Perhaps it was

the cold weather, my prodigal return to Brooklyn, or the unaccustomed loneliness, but I fell into long bouts of weeping. Robert did everything to make me feel better while Terry stood by helplessly. When Robert came alone, I begged him to stay. He assured me I was always in his thoughts.

As the holidays approached, we agreed to work on books of drawings as a mutual gift. In some way, Robert was giving me an assignment to help me pull myself together, something creative on which to focus. I filled a leather manuscript book with drawings and poems for him, and in turn he presented me a graph paper composition book with drawings very similar to the ones I had seen on our first night. He covered it in purple silk, hand-stitched with black thread.

What remains in my memory of the end of 1968 is Robert's worried expression, the heavy snow, stillborn canvases, and a bit of respite provided by the Rolling Stones. On my birthday Robert came to see me by himself. He brought me a new record. He put the needle on side one and winked. "Sympathy for the Devil" came on and we both started dancing. "It's my song," he said.

★

Where does it all lead? What will become of us? These were our young questions, and young answers were revealed.

It leads to each other. We become ourselves.

For a time Robert protected me, then was dependent on me, and then possessive of me. His transformation was the rose of Genet, and he was pierced deeply by his blooming. I too desired to feel more of the world. Yet sometimes that desire was nothing more than a wish to go backward where our mute light spread from hanging lanterns with mirrored panels. We had ventured out like Maeterlinck's children seeking the bluebird and were caught in the twisted briars of our new experiences.

Robert responded as my beloved twin. His dark curls merged with the tangle of my hair as I shuddered tears. He promised we could go back to the way things were, how we used to be, promising me anything if I would only stop crying.

A part of me wanted to do just that, yet I feared that we could never reach that place again, but would shuttle back and forth like the ferryman's children, across our river of tears. I longed to travel, to Paris, to Egypt, to Samarkand, far from him, far from us.

He too had a path to pursue and would have no choice but to leave me behind.

We learned we wanted too much. We could only give from the perspective of who we were and what we had. Apart, we were able to see with even greater clarity that we didn't want to be without each other.

I needed someone to talk to. I went home to New Jersey for my sister Linda's twenty-first birthday. We were both experiencing growing pains and we comforted each other. I brought her a book of Jacques-Henri Lartigue photographs, and as we leafed through the pages we had a longing to visit France. We sat up through the night plotting, and before we said good night, we had promised to go to Paris together, no small feat for two girls who had never been on an airplane.

The idea of this sustained me through the long winter. I worked overtime at Scribner's, saving money and plotting our route, charting ateliers and graveyards, designing an itinerary for my sister and me, just as I had planned tactical movements for our sibling army.

I don't think this was an artistically productive time for Robert and me. Robert was emotionally overwhelmed by the intensity of facing the nature he had suppressed with me and found through Terry. Yet if he was gratified in one sense, he seemed uninspired, if not bored, and perhaps couldn't help drawing comparisons between the atmosphere of their life to ours.

"Patti, nobody sees as we do," he told me.

<-→>

Something in the spring air and the restorative power of Easter
drew Robert and me back together. We sat in the diner near Pratt
and ordered our favorite meal—grilled cheese on rye with tomatoes,
and a chocolate malt. We now had enough money for two sandwiches.

Both of us had given ourselves to others. We vacillated and lost
everyone, but we had found one another again. We wanted, it seemed,
what we already had, a lover and a friend to create with, side by side.
To be loyal, yet be free.

I decided the time was right to go away. My extra hours at the
bookstore without vacation paid off, and they gave me a leave of
absence. My sister and I packed our duffel bags. Reluctantly, I left my
drawing materials behind so I could travel light. I brought a notebook
and gave my camera to my sister.

Robert and I pledged to work hard while we were apart, I to write
poems for him and he to make drawings for me. He promised to write
and keep me abreast of his pursuits.

When we embraced to say goodbye, he drew back and looked at
me intently. We didn't say anything.

★

With our small savings, Linda and I went to Paris via Iceland on a
prop plane. It was an arduous journey, and though I was excited, I was
conflicted about leaving Robert behind. Everything we owned was
piled in two small rooms on Clinton Street in Brooklyn manned by an
old super who was definitely eyeing our stuff.

Robert had moved out of Hall Street and was staying with friends
near Myrtle Avenue. Unlike myself, Robert was not driven by travel.
The prospect of being financially independent through his work was

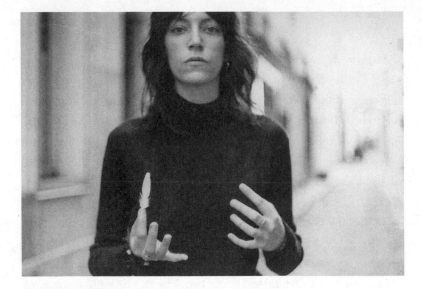

his primary goal, but for the meantime he was dependent on odd jobs and his student loan money.

Linda and I were overjoyed to be in Paris, the city of our dreams. We stayed at a fleabag hotel in Montmartre and combed the city in search of where Piaf had sung, Gérard de Nerval had slept, and Baudelaire was buried. I found some graffiti on the rue des Innocents that inspired me to draw. Linda and I found an art supply shop and lingered for hours examining beautiful French drawing papers with exquisite watermarks of angels. I bought some pencils, a few sheets of Arches, and chose a large red portfolio with canvas ribbons, using it as a makeshift table on my bed. With one leg crossed, the other dangling over the side, I drew confidently.

I dragged my portfolio from gallery to gallery. We joined a troupe of street musicians and busked for change. I worked on my drawings and wrote and Linda took photographs. We ate bread and cheese, drank Algerian wine, contracted lice, wore boatneck shirts, and shuffled happily through the backstreets of Paris.

We saw Godard's *One Plus One*. The film made a huge impression on me politically and renewed my affection for the Rolling Stones. Only days later, the French papers were covered with the face of Brian Jones: *Est Mort, 27 Ans*. I mourned the fact that we could not attend the free concert the remaining Stones held in his memory for over 250,000 in Hyde Park, where Mick Jagger released 3,500 white butterflies into the London sky. I laid my drawing pencils aside and began a cycle of poems to Brian Jones, for the first time expressing my love for rock and roll within my own work.

One of the highlights of our days was our trek to the American Express office to send and receive mail. There was always something from Robert, funny little letters describing his work, his health, his trials, and always his love.

He had temporarily moved from Brooklyn to Manhattan, sharing a loft on Delancey Street with Terry, with whom he still had an amicable friendship, and a couple of Terry's friends who had a moving company. Work as a mover afforded Robert pocket money, and the loft had enough raw space for him to continue developing his art.

His first letters seemed a bit down but brightened when he described seeing *Midnight Cowboy* for the first time. It was unusual for Robert to go to a movie, but he took this film to heart. "It's about a cowboy stud on 42nd Street," he wrote me, and called it a "masterpiece." He felt a deep identification with the hero, infusing the idea of the hustler into his work, and then into his life. "Hustler-hustler-hustler. I guess that's what I'm about."

Sometimes he seemed lost. I would read his letters, wishing I could be home by his side. "Patti—wanted to cry so bad," he wrote, "but my tears are inside. A blindfold keeps them there. I can't see today. Patti—I don't know anything."

He would take the F train to Times Square, mingling with the cons, pimps, and prostitutes in what he called "the Garden of Perversion."

He took a picture for me in a photo booth, wearing the peacoat I gave him and peering from beneath an old French naval cap; it has always been my favorite photograph of him.

In response I made a collage drawing for him called *My Hustler*, where I used one of his letters as a component. Even as he reassured me that I had nothing to worry about, he seemed to be moving deeper into the sexual underworld that he was portraying in his art. He seemed to be attracted to S&M imagery—"I'm not sure what that all means—just know it's good"—and described to me works titled *Tight Fucking Pants*, and drawings in which he lacerated S&M characters with a matte knife. "I have a hook coming out of where his prick should be, where I'm gonna hang that chain with dice and skulls from it." He spoke of using bloody bandages and starred patches of gauze.

He wasn't merely jerking off. He was filtering this world through his own aesthetic, criticizing a movie called *Male Magazine* as "nothing more than an exploitation film using an all male cast." When he visited the Tool Box, an S&M bar, he felt it was "just a bunch of big chains and shit on the wall, nothing really exciting," and wished he could design a place like that.

As the weeks went on, I worried that he wasn't doing well. It wasn't like him to complain about his physical condition. "My mouth is sick," he wrote, "my gums are white and achy." He sometimes didn't have enough money to eat.

His P.S. was still filled with Robert bravado. "I've been accused of dressing like a hustler, having the mind of a hustler and the body of one.

"Still love you through it all," he ended, signing it "Robert" with the *t* forming a blue star, our sign.

★

My sister and I returned to New York on July 21. Everybody was talking about the moon. A man had walked upon it, but I hardly noticed.

Dragging my duffel bag and portfolio, I found the loft where Robert was staying on Delancey Street, beneath the Williamsburg Bridge. He was overjoyed to see me, but I found him in very bad shape. His letters hadn't completely prepared me for how poorly he was doing. He was suffering from trench mouth and a high-grade fever, and he had lost weight. He tried to hide how weak he was, but every time he stood up he got dizzy. Yet he had been productive.

We were alone; the other fellows he shared the loft with had gone to Fire Island for the weekend. I read him some of my new poems and he fell asleep. I roamed the loft. The polished floors were scattered with the work he had so vividly described in his letters. He was right to be confident about it. It was good. Male sex. There was also one of me, with my straw hat in a field of orange rectangles.

I straightened his things. His colored pencils, brass sharpeners, remnants of male magazines, gold stars, and gauze. Then I lay down beside him, considering my next move.

Before dawn we were awakened by a series of shots and screams. The police instructed us to lock our doors and not leave for a few hours. A young man had been murdered outside our door. Robert was horrified that we had been so close to danger on the night of my return.

In the morning when I opened the door, I was shaken to see the chalk outline of the victim's body. "We can't stay here," he said. He was concerned for our safety. We left most everything behind—my duffel bag with my Paris mementos, his art supplies and clothing—and took only our most precious possessions, our portfolios, traveling across town to the Hotel Allerton on Eighth Avenue, a place known for its very cheap rooms.

These days marked the lowest point in our life together. I don't remember how we found our way to the Allerton. It was a terrible place, dark and neglected, with dusty windows that overlooked the noisy street. Robert gave me twenty dollars that he had made moving pianos; most of it went for the room deposit. I bought a carton of milk, bread, and peanut butter, but he couldn't eat. I sat there watching him sweat and shiver on an iron bed. The springs of the ancient mattress poked through the stained sheet. The place reeked of piss and exterminator fluid, the wallpaper peeling like dead skin in summer. There was no running water in the corroded sink, only occasional rusted droplets plopping through the night.

Despite his illness, he wanted to make love, and perhaps our union was some comfort, for it drew out his sweat. In the morning he went out in the hall to go to the bathroom and came back visibly upset. He had exhibited signs of gonorrhea. His immediate sense of guilt and worry that I might have contracted it magnified his anxiety about our situation.

He thankfully slept through the afternoon as I wandered the halls. The place was filled with derelicts and junkies. I was no stranger to cheap hotels. My sister and I had stayed in Pigalle in a sixth-floor walk-up, but our room was clean, even cheery, with a romantic view of the rooftops of Paris. There was nothing romantic about this place, seeing half-naked guys trying to find a vein in limbs infested with sores. Everybody's door was open because it was so hot, and I had to avert my eyes as I shuttled to and from the bathroom to rinse out cloths for Robert's forehead. I felt like a kid in a movie theater trying to hide from the shower scene in *Psycho*. It was the one image that made Robert laugh.

His lumpy pillow was crawling with lice and they mingled with his damp matted curls. I had seen plenty of lice in Paris and could at least connect them with the world of Rimbaud. The stained lumpy pillow was sadder still.

I went to get Robert some water and a voice called to me from across the hall. It was hard to tell whether it was male or female. I looked and saw a somewhat battered beauty wrapped in ragged chiffon sitting on the edge of a bed. I felt safe with him as he told me his tale. He had once been a ballet dancer but now he was a morphine addict, a mix of Nureyev and Artaud. His legs were still muscled but most of his teeth were gone. How glorious he must have been with his golden hair, square shoulders, and high cheekbones. I sat outside his door, the sole audience to his dreamlike performance, drifting through the hall like Isadora Duncan with chiffon streaming as he sang an atonal version of "Wild Is the Wind."

He told me the stories of some of his neighbors, room by room, and what they had sacrificed for alcohol and drugs. Never had I seen so much collective misery and lost hopes, forlorn souls who had fouled their lives. He seemed to preside over them all, sweetly mourning his own failed career, dancing through the halls with his length of pale chiffon.

Sitting by Robert, examining our own fate, I nearly regretted the pursuit of art. The heavy portfolios propped against the stained wall, mine red with gray ribbons, his black with black ribbons, seemed such a material burden. There were times, even when I was in Paris, that I had just wanted to leave the lot of it in an alley and be free. But as I untied the ribbons and looked at our work, I felt we were on the right path. We just needed a little luck.

In the night, Robert, generally so stoic, cried out. His gums had abscessed, he was deeply flushed, and the sheet was soaked with his sweat. I sought the morphine angel. "Do you have anything for him?" I pleaded. "Anything to ease his pain?" I tried to permeate his opiate veil. He gave me a moment of lucidity, and came to our room. Robert was lying there, delirious with fever. I thought he might die.

"You have to take him to a doctor," the morphine angel said. "You have to leave here. This place isn't for you." I looked into his face. All that he had experienced was in those dead blue eyes. For a moment they ignited. Not for himself but for us.

We did not have enough money to pay our bill. At first light I woke Robert, helped him dress, and walked him down the fire escape. I left him there on the sidewalk so I could climb back up and get our portfolios. All we had in the world.

When I looked up I saw some of the woebegone residents waving handkerchiefs. They leaned out of windows calling "goodbye, goodbye" to the children who were escaping the purgatory of their existence.

I hailed a cab. Robert slid in, followed by the portfolios. Before ducking into the taxi, I took a last look at the sad splendor of this scene, the waving hands, the Allerton's foreboding neon sign, and the morphine angel singing from the fire escape.

Robert rested his head on my shoulder. I could feel some of the stress leave his body. "It's going to be all right," I said. "I'll get my job back and you'll get better."

"We're going to make it, Patti," he said.

We promised that we'd never leave one another again, until we both knew we were ready to stand on our own. And this vow, through everything we were yet to go through, we kept.

"Chelsea Hotel," I told the driver, fumbling through my pockets for change, not completely certain I could pay him.

# Hotel Chelsea

<++>

*I'm in Mike Hammer mode, puffing on Kools reading cheap detective novels sitting in the lobby waiting for William Burroughs. He comes in dressed to the nines in a dark gabardine overcoat, gray suit, and tie. I sit for a few hours at my post scribbling poems. He comes stumbling out of the El Quixote a bit drunk and disheveled. I straighten his tie and hail him a cab. It's our unspoken routine.*

*In between I clock the action. Eyeing the traffic circulating the lobby hung with bad art. Big invasive stuff unloaded on Stanley Bard in exchange for rent. The hotel is an energetic, desperate haven for scores of gifted hustling children from every rung of the ladder. Guitar bums and stoned-out beauties in Victorian dresses. Junkie poets, playwrights, broke-down filmmakers, and French actors. Everybody passing through here is somebody, if nobody in the outside world.*

*The elevator is slowgoing. I get off at the seventh floor to see if Harry Smith is around. I place my hand on the doorknob, sensing nothing but silence. The yellow walls have an institutional feel like a middle school prison. I use the stairs and return to our room. I take a piss in the hall bathroom we share with unknown inmates. I unlock our door. No sign of Robert save a note on the mirror.* Went to big 42nd street. Love you. Blue. *I see he straightened his stuff. Men's magazines neatly piled. The chicken wire rolled and tied and the spray cans lined in a row under the sink.*

*I fire up the hot plate. Get some water from the tap. You got to let it run for a while as it comes out brown. It's just minerals and rust, so Harry says. My stuff is in the bottom drawer. Tarot cards, silk ribbons, a jar of Nescafé, and my own cup—a childhood relic with the likeness of Uncle Wiggly, rabbit gentleman. I drag my Remington from under the bed, adjust the ribbon, and insert a fresh sheet of foolscap. There's a lot to report.*

ROBERT SAT IN A CHAIR UNDER A BLACK-AND-WHITE Larry Rivers. He was really pale. I knelt down and took his hand. The morphine angel had said sometimes you could get a room at the Chelsea Hotel in exchange for art. It was my intention to offer our work. I believed the drawings I had done in Paris were strong and there was no question Robert's work eclipsed anything hanging in the lobby. My first hurdle would be Stanley Bard, the hotel manager.

I sauntered into his office to pitch our virtues. He waved me right back out while continuing a seemingly endless phone conversation. I went and sat on the floor next to Robert, silently sizing up our situation.

Harry Smith suddenly materialized, as if he had disengaged from the wall. He had wild silver hair, a tangled beard, and peered at me with bright inquisitive eyes magnified by Buddy Holly glasses. He shot animated questions that overlapped my answers. "Who are you do you have money are you twins why are you wearing a ribbon around your wrist?"

He was waiting for his friend Peggy Biderman, hoping she would stand him a meal. Though preoccupied with his own plight, he seemed sympathetic to ours and immediately fretted over Robert, who could barely sit up.

He stood before us, slightly hunchbacked in a shabby tweed jacket, chinos, and desert boots, with his head cocked like a highly intelligent hound. Although barely forty-five, he was like an old man with ceaseless childlike enthusiasm. Harry was revered for his *Anthology of American Folk Music*, and everyone from the most obscure guitar player to Bob Dylan was influenced by it. Robert was too ill to speak so Harry and I discoursed on Appalachian music as I awaited my audience with Mr. Bard. Harry mentioned he was making a film inspired by Bertolt Brecht and I recited some of "Pirate Jenny" for him. That sealed things between us, though he was a little disappointed we had no money. He followed me around the lobby saying, "Are you sure you're not rich?"

"We Smiths are never rich," I said. He seemed taken aback.

"Are you sure your name is really Smith?"

"Yes," I said, "and even surer that we're related."

I got the go-ahead to reenter Mr. Bard's office. I took the positive approach. I told him I was on my way to get an advance from my employer but would give him the opportunity to have work that was worth far more than rent. I sang Robert's praises, offering our portfolios as collateral. Bard was skeptical but he gave me the benefit of the doubt. I don't know if the prospect of seeing our work meant anything to him but he seemed impressed with my pledge of employment. We shook hands and I palmed the key. Room 1017. Fifty-five dollars a week to live in the Chelsea Hotel.

Peggy had arrived and they helped me get Robert upstairs. I unlocked the door. Room 1017 was famous for being the smallest in

the hotel, a pale blue room with a white metal bed covered over with a cream-colored chenille spread. There was a sink and mirror, a small chest of drawers, and a portable black-and-white TV sitting on the center of a large faded doily. Robert and I had never owned a TV and it sat there, a futuristic yet obsolete talisman, with the plug dangling for our entire stay.

There was a doctor in the hotel and Peggy gave me his number. We had a clean room and a helping hand. Mostly it served as a place for Robert's convalescence. We were home.

The doctor arrived and I waited outside the door. The room was too small for the three of us and I didn't want to see Robert get a shot. The doctor gave Robert a heavy dose of tetracycline, wrote out some prescriptions, and urged me to get a test. Robert was malnourished with a high fever, trench mouth, impacted wisdom teeth, and gonorrhea. We would both have to get shots and register that we had a communicable disease. The doctor said I could pay him later.

I had bad feelings about the likelihood that I had contracted a social disease by way of a stranger. It was not jealousy; it was more that I felt unclean. All the Jean Genet I had read contained a sense of sainthood that did not include the clap. This was compounded by my needle phobia as the doctor alluded to a regimen of shots. But I had to set my misgivings aside. My first concern was for Robert's well-being and he was far too ill for any emotional tirade.

I sat there next to him in silence. How different the light in the Chelsea Hotel seemed as it fell over our few possessions, it was not natural light, spreading from the lamp and the overhead bulb, intense and unforgiving, yet it seemed filled with unique energy. Robert lay comfortably and I told him not to worry, promising to come back soon. I had to stick by him. We had our vow.

It meant we were not alone.

I exited the hotel and stood before the plaque honoring the poet Dylan Thomas. Only that morning we had escaped the depressing aura of the Allerton and now we had a small but clean room in one of the most historic hotels in New York City. I scoped our immediate terrain. In 1969, Twenty-third Street between Seventh and Eighth Avenues still had a postwar feel. I passed a fishing and tackle shop, a used record store with Parisian jazz discs barely perceptible through the dusty windows, a sizable Automat, and the Oasis Bar with a neon sign of a palm tree. Across the street was a branch of the public library next to a sprawling YMCA.

I headed east, turned on Fifth Avenue, and walked uptown to Scribner's at Forty-eighth Street. Though I had taken a long leave of absence, I was confident they would take me back. I was returning a bit halfheartedly, but considering our situation, Scribner's was a real salvation. My employers greeted me warmly and I went down to the basement, shared their coffee and cinnamon rolls, and entertained them with tales of Paris street life, accentuating the humorous aspects of our misadventures and ending with me getting my job back. As a bonus they staked me an advance for immediate expenses and a week's rent, which was to impress Mr. Bard enormously. He hadn't looked at our work but he kept the portfolios for future consideration, so there was still hope we could barter.

I brought Robert a little food. It was the first he had eaten since my return. I recounted my dealings with Scribner's and Bard. We were amazed at how much had happened, retracing our small odyssey from calamitous to calm. Then he fell silent. I knew what he was thinking. He didn't say he was sorry, but I knew he was. He wondered, as he rested his head on my shoulder, if I would have been better off if I hadn't come back. But I did come back. In the end we were better off together.

I knew how to take care of him. I was good at tending the sick, bringing one out of fever, for I had learned that from my mother. I sat by his side as he drifted off to sleep. I was tired. My homecoming had taken a rough turn but things were working out and I wasn't sorry at all. I was excited. I sat there listening to him breathe, the night-light spilling over his pillow. I felt the strength of community in the sleeping hotel. Two years before, he had rescued me, appearing out of the blue in Tompkins Square Park. Now I had rescued him. On that count we were even.

A few days later, I went to Clinton Street to settle up with Jimmy Washington, our former superintendent. I climbed the heavy stone steps one last time. I knew I was never coming back to Brooklyn. I stood outside his door for a moment getting ready to knock. I could hear "Devil in a Blue Dress" playing and Jimmy Washington talking to his lady. He opened the door slowly and was surprised to see me. He had packed up Robert's things but it was obvious that he had taken a liking to most of mine. I had to laugh coming into his front room. My blue poker chips in their open inlay box, clipper ship with handmade sails, and garishly appointed plaster Infanta were carefully arranged on his mantel. My Mexican shawl was draped over the big wood desk chair I had laboriously sanded and painted over with white enamel. I called it my Jackson Pollock chair for it resembled a lawn chair I had seen in a photograph of the Pollock-Krasner farm in the Springs.

"I was keeping it all safe for you," he said a bit sheepishly. "I couldn't be sure you were coming back." I just smiled. He fired up some coffee and we struck a bargain. I owed him three months' rent: one hundred and eighty dollars. He could keep the sixty-dollar deposit and my stuff and we'd call it square. He had packed the books and records. I noticed *Nashville Skyline* on the top of the record pile.

Robert had given it to me before I went to Paris and I had played "Lay Lady Lay" over and over. I gathered up my notebooks and found among them the copy of Sylvia Plath's *Ariel* that Robert bought me when we first met. I felt a fleeting pang in my heart for I knew that innocent phase of our life had passed. I slipped an envelope with the black-and-white shots of *Woman I* that I had taken at the Modern into my pocket but left behind my failed attempts at painting her portrait, rolls of canvas splashed in umber, pinks, and green, souvenirs of a gone ambition. I was too curious about the future to look back.

As I was leaving, I noticed one of my drawings hanging on the wall. If Bard didn't get it, at least Jimmy Washington did. I said good-bye to my stuff. It suited him and Brooklyn better. There's always new stuff, that's for sure.

★

Although I was grateful for the job, I returned reluctantly to Scribner's. Being on my own in Paris had given me a taste of mobility and I had a difficult time readjusting. My friend Janet had moved to San Francisco, so I had lost my poet confidante.

Things eventually picked up when I made a new friend named Ann Powell. She had long brown hair, sad brown eyes, and a melancholy smile. Annie, as I called her, was also a poet, but with an American angle. She adored Frank O'Hara and gangster movies, and she would drag me to Brooklyn to see films with Paul Muni and John Garfield. We wrote daring B movie scripts and I'd play all the parts to amuse her on our lunch hour. Our spare time was consumed with scouring junk stores for just the right black turtleneck, the perfect white kid gloves.

Annie had gone to convent school in Brooklyn but loved Mayakovsky and George Raft. I was happy to have someone to talk to

about poetry and crime as well as argue the merits of Robert Bresson versus Paul Schrader.

I cleared about seventy dollars a week at Scribner's. After rent, the rest of the money went for food. I had to supplement our income, and looked into other ways to make a living besides punching a clock. I scoured secondhand stores for books to sell. I had a good eye, scouting rare children's books and signed first editions for a few dollars and reselling them for much more. The turnover on a pristine copy of *Love and Mr. Lewisham* inscribed by H. G. Wells covered rent and subway fares for a week.

On one of my expeditions I found Robert a slightly used copy of Andy Warhol's *Index Book*. He liked it but it also agitated him as he was designing a notebook with foldouts and pop-ups as well. The *Index Book* had photographs by Billy Name, who took the classic shots of the Warhol Factory. It included a pop-up castle, a red accordion that squeaked, a pop-up biplane, and a hairy-torsoed dodecahedron. Robert felt he and Andy were on parallel paths. "It's good," he said. "But mine will be better." He was impatient to get up and work. "I can't just lie here," he said. "The whole world is leaving me behind."

Robert was restless but obliged to stay in bed, as his impacted wisdom teeth could not be extracted until the infection and fever abated. He hated being sick. He would get up too fast and relapse. He didn't have the nineteenth-century view of convalescence that I had, savoring the opportunity of being bedridden to read books or pen long, feverish poems.

I had no concept of what life at the Chelsea Hotel would be like when we checked in, but I soon realized it was a tremendous stroke of luck to wind up there. We could have had a fair-sized railroad flat in the East Village for what we were paying, but to dwell in this eccentric and damned hotel provided a sense of security as well as a stellar education. The goodwill that surrounded us was proof that the Fates were conspiring to help their enthusiastic children.

It took a while, but as Robert got stronger and more fully recovered, he thrived in Manhattan as I had toughened in Paris. He soon hit the streets looking for work. We both knew he could not function holding a steady job, but he took on any odd employment he could get. His most hated job was carting art to and from galleries. It irked him to labor on behalf of artists he felt to be inferior, but he was paid in cash. We put every extra cent in the back of a drawer to go toward our immediate goal—a larger room. It was the main reason we were so diligent paying our rent.

Once you secured your room at the Chelsea, you weren't immediately kicked out if you got behind on the rent. But you did become part of the legion hiding from Mr. Bard. We wanted to establish ourselves as good tenants since we were on a waiting list for a bigger room on the second floor. I had seen my mother closing all the venetian blinds on many a sunny day, hiding from loan sharks and bill collectors throughout my childhood, and I had no desire to cower in the face of Stanley Bard. Mostly everybody owed Bard something. We owed him nothing.

We dwelled in our little room as inmates in a hospitable prison. The single bed was good for sleeping close, but Robert had no space to work and neither did I.

The first friend Robert made at the Chelsea was an independent fashion designer named Bruce Rudow. He had been in the Warhol film *The Thirteen Most Beautiful Boys*, and had a cameo in *Midnight Cowboy*. He was small and light-footed with an uncanny resemblance to Brian Jones. There were circles beneath his pale eyes, shaded by a black wide-brimmed cordovan hat like Jimi Hendrix wore. He had silky strawberry blond hair that fell over his high cheekbones and a wide smile. The Brian Jones connection would have been enough for

me, but he also possessed a sweet and generous disposition. He was mildly flirtatious but nothing passed between him and Robert. It was part of his affable nature.

He came to visit us but there was nowhere to sit so he invited us down to his place. He had a spacious working area strewn with hides, snakeskin, lambskin, and red leather cuttings. Tissue sewing patterns were laid out on long worktables and the walls were lined with racks of finished pieces. He had his own small factory. Bruce designed black leather jackets with silver fringe, beautifully made and featured in *Vogue* magazine.

Bruce took Robert under his wing, giving him welcome encouragement. They were both resourceful and inspired one another. Robert was intrigued with merging art and fashion and Bruce gave him advice on ways to break into the fashion world. He offered him an area in his workspace. Though grateful, Robert was not content to work in someone else's environment.

Possibly the most influential person we met at the Chelsea was Sandy Daley. She was a warm and somewhat reclusive artist who lived next to us in room 1019. It was a completely white room; even the floors were white. We had to take off our shoes before we entered. Silver helium pillows from the original Factory drifted and suspended above us. I had never seen such a place. We sat barefoot on the white floor and drank coffee and looked at her photography books. Sandy sometimes seemed a dark captive in her white room. She often wore a long black dress and I liked to walk behind her so as to observe her hem trailing the hallway and the staircase.

Sandy had spent much time working in England, the London of Mary Quant, plastic raincoats, and Syd Barrett. She had long nails and I marveled at her technique of lifting the arm of the record player so as to not damage her manicure. She took simple, elegant photographs and always had a Polaroid camera on hand. It was Sandy who lent

Robert his first Polaroid camera and served as a valued critic and confidante in critiquing his earliest photographs. Sandy was supportive to both of us and was able to ride, without judgment, the transitions Robert went through as a man and an artist.

Her environment suited Robert more than me, but it was a nice respite from the clutter of our tiny room. If I needed a shower or just wanted to daydream in an atmosphere of light and space, her door was always open. I often sat on the floor next to my favorite object, a large bowl of hammered silver resembling a glowing hubcap with a single gardenia swimming in its center. I would listen to *Beggars Banquet* over and over while its fragrance permeated the all but empty room.

I also befriended a musician named Matthew Reich. His living space was totally utilitarian, with nothing of his own except an acoustic guitar and a black-and-white composition book containing his lyrics and disjointed observations written with inhuman velocity. He was wiry and obviously obsessed with Bob Dylan. Everything about him—his hair, dress, and demeanor—reflected the style of *Bringing It All Back Home*. He had married the actress Geneviève Waïte in an apparent whirlwind courtship. She quickly realized Matthew was intelligent though somewhat unhinged, and not a relative of Bob Dylan. She ran off with Papa John from the Mamas and the Papas and left Matthew prowling the halls of the hotel dressed in a snap tab-collar shirt and pegged pants.

Although he mirrored Bob Dylan, there still wasn't anyone like Matthew. Robert and I were fond of him but Robert could only take him in small doses. Matthew was the first musician I met in New York. I could relate to his Dylan fixation, and as he put together a song, I saw possibilities in shaping my own poems into songs.

I never knew whether his speedy speech patterns reflected amphetamine use or an amphetamine mind. He would often lead me up blind

alleys or through an endless labyrinth of incomprehensible logic. I felt like Alice with the Mad Hatter, negotiating jokes without punch lines, and having to retrace my steps on the chessboard floor back to the logic of my own peculiar universe.

I had to work long hours to make up for the advance I got at Scribner's. After a time, I got a promotion and started work even earlier, waking at six and walking to Sixth Avenue to get the F train to Rockefeller Center. The subway fare was twenty cents. At seven I opened the safe, filled the registers, and got things ready for the day ahead, platooning duties with the head cashier. I was making a little more money but I preferred having my own section and ordering books. I finished work at seven and usually walked home.

Robert would greet me, impatient to show me something he was working on. One evening, having read my notebook, he designed a totem for Brian Jones. It was shaped like an arrow, with rabbit hair for the White Rabbit, a line from Winnie the Pooh, and a locket-sized portrait of Brian. We finished it together and hung it over our bed.

"Nobody sees as we do, Patti," he said again. Whenever he said things like that, for a magical space of time, it was as if we were the only two people in the world.

Robert finally was able to have his impacted wisdom teeth extracted. He felt bad for a few days but was also relieved. Robert was sturdy but he was prone to infection, so I followed him around with warm salt water to keep the sockets clean. He rinsed but pretended to be annoyed. "Patti," he said, "you're like a Ben Casey mermaid with the salt-water treatments."

Harry, often at our heels, agreed with me. He pointed out the importance of salt in alchemical experiments and then immediately suspected I was up to something supernatural.

"Yeah," I said, "I'm going to turn his fillings into gold."

Laughter. An essential ingredient for survival. And we laughed a lot.

★

Yet you could feel a vibration in the air, a sense of hastening. It had started with the moon, inaccessible poem that it was. Now men had walked upon it, rubber treads on a pearl of the gods. Perhaps it was an awareness of time passing, the last summer of the decade. Sometimes I just wanted to raise my hands and stop. But stop what? Maybe just growing up.

The moon was on the cover of *Life* magazine, but the headlines of every newspaper were emblazoned with the brutal murders of Sharon Tate and her companions. The Manson murders didn't gel with any film noir vision I had of crime, but it was the kind of news that sparked the imagination of the hotel inhabitants. Nearly every-

one was obsessed with Charles Manson. At first Robert went over every detail with Harry and Peggy, but I couldn't bear talking about it. The last moments of Sharon Tate haunted me, imagining her horror knowing that they were about to slaughter her unborn child. I retreated into my poems, scrawling in an orange composition book. Envisioning Brian Jones floating facedown in a swimming pool was as much tragedy as I could handle.

Robert had a fascination with human behavior, in what drove seemingly normal people to create mayhem. He kept up with the Manson news but his curiosity waned as Manson's behavior grew more bizarre. When Matthew showed Robert a newspaper picture of Manson with an *X* carved on his forehead, Robert lifted the *X*, using the symbol in a drawing.

"The *X* interests me, but not Manson," he said to Matthew. "He's insane. Insanity doesn't interest me."

A week or two later I waltzed into the El Quixote looking for Harry and Peggy. It was a bar-restaurant adjacent to the hotel, connected to the lobby by its own door, which made it feel like our bar, as it had been for decades. Dylan Thomas, Terry Southern, Eugene O'Neill, and Thomas Wolfe were among those who had raised one too many a glass there.

I was wearing a long rayon navy dress with white polka dots and a straw hat, my *East of Eden* outfit. At the table to my left, Janis Joplin was holding court with her band. To my far right were Grace Slick and the Jefferson Airplane, along with members of Country Joe and the Fish. At the last table facing the door was Jimi Hendrix, his head lowered, eating with his hat on, across from a blonde. There were musicians everywhere, sitting before tables laid with mounds of shrimp with green sauce, paella, pitchers of sangria, and bottles of tequila.

I stood there amazed, yet I didn't feel like an intruder. The Chelsea was my home and the El Quixote my bar. There were no

security guards, no pervasive sense of privilege. They were here for the Woodstock festival, but I was so afflicted by hotel oblivion that I wasn't aware of the festival or what it meant.

Grace Slick got up and brushed past me. She was wearing a floor-length tie-dyed dress and had dark violet eyes like Liz Taylor.

"Hello," I said, noticing I was taller.

"Hello yourself," she said.

When I went back upstairs I felt an inexplicable sense of kinship with these people, though I had no way to interpret my feeling of prescience. I could never have predicted that I would one day walk in their path. At that moment I was still a gangly twenty-two-year-old book clerk, struggling simultaneously with several unfinished poems.

On that night, too excited to sleep, infinite possibilities seemed to swirl above me. I stared up at the plaster ceiling as I had done as a child. It seemed to me that the vibrating patterns overhead were sliding into place.

The mandala of my life.

★

Mr. Bard returned the ransom. I unlocked our door and saw our port-folios leaning against the wall, the black with black ribbons, the red with gray ribbons. I untied them both and carefully looked at each drawing. I couldn't be sure if Bard had even looked at the work. Certainly if he had, he didn't see it with my eyes. Each drawing, each collage, reaffirmed my faith in our ability. The work was good. We deserved to be here.

Robert was frustrated that Bard didn't accept our art as recompense. He was anxious about how we'd get by since that afternoon both his moving jobs were canceled. He lay on the bed with his white

T-shirt, dungarees, and huaraches, looking very much like the day we met. But when he opened his eyes to look at me he did not smile. We were like fishermen throwing out our nets. The net was strong but often we returned from ventures empty-handed. I figured we had to step up the action and find someone who would invest in Robert. Like Michelangelo, Robert just needed his own version of a pope. With so many influential people passing through the doors of the Chelsea, it was conceivable we could one day secure him a patron. Life at the Chelsea was an open market, everyone with something of himself to sell.

In the meantime we agreed to forget our cares for the night. We took a little money from our savings and walked to Forty-second Street. We stopped at a photo booth in Playland to take our pictures, a strip of four shots for a quarter. We got a hot dog and papaya drink at Benedict's, then merged with the action. Boys on shore leave, prostitutes, runaways, abused tourists, and assorted victims of alien abduction. It was an urban boardwalk with Kino parlors, souvenir stands, Cuban diners, strip clubs, and late-night pawnshops. For fifty cents one could slip inside a theater draped in stained velvet and watch foreign films paired with soft porn.

We hit the used paperback stalls stocked with greasy pulp novels and pinup magazines. Robert was always on the lookout for collage material and I for obscure UFO tracts or detective novels with lurid covers. I scored a copy of the Ace double novel edition of *Junkie* by William Burroughs under his pseudonym William Lee, which I never resold. Robert found a few loose pages from a portfolio of sketches of Aryan boys in motorcycle caps by Tom of Finland.

For just a couple dollars we both got lucky. We headed home holding hands. For a moment I dropped back to watch him walk. His sailor's gait always touched me. I knew one day I would stop and he would keep on going, but until then nothing could tear us apart.

The last weekend of the summer I went home to visit my parents. I walked to Port Authority feeling optimistic as I boarded the bus to South Jersey, looking forward to seeing my family and going to secondhand bookstores in Mullica Hill. We were all book lovers and I usually found something to resell in the city. I found a first edition of *Doctor Martino* signed by William Faulkner.

The atmosphere at my parents' house was uncharacteristically bleak. My brother was about to enlist in the Navy, and my mother, though intensely patriotic, was distraught at the prospect of Todd being shipped off to Vietnam. My father was deeply disturbed by the My Lai massacre. "Man's inhumanity to man," he would say, quoting Robert Burns. I watched him plant a weeping willow in the backyard. It seemed to symbolize his sorrow for the direction our country had taken.

Later people would say the murder at the Altamont Stones concert in December marked the end of the idealism of the sixties. For me it punctuated the duality of the summer of 1969, Woodstock and the Manson cult, our masked ball of confusion.

★

Robert and I rose early. We had put aside money for our second anniversary. I had prepared our clothing the night before, washing our things in the sink. He squeezed out the excess water, as his hands were stronger, and draped the clothes over the iron headboard we used as a clothesline. In order to dress for the occasion, he disassembled the piece in which he had stretched two black T-shirts on a vertical frame. I had sold the Faulkner book and, along with a week's rent, was able to buy Robert a Borsalino hat at the JJ Hat Center on Fifth Avenue. It was a fedora and I watched him comb his hair and try it on in different ways before the mirror. He was obviously pleased as he jokingly pranced around in his anniversary hat.

He put the book I was reading, my sweater, his cigarettes, and a bottle of cream soda in a white sack. He didn't mind carrying it, because it lent him a sailor's air. We boarded the F train and rode to the end of the line.

I always loved the ride to Coney Island. Just the idea that you could go to the ocean via subway was so magical. I was deeply absorbed in a biography of Crazy Horse when I snapped to the present and looked at Robert. He was like a character in *Brighton Rock* in his forties-style hat, black net T-shirt, and huaraches.

We pulled into our stop. I leapt to my feet, filled with the anticipation of a child, slipping the book back into the sack. He took my hand.

Nothing was more wonderful to me than Coney Island with its gritty innocence. It was our kind of place: the fading arcades, the peeling signs of bygone days, cotton candy and Kewpie dolls on a stick, dressed in feathers and glittering top hats. We wandered through the last gasp of the sideshows. They had lost their luster, though they still touted such human oddities as the donkey-faced boy, the alligator man, and the three-legged girl. Robert found the world of freaks fascinating, though of late he was forgoing them for leather boys in his work.

We strolled the boardwalk and got our picture taken by an old man with a box camera. We had to wait for an hour for it to be developed, so we went to the end of the long fishing pier where there was a shack that served coffee and hot chocolate. Pictures of Jesus, President Kennedy, and the astronauts were taped to the wall behind the register. It was one of my favorite places and I would often daydream of getting a job there and living in one of the old tenement buildings across from Nathan's.

All along the pier young boys and their grandfathers were crabbing. They'd slide raw chicken as bait in a small cage on a rope and

hurl it over the side. The pier was swept away in a big storm in the eighties but Nathan's, which was Robert's favorite place, remained. Normally we only had money for one hot dog and a Coke. He would eat most of the dog and I most of the sauerkraut. But that day we had enough money for two of everything. We walked across the beach to say hello to the ocean, and I sang him the song "Coney Island Baby" by the Excellents. He wrote our names in the sand.

We were just ourselves that day, without a care. It was our good fortune that this moment in time was frozen in a box camera. It was our first real New York portrait. Who we were. Only weeks before we had been at the bottom, but our blue star, as Robert called it, was rising. We boarded the F train for the long ride back, returned to our little room, and cleared off the bed, happy to be together.

Harry and Robert and I sat in a booth at the El Quixote sharing shrimp and green-sauce appetizers, talking about the word *magic*. Robert would often use it to describe us, about a successful poem or drawing, and ultimately in choosing a photograph on a contact sheet. "That's the one with the magic," he would say.

Harry, feeding into Robert's fascination with Aleister Crowley, was claiming to have been fathered by the black magician. I asked if we drew a pentagram on the table, could he make his dad appear? Peggy, who had joined us, brought us all down to earth. "Can any of you second-class wizards conjure the dough to pay for the check?"

I can't exactly say what Peggy did. I know she had a job at the Museum of Modern Art. We used to joke that she and I were the only officially employed people at the hotel. Peggy was a kind, fun-loving woman with a tight ponytail, dark eyes, and a worn tan, who seemed to know everybody. She had a mole between her brows that Allen Ginsberg had dubbed her third eye, and could easily have been a fringe

player in a beatnik movie. We made quite a crew, all talking at once, contradicting and sparring, a cacophony of affectionate arguing.

Robert and I didn't fight very often. He seldom raised his voice, but if he was angry you could see it in his eyes, his brow, or the stiffening of his jaw. When we had a problem that needed hashing out, we went to the "bad doughnut shop" on the corner of Eighth Avenue and Twenty-third Street. It was the Edward Hopper version of Dunkin' Donuts. The coffee was burnt, the doughnuts were stale, but you could count on it being open all night. We felt less confined there than in our room and nobody bothered us. All kinds of characters could be found at any given hour, guys on the nod, hookers on the night shift, transients and transvestites. One could enter this atmosphere unnoticed, inspiring at the most a brief glance.

Robert always had a powdered jelly doughnut and I had a French cruller. For some reason they were five cents more than normal doughnuts. Every time I ordered one he'd say, "Patti! You don't really like them; you're just being difficult. You just want them because they're French." Robert tagged them "poet's cruller."

It was Harry who settled the etymology of the cruller. It wasn't French at all, but Dutch: a fluted ring-shaped affair made from choux pastry with a light and airy texture eaten on Shrove Tuesday. They were made with all the eggs, butter, and sugar forbidden at Lent. I declared it the holy doughnut. "Now we know why the doughnut has a hole." Harry thought for a moment, and then scolded me, feigning annoyance. "No, no, it's Dutch," he said. "It doesn't translate that way." Holy or not, the French confection connection was permanently squelched.

One evening Harry and Peggy invited us to visit with the composer George Kleinsinger, who had a suite of rooms at the Chelsea. I was always reluctant to visit people, especially grown-ups. But Harry lured me with the information that George had written the music to

*Archy and Mehitabel*, a cartoon tale of the friendship between a cockroach and an alley cat. Kleinsinger's rooms were more tropical forest than hotel residence, a real Anna Kavan setup. The draw was supposed to be his collection of exotic snakes, including a twelve-foot python. Robert seemed transfixed by them, but I was terrified.

As everyone was taking turns petting the python, I was free to rummage through George's musical compositions, stacked randomly among the ferns, palms, and caged nightingales. I was elated to find original sheet music from Shinbone Alley in a pile atop a filing cabinet. But the real revelation was finding evidence that this modest and kindly snake-rearing gentleman was none other than the composer of the music for *Tubby the Tuba*. He confirmed this fact and I nearly wept when he showed me original scores for the music so beloved in my childhood.

The Chelsea was like a doll's house in the Twilight Zone, with a hundred rooms, each a small universe. I wandered the halls seeking its spirits, dead or alive. My adventures were mildly mischievous, tapping open a door slightly ajar and getting a glimpse of Virgil Thomson's grand piano, or loitering before the nameplate of Arthur C. Clarke, hoping he might suddenly emerge. Occasionally I would bump into Gert Schiff, the German scholar, armed with volumes on Picasso, or Viva in Eau Sauvage. Everyone had something to offer and nobody appeared to have much money. Even the successful seemed to have just enough to live like extravagant bums.

I loved this place, its shabby elegance, and the history it held so possessively. There were rumors of Oscar Wilde's trunks languishing in the hull of the oft-flooded basement. Here Dylan Thomas, submerged in poetry and alcohol, spent his last hours. Thomas Wolfe plowed through hundreds of pages of manuscript that formed *You Can't Go Home Again*. Bob Dylan composed "Sad-Eyed Lady of the Lowlands" on our floor, and a speeding Edie Sedgwick was said to

have set her room on fire while gluing on her thick false eyelashes by candlelight.

So many had written, conversed, and convulsed in these Victorian dollhouse rooms. So many skirts had swished these worn marble stairs. So many transient souls had espoused, made a mark, and succumbed here. I sniffed out their spirits as I silently scurried from floor to floor, longing for discourse with a gone procession of smoking caterpillars.

Harry zeroed in on me with his mock, menacing stare. I started laughing.

"Why are you laughing?"

"Because it tickles."

"You can feel that?"

"Yes, certainly."

"Fascinating!"

Occasionally Robert entered the game. Harry would try to stare him down, saying things like, "Your eyes are incredibly green!" A staring match could last for several minutes, but Robert's stoic side always won out. Harry would never admit Robert won. He would just break away and finish a previous conversation as if the staring match never occurred. Robert would flash a knowing smile, obviously pleased.

Harry was taken with Robert but wound up with me. Often I called on Harry on my own. All his Seminole Indian skirts with delicate patchwork would be lying about. He was very particular about them, and seemed delighted to see me wear them, although he would not let me touch his hand-painted Ukrainian egg collection. He handled the eggs like they were tiny infants. They had intricate patterns akin to the skirts. He did let me play with his magic wand collection, intricately carved shaman wands wrapped in newspapers. Most were

about eighteen inches long, but my favorite was the smallest, the size of a conductor's wand, with the patina of an old rosary rubbed smooth from prayer.

Harry and I spieled simultaneously on alchemy and Charlie Patton. He was slowly piecing together hours of footage for his mystery film project based on Brecht's *The Rise and Fall of the City of Mahagonny*. None of us knew exactly what it was but sooner or later we were all summoned to serve in its lengthy inception. He played tapes of peyote rituals of the Kiowa and songs of the common folk of West Virginia. I felt a kinship with their voices and, so inspired, made up a song and sang it to him before it dissipated into the musty air of his cluttered room.

We talked about everything, ranging from the tree of life to the pituitary gland. Most of my knowledge was intuitive. I had a flexible imagination and was always ready for a game that we would play. Harry would test me with a question. The answer had to be a sliver of knowledge expanding into a lie composed of facts.

"What are you eating?"

"Kidney beans."

"Why are you eating them?"

"To piss off Pythagoras."

"Under the stars?"

"Out of the circle."

It would begin simply and we would keep it going for as long as it took to get to the punch line, somewhere between a limerick and a poem, unless I tripped up and used an inappropriate reference. Harry never made mistakes, as he seemed to know something about everything, the undisputed king of information manipulation.

Harry was also an expert at string figures. If he was in a good mood he would pull a loop of string several feet long from his pocket

and weave a star, a female spirit, or a one-man cat's cradle. We all sat at his feet in the lobby like amazed children watching as his deft fingers produced evocative patterns by twisting and knotting the loop. He documented string figure patterns and their symbolic importance in hundreds of pages of notes. Harry would regale us with this precious information that regrettably none of us would grasp, as we were so mesmerized by his sleight of hand.

One time, when I was sitting in the lobby reading *The Golden Bough*, Harry noticed I had a beat-up two-volume first edition. He insisted we go on an expedition to Samuel Weiser's to bask in the proximity of the preferred and vastly expanded third edition. Weiser's harbored the greatest selection of books on esoteric matters in the city. I agreed to go if he and Robert didn't get stoned, as the combination of the three of us in the outside world, in an occult bookstore, was lethal enough.

Harry knew the Weiser brothers quite well and I was given the key to a glass case to examine the famous 1955 edition of *The Golden Bough*, which consisted of thirteen heavy green volumes with evocative titles like *The Corn Spirit* and *The Scapegoat*. Harry disappeared into some antechamber with Mr. Weiser, most likely to decipher some mystical manuscript. Robert was reading *Diary of a Drug Fiend*.

It seemed like we milled around in there for hours. Harry was gone for a long time, and we found him standing, as though transfixed, in the center of the main floor. We watched him for quite a while but he never moved. Finally, Robert, perplexed, went up to him and asked, "What are you doing?"

Harry gazed at him with the eyes of an enchanted goat. "I'm reading," he said.

We met a lot of intriguing people at the Chelsea but somehow when I close my eyes to think of them, Harry is always the first person

I see. Perhaps because he was the first person we met. But more likely because it was a magic period, and Harry believed in magic.

◅◆▻

Robert's great wish was to break into the world that surrounded Andy Warhol, though he had no desire to be part of his stable or to star in his movies. Robert often said he knew Andy's game, and felt that if he could talk to him, Andy would recognize him as an equal. Although I believed he merited an audience with Andy, I felt any significant dialogue with him was unlikely, for Andy was like an eel, perfectly able to slither from any meaningful confrontation.

This mission led us to the city's Bermuda Triangle: Brownie's, Max's Kansas City, and the Factory, all located within walking distance of one another. The Factory had moved from its original location on Forty-seventh Street to 33 Union Square. Brownie's was a health food restaurant around the corner where the Warhol people ate lunch, and Max's where they spent their nights.

Sandy Daley first accompanied us to Max's, as we were too intimidated to go by ourselves. We didn't know the rules and Sandy served as an elegantly dispassionate guide. The politics at Max's were very similar to high school, except the popular people were not the cheerleaders or football heroes and the prom queen would most certainly be a he, dressed as a she, knowing more about being a she than most she's.

Max's Kansas City was on Eighteenth Street and Park Avenue South. It was supposedly a restaurant, though few of us actually had the money to eat there. The owner, Mickey Ruskin, was notoriously artist-friendly, even offering a free cocktail-hour buffet for those with the price of a drink. It was said that this buffet, which included Buffalo wings, kept a

lot of struggling artists and drag queens alive. I never frequented it as I was working and Robert, who didn't drink, was too proud to go.

There was a big black-and-white awning flanked by a bigger sign announcing that you were about to enter Max's Kansas City. It was casual and sparse, adorned with large abstract pieces of art given to Mickey by artists who ran up supernatural bar tabs. Everything, save the white walls, was red: booths, tablecloths, napkins. Even their signature chickpeas were served in little red bowls. The big draw was surf and turf: steak and lobster. The back room, bathed in red light, was Robert's objective, and the definitive target was the legendary round table that still harbored the rose-colored aura of the absent silver king.

On our first visit we only made it as far as the front section. We sat in a booth and split a salad and ate the inedible chickpeas. Robert and Sandy ordered Cokes. I had a coffee. The place was fairly dead. Sandy had experienced Max's at the time when it was the social hub of the subterranean universe, when Andy Warhol passively reigned over the round table with his charismatic ermine queen, Edie Sedgwick. The ladies-in-waiting were beautiful, and the circulating knights were the likes of Ondine, Donald Lyons, Rauschenberg, Dalí, Billy Name, Lichtenstein, Gerard Malanga, and John Chamberlain. In recent memory the round table had seated such royalty as Bob Dylan, Bob Neuwirth, Nico, Tim Buckley, Janis Joplin, Viva, and the Velvet Underground. It was as darkly glamorous as one could wish for. But running through the primary artery, the thing that ultimately accelerated their world and then took them down, was speed. Amphetamine magnified their paranoia, robbed some of their innate powers, drained their confidence, and ravaged their beauty.

Andy Warhol was no longer there, nor was his high court. Andy didn't go out as much since Valerie Solanas shot him, but it was also likely he had become characteristically bored. Despite his absence,

in the fall of 1969 it was still the place to go. The back room was the
haven for those desiring the keys to Andy's second silver kingdom,
often described more as a place of commerce than of art.

Our Max's debut was uneventful and we splurged on a taxi home
for Sandy's sake. It was raining and we did not wish to see the hem of
her long black dress trail in the mud.

For a while the three of us continued to go to Max's together.
Sandy had no emotional investment in these excursions and served as
a buffer to my sullen, restless behavior. Eventually I fell in line and
accepted the Max's thing as a Robert-related routine. I came home
from Scribner's after seven and we'd eat grilled cheese sandwiches at
a diner. Robert and I would tell each other tales of our day and share
any new work we had accomplished. Then there would be the long
stretch of figuring out what to wear to Max's.

Sandy didn't have a diverse wardrobe but was meticulous with her
appearance. She had a few identical black dresses designed by Ossie
Clark, the king of King's Road. They were like elegant floor-length
T-shirts, unconstructed yet lightly clinging, with long sleeves and a
scooped neck. They seemed so essential to her persona that I often
daydreamed of buying her a whole closetful.

I approached dressing like an extra preparing for a shot in a
French New Wave film. I had a few looks, such as a striped boatneck
shirt and a red throat scarf like Yves Montand in *Wages of Fear*, a Left
Bank beat look with green tights and red ballet slippers, or my take on
Audrey Hepburn in *Funny Face*, with her long black sweater, black
tights, white socks, and black Capezios. Whatever the scenario, I usu-
ally needed about ten minutes to get ready.

Robert approached dressing like living art. He would roll a small
joint, have a smoke, and look at his few pieces of clothing while con-
templating his accessories. He saved pot for socializing, which made
him less nervous but abstracted his sense of time. Waiting as Robert

decided on the right number of keys to hang on his belt loop was humorously maddening.

Sandy and Robert were very similar in their attention to detail. The search for the appropriate accessory could lead them on an aesthetic treasure hunt, mining Marcel Duchamp, the photographs of Cecil Beaton, Nadar, or Helmut Newton. Sometimes comparative studies could propel Sandy to take a few Polaroids, leading into a discussion on the validity of the Polaroid as art. Finally the moment would arrive to tackle the Shakespearean question: should he or should he not wear three necklaces? In the end, one was too subtle and two had no impact. So the second debate would be, should it be three or none? Sandy understood Robert was factoring an artistic equation. I knew that as well, but for me the question was to go or not to go; in these elaborate decision-making processes, I had the attention span of a hopped-up teenage boy.

★

On Halloween night, when expectant children raced across Twenty-third Street in their bright paper costumes, I exited our tiny room in my *East of Eden* dress, stepped upon the white squares of the chessboard floors, skipped down several flights of stairs, and stood before the door of our new room. Mr. Bard had made good on his promise, placing the key to room 204 in the palm of my hand with an affectionate nod. It was right next door to the room where Dylan Thomas had written his last words.

On All Saints' Day Robert and I gathered our few belongings, slid them into the elevator, and got off at the second floor. Our new room was in the back of the hotel. The bathroom, which was a bit gritty, was in the hall. But the room was really pretty, with two windows overlooking old brick buildings and high trees shedding the last of their leaves. There was a double bed, a sink with a mirror, and a closet area without a door. We were energized by the change.

Robert lined his spray cans under the sink and I rummaged through my cloth pile and found a length of Moroccan silk to hang over the closet area. There was a big wooden desk that Robert could use as a worktable. And because it was on the second floor I could fly up and down the stairs—I hated using the elevator. It gave me a sense that the lobby was an extension of the room, for it was truly my station. If Robert was out, I could write and enjoy the din of the comings and goings of our neighbors, who would often offer encouraging words.

Robert stayed up most of the night at the big desk working on the opening pages of a new foldout book. He used three of the photo booth pictures of me in my Mayakovsky cap and surrounded it with toile butterflies and angels. I felt, as always, a rising pleasure when he used a reference to me in a work, as if through him I would be remembered.

Our new room was more suited to me than to Robert. I had everything I needed but it was not big enough for two people to work. Since he used the desk, I taped a sheet of Arches sateen to my section of the wall and began a drawing of the two of us in Coney Island.

Robert sketched installations that he couldn't realize and I could feel his frustration. He turned his attention to making necklaces, encouraged by Bruce Rudow, who saw commercial potential in them. Robert had always liked making necklaces, for his mother, then for himself. In Brooklyn, Robert and I had made each other special amulets, which slowly became more elaborate. In room 1017 the top drawer of our bureau was filled with ribbons, string, tiny ivory skulls, and beads of colored glass and silver, gathered for next to nothing at flea markets and Spanish religious stores.

We sat on our bed and strung pearls, African trade beads, and varnished seeds from broken rosaries. My necklaces were kind of

crude but Robert's were intricate. I wove him leather braids and he added beads, feathers, knots, and rabbit's feet. The bed was not the best place to work, however, as the beads would get lost in the folds of the covers or fall into the cracks of the wood floor.

Robert hung a few finished pieces on the wall and the rest on a clothes hook on the back of the door. Bruce was very enthusiastic about the necklaces, which moved Robert to develop some new approaches. He envisioned stringing beads of semiprecious stones, mounting rabbit's feet in platinum, or casting skulls in silver and gold, but for now we used whatever we could find. With little capital we had to be extremely inventive. Robert was a master at transforming the insignificant into the divine. His local suppliers were Lamston's five-and-dime across the street and the Capitol Fishing tackle shop a few doors down from the Chelsea.

The Capitol was a place to pick up rain gear, bamboo fly rods, or an Ambassador reel, but it was the small things we were looking for. We bought hair jigs, feathered lures, and tiny lead weights. The Musky bucktail lures were best for necklaces as they came in a multitude of colors, as well as spotted tail and pure white. The owner would just sigh and give us our purchase in a little brown paper bag like the kind used for penny candy. It was pretty obvious we weren't qualified fishermen but he got to know us, offering low prices for broken lures with good feathers and a used tackle box with unfolding trays that was perfect for our supplies.

We also kept watch for anyone ordering shellfish at the El Quixote. After they paid the check I would gather the lobster claws in a napkin. Robert scrubbed, sanded, and spray-painted them. I would say a little prayer to thank the lobster as he strung them on a necklace, adding brass beads between small knots. I made bracelets, braiding shoestring leather and using a few small beads. Robert confidently wore everything we made. People were showing interest and Robert had hopes of selling them.

There was no lobster at the Automat but it was one of our favorite places to eat. It was fast and cheap, but the food still seemed homemade. Robert, Harry, and I often went together, and getting the fellows under way could take a lot more time than eating.

The routine went something like this: I have to fetch Harry. He can't find his keys. I search the floor and locate them under some esoteric volume. He starts reading it and it reminds him of another book he needs to find. Harry rolls a joint while I look for the second book. Robert arrives and has a smoke with Harry. I know then it's curtains for me. When they have a smoke it takes them an hour to accomplish a ten-minute thing. Then Robert decides to wear the denim vest he made by cutting the sleeves off his jacket and goes back to our room. Harry thinks my black velvet dress is too bleak for daytime. Robert comes up on the elevator as we go down the stairs, frantic comings and goings like playing out the verses of "Taffy Was a Welshman."

Horn and Hardart, the queen of Automats, was just past the tackle shop. The routine was to get a seat and a tray, then go to the back wall where there were rows of little windows. You would slip some coins into a slot, open the glass hatch, and extract a sandwich or fresh apple pie. A real Tex Avery eatery. My favorite was chicken potpie or cheese and mustard with lettuce on a poppy seed roll. Robert liked their two specialties, baked macaroni and cheese and chocolate milk. Both Robert and Harry were mystified that I didn't appreciate Horn and Hardart's famous chocolate milk, but for a girl raised on Bosco and powdered milk, it was too thick, so I just got coffee.

I was always hungry. I metabolized my food quickly. Robert could go without eating much longer than me. If we were out of money we just didn't eat. Robert might be able to function, even if he got a little shaky, but I would feel like I was going to pass out. One driz-

zly afternoon I had a hankering for one of those cheese-and-lettuce sandwiches. I went through our belongings and found exactly fifty-five cents, slipped on my gray trench coat and Mayakovsky cap, and headed to the Automat.

I got my tray and slipped in my coins but the window wouldn't open. I tried again without luck and then I noticed the price had gone up to sixty-five cents. I was disappointed, to say the least, when I heard a voice say, "Can I help?"

I turned around and it was Allen Ginsberg. We had never met but there was no mistaking the face of one of our great poets and activists. I looked into those intense dark eyes punctuated by his dark curly beard and just nodded. Allen added the extra dime and also stood me to a cup of coffee. I wordlessly followed him to his table, and then plowed into the sandwich.

Allen introduced himself. He was talking about Walt Whitman and I mentioned I was raised near Camden, where Whitman was buried, when he leaned forward and looked at me intently. "Are you a girl?" he asked.

"Yeah," I said. "Is that a problem?"

He just laughed. "I'm sorry. I took you for a very pretty boy."

I got the picture immediately.

"Well, does this mean I return the sandwich?"

"No, enjoy it. It was my mistake."

He told me he was writing a long elegy for Jack Kerouac, who had recently passed away. "Three days after Rimbaud's birthday," I said. I shook his hand and we parted company.

Sometime later Allen became my good friend and teacher. We often reminisced about our first encounter and he once asked how I would describe how we met. "I would say you fed me when I was hungry," I told him. And he did.

Our room was getting cluttered. It now contained not only our port-folios, books, and clothes, but the supplies Robert had stored in Bruce Rudow's room: chicken wire, gauze, spools of rope, spray cans, glues, Masonite board, wallpaper rolls, bathroom tiles, linoleum, and piles of vintage men's magazines. He could never throw any of it away. He was using male subject matter in a way that I had never seen, cuttings from magazines he had gotten from Forty-second Street integrated in collages with intersecting lines that served as visual pulleys.

I asked him why he just didn't take his own pictures. "Oh, it's so much trouble," he'd say. "I can't be bothered and the printing would cost too much money." He had taken photographs at Pratt, but was too impatient with the time-consuming process of the darkroom.

Meanwhile, searching out male magazines was its own ordeal. I would stay in the front looking for Colin Wilson paperbacks, and Robert would go in the back. It felt a little scary, as if we were doing something wrong. The guys running those places were grouchy, and if you opened a sealed magazine you had to buy it.

These transactions made Robert edgy. The magazines were expensive, five dollars apiece, and he was always taking a chance on the contents. When he would finally choose one we'd hurry back to the hotel. Robert would unseal the cellophane with the expectation of Charlie peeling back the foil of a chocolate bar in hopes of find-ing a golden ticket. Robert likened it to when he ordered grab bag packages from the back covers of comic books, sending for them without telling his parents. He would watch for the mail to intercept them, and take his treasure to the bathroom, where he would lock the door, open the box, and spread out magic tricks, X-ray glasses, and miniature sea horses.

Sometimes he'd luck out and there would be several images he could use in an existing piece, or such a good one that it would trig-ger a whole new idea. But often the magazines were a disappointment

and he'd toss them on the floor, frustrated and remorseful that he'd wasted our money.

Sometimes his choice of imagery mystified me, as it did in Brooklyn, but his process did not. I had made cuttings from fashion magazines to make elaborate costumes for paper dolls.

"You should take your own pictures," I'd say.

I said that over and over.

Occasionally I took my own pictures, but had them developed at a Fotomat. I knew nothing about the darkroom. I got a glimpse of the printing process from watching Judy Linn work. Judy, having graduated from Pratt, had committed herself to photography. When I would visit her in Brooklyn, we would sometimes spend the day taking photographs, I as her model. As artist and subject we were suited for each other, because we shared the same visual references.

We drew on everything from *Butterfield 8* to the French New Wave. She shot the stills from our imagined movies. Although I didn't smoke, I would pocket a few of Robert's Kools to achieve a certain look. For our Blaise Cendrars shots we needed thick smoke, for our Jeanne Moreau a black slip and a cigarette.

When I showed him Judy's prints, Robert was amused by my personas. "Patti, you don't smoke," he'd say, tickling me. "Are you stealing my cigarettes?" I thought he would be annoyed, since cigarettes were expensive, but the next time I went to Judy's, he surprised me with the last couple from his battered pack.

"I know I'm a fake smoker," I would say, "but I'm not hurting anybody and besides I gotta enhance my image." It was all for Jeanne Moreau.

Robert and I continued to go to Max's late at night on our own. We eventually graduated to the back room and sat in a corner under the

Dan Flavin fluorescent sculpture, washed in red light. The gatekeeper, Dorothy Dean, had taken a liking to Robert and let us pass.

Dorothy was small, black, and brilliant. She had harlequin glasses, wore classic cardigan sweater sets, and had gone to the finest schools. She stood before the entrance to the back room like an Abyssinian priest guarding the Ark. No one got past her unless she approved. Robert responded to her acid tongue and acerbic sense of humor. She and I stayed out of each other's way.

I knew that Max's was important to Robert. He was so supportive of my work that I could not refuse him this nightly ritual.

Mickey Ruskin allowed us to sit for hours nursing coffee and Coca-Colas and hardly ordering a thing. Some nights were totally dead. We would walk home exhausted and Robert would say we were never going back. Other nights were desperately animated, a dark cabaret infused with the manic energy of thirties Berlin. Screaming catfights erupted between frustrated actresses and indignant drag queens. They all seemed as if they were auditioning for a phantom, and that phantom was Andy Warhol. I wondered if he cared about them at all.

One such night, Danny Fields came over and invited us to sit at the round table. This single gesture afforded us a trial residency, which was an important step for Robert. He was elegant in his response. He just nodded and led me to the table. He didn't reveal at all how much it meant to him. For Danny's thoughtfulness toward us I have always been grateful.

Robert was at ease because, at last, he was where he wanted to be. I can't say I felt comfortable at all. The girls were pretty but brutal, perhaps because there seemed a low percentage of interested males. I could tell they tolerated me and were attracted to Robert. He was as much their target as their inner circle was his. It seemed as if they were all after him, male and female, but at the time Robert was motivated by ambition, not sex.

He was elated with clearing this small yet monumental hurdle. But privately I thought that the round table, even at the best of times, was innately doomed. Disbanded by Andy, banded by us, no doubt to be disbanded again to accommodate the next scene.

I looked around at everyone bathed in the blood light of the back room. Dan Flavin had conceived his installation in response to the mounting death toll of the war in Vietnam. No one in the back room was slated to die in Vietnam, though few would survive the cruel plagues of a generation.

★

I thought I could hear the voice of Tim Hardin singing "Black Sheep Boy" as I returned with our laundry. Robert had gotten paid for a moving job with an old record player and had put on our favorite album. It was his surprise for me. We hadn't had a record player since Hall Street.

It was the Sunday before Thanksgiving. Though autumn was ending, it was a bright Indian summer kind of day. I had gathered up our laundry, slipped on an old cotton dress, wool stockings, and a thick sweater, and headed toward Eighth Avenue. I had asked Harry if he wanted any laundry done, but he responded in mock horror at the prospect of me touching his boxer shorts and scooted me away. I put the stuff in the washer with a fair amount of baking soda and walked the couple of blocks to Asia de Cuba to get a cup of café con leche.

I folded our things. The song that we called ours came on, "How Can You Hang On to a Dream?" We were both dreamers, but Robert was the one who got things done. I made the money but he had drive and focus. He had plans for himself but for me as well. He wanted us to develop our work but there was no room. All the wall space was taken. There was no possibility for him to realize his blueprints for

installations. His spray painting was bad for my persistent cough. He sometimes went up on the Chelsea roof but it was getting too cold and windy. Finally he decided he was going to find a raw space for us, and began looking through the *Village Voice* and asking around.

Then he had a piece of luck. We had a neighbor, an overweight sad sack in a rumpled overcoat, who walked his French bulldog back and forth on Twenty-third Street. He and his dog had identical faces of slack folding skin. We coded him Pigman. Robert noticed he lived a few doors down, over the Oasis Bar. One evening he stopped to pet the dog and struck up a conversation. Robert asked him if he knew of any vacancies in his building, and Pigman told him he had the whole second floor but the front room was just for storage. Robert asked if he could sublet it. At first he was reluctant, but the dog liked Robert and he agreed, offering the front room starting January 1 for a hundred dollars a month. With a month's deposit, he could have the place for the balance of this year to clean it out. Robert wasn't sure where the money would come from but sealed it with a handshake.

Robert took me over to see the space. There were floor-to-ceiling windows overlooking Twenty-third Street, and we could see the YMCA and the top of the Oasis sign. It was everything he needed: at least three times the size of our room with plenty of light and a wall with about a hundred nails protruding. "We can hang the necklaces there," he said.

"We?"

"Of course," he said. "You can work here too. It will be our space. You can start drawing again."

"The first drawing will be of Pigman," I said. "We owe him a lot. And don't worry about the money. We'll get it."

Not long after, I found a twenty-six-volume set of the complete Henry James for next to nothing. It was in perfect condition. I knew a customer at Scribner's who would want it. The tissue guards were intact, the gravures

fresh-looking, and there was no foxing on the pages. I cleared over one hundred dollars. Slipping five twenty-dollar bills in a sock, I tied a ribbon around it and gave it to Robert. He opened it, saying, "I don't know how you do it."

Robert gave the money to Pigman, and set to cleaning out the front half of the loft. It was a big job. I would stop in after work and he would be standing knee-deep in the center of Pigman's incomprehensible debris: dusty fluorescent tubing, rolls of insulation, racks of expired canned goods, half-empty bottles of unidentified cleaning fluids, vacuum cleaner bags, stacks of bent venetian blinds, moldy boxes spilling over with decades of tax forms, and bundles of stained *National Geographic*s tied with red-and-white string, which I snapped up to braid for bracelets.

He cleared, scrubbed, and painted the space. We borrowed buckets from the hotel, filled them with water, and carted them over. When we were finished, we stood together in silence, imagining the possibilities. We'd never had so much light. Even after he cleaned and painted half the large windows black, light still flooded in. We scavenged for a mattress, worktables, and chairs. I mopped the floor with water boiled with eucalyptus on our hot plate.

The first things Robert brought over from the Chelsea were our portfolios.

Things were picking up at Max's. I stopped being so judgmental and got in the swing of things. Somehow I was accepted, though I never really fit in. Christmas was coming and there was a pervasive melancholy, as if everyone simultaneously remembered they had nowhere to go.

Even here, in the land of the so-called drag queens, Wayne County, Holly Woodlawn, Candy Darling, and Jackie Curtis were not to be cat-

egorized so lightly. They were performance artists, actresses, and come-
diennes. Wayne was witty, Candy was pretty, and Holly had drama,
but I put my money on Jackie Curtis. In my mind, she had the most
potential. She would successfully manipulate a whole conversation just
to deliver one of Bette Davis's killer lines. And she knew how to wear a
housedress. With all her makeup she was a seventies version of a thirties
starlet. Glitter on her eyelids. Glitter in the hair. Glitter face powder.
I hated glitter and sitting with Jackie meant going home speckled all
over.

Right before the holidays Jackie seemed distraught. I ordered
her a snowball, a coveted unaffordable treat. It was a mound of
devil's food cake filled with vanilla ice cream and covered with
shredded coconut. She sat there eating it, plopping large glitter tears
in the melting ice cream. Candy Darling slinked in next to her, dip-
ping her lacquered fingernail into the dish, offering a bit of comfort
with her soothing voice.

There was something especially poignant about Jackie and
Candy as they embraced the imagined life of the actress. They both
had aspects of Mildred Rogers, the coarse illiterate waitress in *Of
Human Bondage*. Candy had Kim Novak's looks and Jackie had the
delivery. Both of them were ahead of their time, but they didn't live
long enough to see the time they were ahead of.

"Pioneers without a frontier," as Andy Warhol would say.

It snowed on Christmas night. We walked to Times Square to see the
white billboard proclaiming *WAR IS OVER! If you want it. Happy
Christmas from John and Yoko*. It hung above the bookstall where
Robert bought most of his men's magazines, between Child's and
Benedict's, two all-night diners.

Looking up, we were struck by the ingenuous humanity of this New York City tableau. Robert took my hand, and as the snow swirled around us I glanced at his face. He narrowed his eyes and nodded in affirmation, impressed to see artists take on Forty-second Street. For me it was the message. For Robert, the medium.

Newly inspired, we walked back to Twenty-third Street to look at our space. The necklaces hung on hooks and he had tacked up some of our drawings. We stood at the window and looked out at the snow falling beyond the fluorescent Oasis sign with its squiggly palm tree. "Look," he said, "it's snowing in the desert." I thought about a scene in Howard Hawks's movie *Scarface* where Paul Muni and his girl are looking out the window at a neon sign that said The World Is Yours. Robert squeezed my hand.

The sixties were coming to an end. Robert and I celebrated our birthdays. Robert turned twenty-three. Then I turned twenty-three. The perfect prime number. Robert made me a tie rack with the image of the Virgin Mary. I gave him seven silver skulls on a length of leather. He wore the skulls. I wore a tie. We felt ready for the seventies.

"It's our decade," he said.

<div align="center">❖❖❖</div>

Viva stormed into the lobby with a Garbo-like inapproachability, attempting to intimidate Mr. Bard so he wouldn't ask her for back rent. The filmmaker Shirley Clarke and the photographer Diane Arbus entered separately, each with a sense of agitated mission. Jonas Mekas, with his ever-present camera and secret smile, shot the obscure corners of life surrounding the Chelsea. I stood there holding a stuffed black crow I had bought for next to nothing from the

*Tie rack. December 30, 1969*

Museum of the American Indian. I think they wanted to get rid of it. I had decided to name it Raymond, after Raymond Roussel, who wrote *Locus Solus*. I was thinking what a magical portal this lobby was when the heavy glass door opened as if swept by wind and a familiar figure in a black and scarlet cape entered. It was Salvador Dalí. He looked around the lobby nervously, and then, seeing my crow, smiled. He placed his elegant, bony hand atop my head and said: "You are like a crow, a gothic crow."

"Well," I said to Raymond, "just another day at the Chelsea."

In mid-January we met Steve Paul, who managed Johnny Winter. Steve was a charismatic entrepreneur who had provided the sixties with one of the great rock clubs in New York City, the Scene. Located on a side street near Times Square, it became a gathering spot for visiting musicians and late-night jams. Dressed in blue velvet and perpetually bemused, he was a bit of Oscar Wilde, a bit of the Cheshire Cat. He was negotiating a recording contract for Johnny, and had installed him in a suite of rooms at the Chelsea.

We all collided one evening at the El Quixote. In the short time that we spent with Johnny, I was intrigued by his intelligence and instinctive appreciation of art. In conversation he was open, and benevolently strange. We were invited to see him play at the Fillmore East, and I had never seen a performer interact with his audience with such complete assurance. He was fearless and joyously confrontational, spinning like a dervish and stalking the stage swinging the veil of his pure white hair. Fast and fluid on guitar, he transfixed the crowd with his misaligned eyes and playfully demonic smile.

On Groundhog Day we attended a small party in the hotel for Johnny, to celebrate his signing with Columbia Records. We spent most of the evening rapping with Johnny and Steve Paul. Johnny admired Robert's necklaces and offered to buy one; they also spoke of Robert designing him a black net cape.

As I sat there I noticed that I felt physically unstable, malleable, as if I were made of clay. No one seemed to indicate that I had changed in any way. Johnny's hair seemed to droop like two long white ears. Steve Paul, in his blue velvet, was leaning into a mound of pillows, chain-smoking joints in slow motion, contrasting with the erratic presence of Matthew bounding in and out of the room. I felt so profoundly altered that I fled and locked myself in our old shared bathroom on the tenth floor.

I wasn't certain what had happened to me. My experience most closely mirrored the "eat me, drink me" scene in *Alice in Wonderland*. I tried to access her restrained and curious reaction to her own psychedelic trials. I reasoned someone had dosed me with a form of hallucinogen. I had never taken any kind of drug before and my limited knowledge came from observing Robert or reading descriptions of the drug-induced visions of Gautier, Michaux, and Thomas de Quincey. I huddled in a corner, not sure what to do. I certainly didn't want anyone to see me telescoping in size, even if it was all in my head.

Robert, most likely high himself, searched the hotel until he found me, and sat outside the door talking to me, helping me to find my way back.

Finally I unlocked the door. We took a walk and then went back to the safety of our room. The next day we stayed in bed. When I got up I dramatically wore dark glasses and a raincoat. Robert was very considerate and didn't tease me at all, not even about the raincoat.

We had a beautiful day that blossomed into an unusually passionate night. I happily wrote of this night in my diary, adding a small heart like a teenage girl.

It's hard to convey the speed at which our lives changed in the following months. We had never seemed closer, but our happiness would soon be clouded by Robert's anxiety over money.

He couldn't get any work. He worried we wouldn't be able to keep both places. He continually made the rounds of the galleries, usually returning frustrated and demoralized. "They don't really look at the work," he complained. "They wind up trying to pick me up. I'd rather dig ditches than sleep with these people."

He went to a placement service to get part-time work but nothing panned out. Although he sold an occasional necklace, breaking into the fashion business was slowgoing. Robert got increasingly depressed about money, and the fact that it fell on me to get it. It was partially the stress of worrying about our financial position that drove him back to the idea of hustling.

Robert's early attempts at hustling had been fueled by curiosity and the romance of *Midnight Cowboy*, but he found working on Forty-second Street to be harsh. He decided to shift to Joe Dallesandro territory, on the East Side near Bloomingdale's, where it was safer.

I begged him not to go, but he was determined to try. My tears did not stop him, so I sat and watched him dress for the night ahead. I imagined him standing on a corner, flushed with excitement, offering himself to a stranger, to make money for us.

"Please be careful," was all I could say.

"Don't worry. I love you. Wish me luck."

Who can know the heart of youth but youth itself?

★

I awoke and he was gone. There was a note to me on the desk. "Couldn't sleep," it said. "Wait for me." I straightened up and was writing a letter to my sister when he came into the room in a highly agitated state. He said he had to show me something. I

quickly dressed and followed him to the space. We bounded up the stairs.

Entering the space, I did a quick scan. His energy seemed to vibrate the air. Mirrors, lightbulbs, and pieces of chain were spread on a length of black oilcloth. He had begun a new installation, but he drew my attention to another work leaning against the necklace wall. He had stopped stretching canvas when he lost interest in painting but he kept one of the stretchers. He had completely covered it with out-takes from his male magazines. The faces and torsos of young men wrapped the frame. He was nearly shaking.

"It's good, isn't it?"

"Yes," I said. "It's genius."

It was a relatively simple piece yet it seemed to have innate power. There was no excess: it was a perfect object.

The floor was littered with paper cuttings. The room reeked of glue and varnish. Robert hung the frame on the wall, lit a cigarette, and we looked at it wordlessly together.

It is said that children do not distinguish between living and inani-mate objects; I believe they do. A child imparts a doll or tin soldier with magical life-breath. The artist animates his work as the child his toys. Robert infused objects, whether for art or life, with his creative impulse, his sacred sexual power. He transformed a ring of keys, a kitchen knife, or a simple wooden frame into art. He loved his work and he loved his things. He once traded a drawing for a pair of rid-ing boots—completely impractical, but almost spiritually beautiful. These he buffed and polished with the devotion of a groom dressing a greyhound.

This affair with fine footwear reached its summit one evening as we returned from Max's. Turning the corner off Seventh Avenue we came upon a pair of alligator shoes, aglow on the sidewalk. Robert

scooped them up and pressed them to him, declaring them treasure. They were deep brown with silk laces, showing no trace of wear. They tiptoed into a construction, which he often disassembled for the need of them. With a wad of tissue stuffed in the pointed toes, they were not a bad fit, though perhaps incongruous with dungarees and turtleneck. He exchanged his turtleneck for a black net T, adding a large cache of keys to his belt loop and discarding his socks. Then he was ready for a night at Max's, without money for cab fare but his feet resplendent.

The night of the shoes, as we came to call it, was for Robert a sign that we were on the right path, even as so many paths crossed each other.

Gregory Corso could enter a room and commit instant mayhem, but he was easy to forgive because he had the equal potential to commit great beauty.

Perhaps Peggy introduced me to Gregory, for the two of them were close. I took a great liking to him, to say nothing that I felt he was one of our greatest poets. My worn copy of his *The Happy Birthday of Death* lived on my night table. Gregory was the youngest of the beat poets. He had a ravaged handsomeness and a John Garfield swagger. He did not always take himself seriously, but he was dead serious about his poetry.

Gregory loved Keats and Shelley and would stagger into the lobby with his trousers hanging low, eloquently spewing their verses. When I mourned my inability to finish any of my poems, he quoted Paul Valéry to me: "Poets don't finish poems, they abandon them," and then added, "Don't worry, you'll do okay, kid."

I'd say, "How do you know?"

And he'd reply, "Because I know."

Gregory took me to the St. Mark's Poetry Project, which was a poets' collective at the historic church on East Tenth Street. When we went to listen to the poets read, Gregory would heckle them, punctuating the mundane with cries of *Shit! Shit! No blood! Get a transfusion!*

In watching his reaction, I made a mental note to make certain I was never boring if I read my own poems one day.

Gregory made lists of books for me to read, told me the best dictionary to own, encouraged and challenged me. Gregory Corso, Allen Ginsberg, and William Burroughs were all my teachers, each one passing through the lobby of the Chelsea Hotel, my new university.

★

"I'm tired of looking like a shepherd boy," Robert said, inspecting his hair in the mirror. "Can you cut it like a fifties rock star?" Though I was greatly attached to his unruly curls, I got out my shears and thought rockabilly as I snipped. I sadly picked up a lock and pressed it in a book, while Robert, taken with his new image, lingered at the mirror.

In February he took me to the Factory to see rushes of *Trash*. It was the first time we had been invited, and Robert was filled with anticipation. I was not moved by the movie; perhaps it wasn't French enough for me. Robert circulated easily in the Warhol circle, though taken aback by the clinical atmosphere of the new Factory, and disappointed that Andy himself did not make an appearance. I was relieved to see Bruce Rudow, and he introduced me to his friend Diane Podlewski, who played Holly Woodlawn's sister in the film. She was a sweet-natured southern girl with a huge Afro and Moroccan clothing. I recognized her from a Diane Arbus photograph taken in the Chelsea, more boy than girl.

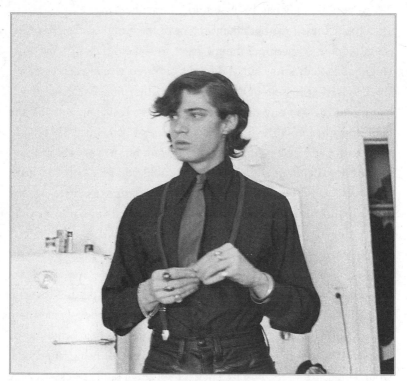

*Hotel Chelsea, room 204, 1970*

As we were leaving in the elevator, Fred Hughes, who managed the Factory, addressed me in a condescending voice. "*Ohhh*, your hair is very Joan Baez. Are you a folksinger?" I don't know why, as I admired her, but it bugged me.

Robert took my hand. "Just ignore him," he said.

I found myself in a dark humor. One of those nights when the mind starts looping bothersome things, I got to thinking about what Fred Hughes had said. Screw him, I thought, annoyed at being dismissed.

I looked at myself in the mirror over the sink. I realized that I hadn't cut my hair any different since I was a teenager. I sat on the floor and spread out the few rock magazines I had. I usually bought them to get any new pictures of Bob Dylan, but it wasn't Bob I was looking for. I cut out all the pictures I could find of Keith Richards. I studied them for a while and took up the scissors, machete-ing my way out of the folk era. I washed my hair in the hallway bathroom and shook it dry. It was a liberating experience.

When Robert came home, he was surprised but pleased. "What possessed you?" he asked. I just shrugged. But when we went to Max's, my haircut caused quite a stir. I couldn't believe all the fuss over it. Though I was still the same person, my social status suddenly elevated. My Keith Richards haircut was a real discourse magnet. I thought of the girls I knew back in high school. They dreamed of being singers but wound up hairdressers. I desired neither vocation, but in weeks to come I would be cutting a lot of people's hair, and singing at La MaMa.

Someone at Max's asked me if I was androgynous. I asked what that meant. "You know, like Mick Jagger." I figured that must be cool. I thought the word meant both beautiful and ugly at the same time. Whatever it meant, with just a haircut, I miraculously turned androgynous overnight.

Opportunities suddenly arose. Jackie Curtis asked me to be in her play *Femme Fatale*. I had no problem replacing a boy who played the

male counterpart of Penny Arcade, shotgunning lines like: *He could take her or leave her / And he took her and then he left her.*

La MaMa was one of the earliest experimental theaters, off-Broadway with a few more offs. I had been in a few plays in college, Phaedra in Euripides' *Hippolytus*, and Madame Dubonnet in *The Boyfriend*. I liked performing, but I dreaded the memorizing, and all the pancake makeup they have you wear onstage. I really didn't understand the avant-garde, though I thought it might be fun working with Jackie and her company. Jackie gave me the part without auditioning, so I had no real idea what I was getting into.

★

I was sitting in the lobby trying to appear that I wasn't waiting for Robert. I worried when he disappeared into the labyrinth of his hustling world. Unable to concentrate, I sat in my usual spot, bent over my orange composition book containing my cycle of poems for Brian Jones. I was dressed in my *Song of the South* getup—straw hat, Brer Rabbit jacket, work boots, and pegged pants—and was hammering away at the same set of phrases when I was interrupted by an oddly familiar voice.

"Whatcha doin', darlin'?"

I looked up into the face of a stranger sporting the perfect pair of dark glasses.

"Writing."

"Are you a poet?"

"Maybe."

I shifted in my seat, acting disinterested, pretending like I didn't recognize him, but there was no mistaking the drawl in his voice, nor his shady smile. I knew exactly who I was facing; he was the guy in *Dont Look Back*. The other one. Bobby Neuwirth, the peacemaker-provocateur. Bob Dylan's alter ego.

He was a painter, singer-songwriter, and risk taker. He was a trusted confidant to many of the great minds and musicians of his generation, which was just a beat before mine.

To hide how impressed I was, I got up, nodded, and headed toward the door without saying goodbye. He called out to me.

"Hey, where did you learn to walk like that?"

I turned. "From *Dont Look Back*."

He just laughed and asked me to join him in the El Quixote for a shot of tequila. I wasn't a drinker but I downed a shot, without the lemon and salt, just to seem cool. He was easy to talk to and we covered everything from Hank Williams to abstract expressionism. He seemed to take a liking to me. He took the notebook out of my hands and checked it out. I guess he saw potential, for he said, "Did you ever think of writing songs?" I wasn't sure how to answer.

"Next time I see you I want a song out of you," he said as we exited the bar.

That was all he had to say. When he left, I pledged to write him a song. I had fooled with lyrics for Matthew, made up a few Appalachian-style songs for Harry, but didn't think much of it. Now I had a real mission and someone worthy of having a mission for.

Robert came home late, sullen and a little angry that I had drinks with a strange guy. But the next morning he agreed it was inspiring that someone like Bob Neuwirth was interested in my work. "Maybe he'll be the one to get you to sing," he said, "but always remember who wanted you to sing first."

Robert had always liked my voice. When we lived in Brooklyn he would ask me to sing him to sleep, and I would sing him the songs of Piaf and Child ballads.

"I don't want to sing. I just want to write songs for him. I want to be a poet, not a singer."

"You can be both," he said.

Robert seemed conflicted much of the day, alternating between affection and moodiness. I could feel something brewing, but Robert didn't want to talk about it.

The following days were unnervingly quiet. He slept a lot, and when he'd awake, he would ask me to read him my poems, especially ones I wrote for him. At first I worried that he might have been harmed. Between his long silences I considered the possibility that he had met someone.

I recognized the silences as signs. We had been through this before. Though we didn't speak about it, I slowly prepared myself for the changes that would surely come. Robert and I were still intimate and I think it was hard for both of us to bring everything out into the open. Paradoxically, he seemed to want to draw me closer. Perhaps it was the closeness before the end, like a gentleman buying his mistress jewels before telling her it's over.

Sunday full moon. Robert was edgy and abruptly needed to go out. He looked at me for a long time. I asked if he was okay. He said he didn't know. I walked him to the corner. I stood there on the street looking at the moon. Later, feeling anxious, I went and got coffee. The moon had turned blood red.

When he finally returned he put his head on my shoulder and fell asleep. I didn't confront him. Later he would reveal he had crossed a line. He had been with a fellow and not for money. I was able to give him some measure of acceptance. My armor still had its vulnerable points, and Robert, my knight, had pierced a few, though without desiring to do so.

He and I began to give each other more gifts. Small things we made or found in a dusty corner of a pawnshop window. Things no one else wanted. Crosses of braided hair, tarnished charms, and haiku valentines made with bits of ribbon and leather. We left notes,

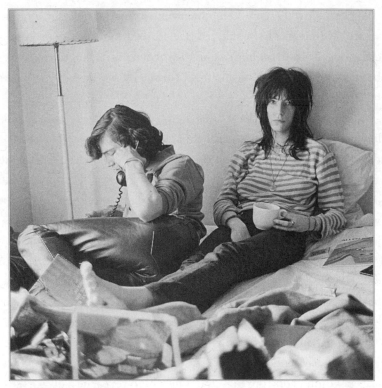

*Hotel Chelsea, room 204, 1970*

JUST KIDS

little cakes. Things. As if we could plug up the hole, rebuild the crumbling wall. Fill the wound we had opened to let other experiences in.

We hadn't seen Pigman for a few days, but had heard his dog wailing. Robert called the police and they pried the door open. Pigman had died. Robert went in to identify the body, and they took Pigman and the dog away. The loft space at the back was twice as big. Though he felt terrible, Robert couldn't help but covet it.

We were sure we would be kicked out of the studio, as we had no lease. Robert went to see the landlord and came clean about our presence there. The owner felt it would be difficult to rent because of the lingering smell of death and dog piss, and instead offered us the entire floor for thirty dollars less than our room at the Chelsea, and two months' grace to clean and paint it. To appease the Pigman gods, I did a drawing called *I saw a man, he was walking his dog*, and when I finished it Robert seemed at peace with Pigman's sad departure.

It was clear we could not afford to live at the Chelsea and also take the whole floor above the Oasis Bar. I didn't really want to leave the Chelsea, its identification with poets and writers, Harry, and our bathroom in the hall. We talked about it a lot. I would have the smaller space in the front, and he would have the back. The money we saved would pay for the utilities. I knew it was a more practical thing to do, even an exciting prospect. We would both have the space to do our work and be close to one another. But it was also very sad, especially for me. I loved living in the hotel, and I knew when we left everything would change.

"What will happen to us?" I asked.

"There will always be us," he answered.

Robert and I had not forgotten the vow that we had exchanged in the taxi from the Allerton to the Chelsea. It was clear we were not ready to go out on our own. "I will only be a door away," he said.

We had to scrape together every cent. We needed to raise four hundred fifty dollars, a month's rent and a month's deposit. Robert disappeared more than usual, making twenty dollars here and there. I had written some record reviews and was now receiving stacks of free records. After reviewing the ones I liked, I took them all down to a place in the East Village called Freebeing. They paid a dollar a record, so if I had ten records it was a good score. I actually made more selling records than writing reviews. I was hardly prolific and usually wrote pieces centered on obscure artists like Patty Waters, Clifton Chenier, or Albert Ayler. I wasn't interested in criticizing so much as alerting people to artists they may have overlooked. Between us both we came up with the money.

I loathed packing and cleaning. Robert willingly took on this burden himself, clearing out debris, scrubbing and painting just as he had done in Brooklyn. Meanwhile my time was divided between Scribner's and La MaMa. At night, we'd meet up at Max's after my rehearsals. We now had the self-assurance to just plop down at the round table like veterans.

*Femme Fatale* previewed on May 4, the day the Kent State students were killed. No one talked much about politics at Max's except the politics of the Factory. It was generally accepted the government was corrupt and that Vietnam was wrong, but the pall of Kent State hung over the production anyway and it wasn't a very good night.

Things got better as the play officially opened, and Robert attended

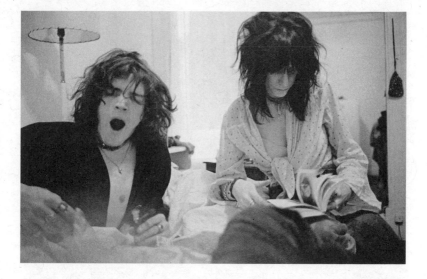

all the performances, often bringing his new friends. Among them was a girl named Tinkerbelle. She lived along Twenty-third Street at the London Terrace apartments, and she was a Factory girl. Robert was attracted to her lively wit, but despite her impish appearance she also possessed an extremely sharp tongue. I tolerated her barbs good-naturedly, figuring she was his version of Matthew.

It was Tinkerbelle who introduced us to David Croland. Physically David was a match for Robert, tall and slender with dark curly hair, pale skin, and deep brown eyes. He was from a good family, and had studied design at Pratt. In 1965 Andy Warhol and Susan Bottomly spotted him on the street and recruited him for films. Susan, who was known as International Velvet, was being groomed as the next Superstar, succeeding Edie Sedgwick. David had an intense affair with Susan, and when she left him in 1969 he fled to London, landing in a hotbed of film, fashion, and rock and roll.

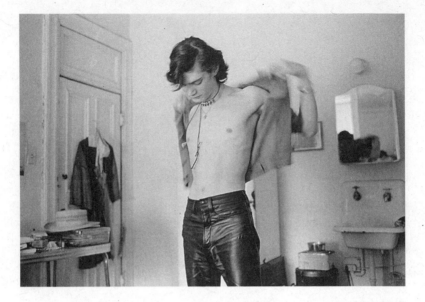

The Scottish film director Donald Cammel took him under his wing. Cammel was at the center of this confluence of the London demimonde; he and Nicolas Roeg had just collaborated on the film *Performance* with Mick Jagger. As a top model at Boys Inc., David was confident and not easily intimidated. When he was chided for using his looks, he retorted, "I'm not using my looks. Other people are using my looks."

He shifted from London to Paris and arrived back in New York in early May. He stayed with Tinkerbelle at London Terrace and she was eager to introduce us all. David was likable and respected us as a couple. He loved visiting our space, calling it our art factory, and showed genuine admiration when looking at our work.

Our life seemed easier with David in it. Robert enjoyed his company and liked that David appreciated his work. It was David who got him an early, important commission, a double-page spread in *Esquire* of Zelda and Scott Fitzgerald, their eyes masked in spray paint. Robert received three hundred dollars, more than he'd ever made at one time.

David drove a white Corvair with red interior and took us for spins around Central Park. It was the first time we had been in a car other than a taxi or my dad picking us up at the bus stop in New Jersey. David wasn't rich but he was better off than Robert and was discreetly generous. He would take Robert out to eat and pick up the tab. Robert in turn gave him necklaces and small drawings. Theirs was a perfectly natural gravitation. David brought Robert into his world, a society he swiftly embraced.

They started spending more and more time together. I watched Robert get ready to go out as if he were a gentleman preparing for a hunt. He chose everything carefully. The colored handkerchief he would fold and tuck in his back pocket. His bracelet. His vest. And the long, slow method of combing his hair. He knew that I liked his hair a bit wild, and I knew he was not taming his curls for me.

Robert was blossoming socially. He was meeting people who criss-crossed the Factory lines, and he befriended the poet Gerard Malanga.

Gerard had wielded a whip, dancing with the Velvet Underground, and exposed Robert to such places as the Pleasure Chest, a store that sold sex accessories. He also invited him to one of the most sophisticated literary salons in the city. Robert insisted that I go to one at the Dakota, at the apartment of Charles Henri Ford, who edited the highly influential magazine *View*, which introduced Surrealism to America.

I felt like I was at a relative's for Sunday dinner. As various poets read interminable poems, I wondered if Ford wasn't secretly wishing he were back in the salons of his youth, lorded over by Gertrude Stein and attended by the likes of Breton, Man Ray, and Djuna Barnes.

At one point in the evening he leaned over to Robert and said, "Your eyes are incredibly blue." I thought that was pretty funny considering Robert's eyes were famously green.

Robert's adaptability in these social situations continued to amaze me. He had been so shy when we first met, and as he negotiated the challenging waters of Max's, the Chelsea, the Factory, I watched him come into his own.

★

Our time at the Chelsea was ending. Though we would only be a few doors away from the hotel, I knew things would be different. I believed we would do more work but would lose a certain intimacy as well as our proximity to Dylan Thomas's room. Someone else would take my station in the Chelsea lobby.

One of the last things I did at the Chelsea was to finish a present for Harry's birthday. *Alchemical Roll Call* was an illustrated poem encoding the things that Harry and I had discussed about alchemy. The elevator was under repair so I climbed the stairs to room 705. Harry opened the door before I knocked, wearing a ski sweater in

May. He was holding a carton of milk, as if he were about to pour it in the saucers of his eyes.

He examined my gift with great interest, then immediately filed it. This being an honor and a curse, for doubtless it would disappear forever into the immense labyrinth of his archive.

He decided to play something special, a rare peyote ritual he had taped years before. He tried to thread the tape, but was having trouble with his recorder, a Wollensak reel-to-reel. "This tape is more tangled than your hair," he said impatiently. He stared at me for a moment and went rummaging through his drawers and boxes until he unearthed a silver-and-ivory hairbrush with long pale bristles. I immediately went for it. "Don't touch that!" he scolded. Without a word he sat in his chair and I sat at his feet. In complete silence Harry proceeded to brush all of the knots out of my hair. I wondered if the brush had belonged to his mother.

Afterward he asked me if I had any money. "No," I said, and he pretended to be mad. But I knew Harry. He just wanted to diffuse the intimacy of the moment. Whenever you had a beautiful moment with Harry he just had to turn it upside down.

On the last day of May, Robert had a gathering of his new friends in his side of the loft. He played Motown songs on our record player and seemed so happy. The loft was several times larger than our room. We even had room to dance.

After a while I left and went back to our old room at the Chelsea. I sat there and cried, then washed my face using our little sink. It was the first and only time that I felt I had sacrificed something of myself for Robert.

We fell into the pattern of our new life quickly. I stepped from square to square of the chessboard floor of our hallway just as I had in the Chelsea. At first we both slept in the small space as Robert got the

larger space situated. The first night I finally slept alone, everything started out fine. Robert let me have the record player and I listened to Piaf and wrote, but I found I could not sleep. No matter what happened, we were used to sleeping in one another's arms. About three in the morning I gathered my muslin sheet around me and lightly tapped on Robert's door. He opened it immediately.

"Patti," he said, "what took you so long?"

I strolled in, trying to appear nonchalant. He had obviously been working all night. I noticed a new drawing, the components for a new construction. A picture of me by his bed.

"I knew you'd come," he said.

"I had a nightmare, I couldn't sleep. And I had to go to the bathroom."

"Did you go to the Chelsea?"

"No," I said, "I peed in an empty takeout cup."

"Patti, no."

It was a long walk to the Chelsea in the middle of the night if you really had to go.

"Come on, China," he said, "get in here."

Everything distracted me, but most of all myself. Robert would come over to my side of our loft and scold me. Without his arranging hand, I lived in a state of heightened chaos. I set the typewriter on an orange crate. The floor was littered with pages of onionskin filled with half-written songs, meditations on the death of Mayakovsky, and ruminations about Bob Dylan. The room was strewn with records to review. The wall was tacked with my heroes but my efforts seemed less than heroic. I sat on the floor and tried to write and chopped my hair instead. The things I thought would happen didn't. Things I never anticipated unfolded.

I went home to visit my family. I had a lot of thinking to do about what direction I should be taking. I wondered if I was doing the right work. Was it all frivolity? It was the nagging sense of guilt I experienced performing on the night the Kent State students were shot. I wanted to be an artist but I wanted my work to matter.

My family sat around the table. My father read us Plato. My mother made meatball sandwiches. As always there was a sense of camaraderie at the family table. In the midst of it I received an unexpected call from Tinkerbelle. She told me abruptly that Robert and David were having an affair. "They're together right now," she said, somewhat triumphantly. I simply told her the call was unnecessary, and that I already knew.

I felt stunned as I hung up the phone, yet I had to wonder if she'd merely put into words what I had myself divined. I wasn't sure why she called me. It wasn't as if she was doing me a favor. We weren't that close. I wondered if she was being mean-spirited, or merely a tattletale. There was also the possibility that she wasn't telling the truth. On the bus ride home, I made the decision to say nothing and give Robert the opportunity to tell me on his own terms.

He had that flustered look, like when he flushed the Blake down the toilet at Brentano's. He had been to Forty-second Street and saw an interesting new male magazine, but it cost fifteen dollars. He had the money but wanted to be sure it was worth it. As he slipped it out of the cellophane, the owner came back and caught him. He started yelling, demanding Robert pay for it. Robert got upset and threw it at him, and the guy went after him. He ran from the store into the subway and all the way home.

"All that for a goddamn magazine."

"Was it any good?"

"I don't know, it looked good, but he made me not want it."

"You should take your own pictures. They'd be better anyway."

"I don't know. I guess it's a possibility."

A few days later we were at Sandy's. Robert casually picked up her Polaroid camera. "Could I borrow this?" he asked.

★

The Polaroid camera in Robert's hands. The physical act, a jerk of the wrist. The snapping sound when pulling the shot and the anticipation, sixty seconds to see what he got. The immediacy of the process suited his temperament.

At first he toyed with the camera. He wasn't totally convinced that it was for him. And film was expensive, ten pictures for about three dollars, a substantial amount in 1971. But it was some steps up from the photo booth, and the pictures developed unsealed.

I was Robert's first model. He was comfortable with me and he needed time to get his technique down. The mechanics of the camera were simple, but the options were limited. We took countless photographs. At first he had to rein me in. I would try to get him to take pictures like the album cover for *Bringing It All Back Home*, where Bob Dylan surrounds himself with his favorite things. I arranged my dice and "Sinners" license plate, a Kurt Weill record, my copy of *Blonde on Blonde*, and wore a black slip like Anna Magnani.

"Too cluttered with crap," he said. "Just let me take your picture."

"But I like this stuff," I said.

"We're not making an album cover, we're making art."

"I hate art!" I yelled, and he took the picture.

He was his own first male subject. No one could question him shooting himself. He had control. He figured out what he wanted to see by seeing himself.

He was pleased with his first images, but the cost of film was so high that he was obliged to set the camera aside, but not for long.

Robert spent a lot of time improving his space and the presentation of his work. But sometimes he gave me a worried look. "Is everything all right?" he would ask. I told him not to worry. Truthfully, I was involved in so many things that the question of Robert's sexual persuasion was not my immediate concern.

I liked David, Robert was doing exceptional work, and for the first time I was able to express myself as I wished. My room reflected the bright mess of my interior world, part boxcar and part fairyland.

One afternoon Gregory Corso came to visit. He called on Robert first and they had a smoke, so by the time he came to visit me the sun was going down. I was sitting on the floor typing on my Remington. Gregory came in and panned the room slowly. Piss cups and broken toys. "Yeah, this is my kind of place." I dragged over an old armchair. Gregory lit a cigarette and read from my pile of abandoned poems, drifting off, making a little burn mark on the arm of the chair. I poured some of my Nescafé over it. He awoke and drank the rest. I staked him a few bucks for his most pressing needs. As he was leaving he looked at an old French crucifix hanging over my mat. Beneath the feet of Christ was a skull embellished with the words *memento mori*. "It means 'Remember we are mortal,'" said Gregory, "but poetry is not." I just nodded.

When he left, I sat down on my chair and ran my fingers over the cigarette burn, a fresh scar left by one of our greatest poets. He would always spell trouble and might even wreak havoc, yet he gave us a body of work pure as a newborn fawn.

Secrecy was smothering Robert and David. Both thrived on a certain amount of mystery but I think David was too open to keep their relationship from me any longer. Tensions arose between them.

Things came to a head at a party where we double-dated with David and his friend Loulou de la Falaise. The four of us were danc-

ing. I liked Loulou, a charismatic redhead who was the celebrated muse of Yves Saint Laurent, the daughter of a Schiaparelli model and a French count. She wore a heavy African bracelet, and when she unclasped it, there was a red string tied around her tiny wrist, placed there, she said, by Brian Jones.

It seemed that the evening was going well, except that Robert and David kept breaking away, heatedly conferring off to the side. Suddenly David grabbed Loulou's hand, pulled her off the dance floor, and abruptly left the party.

Robert raced after him and I followed. As David and Loulou were getting in a taxi, Robert cried out to him not to leave. Loulou looked at David, mystified, saying, "Are you two lovers?" David slammed the door of the taxi and it sped away.

Robert was placed in the position where he was forced to tell me what I already knew. I was calm and sat quietly while he struggled to find the right words to explain what had just happened. I didn't derive any pleasure from seeing Robert so conflicted. I knew this was hard for him, so I told him what Tinkerbelle had told me.

Robert was furious. "Why didn't you say anything?"

Robert was devastated that Tinkerbelle had told me not only that he was having an affair, but that he was homosexual. It was as if Robert had forgotten that I knew. It must have also been difficult as it was the first time he was openly identified with a sexual label. His relationship with Terry in Brooklyn had been between the three of us, not in the public eye.

Robert wept.

"Are you sure?" I asked him.

"I'm not sure about anything. I want to do my work. I know I'm good. That's all I know.

"Patti," he said, holding me, "none of this has anything to do with you."

Robert rarely spoke to Tinkerbelle after that. David moved to Seventeenth Street, close to where Washington Irving had lived. I slept on my side of the wall and Robert on his. Our lives were moving at such speed that we just kept going.

Later, alone with my thoughts, I had a delayed reaction. I felt heavyhearted, disappointed that he hadn't confided in me. He had told me I had nothing to worry about but in the end I did. Yet I understood why he couldn't tell me. I think having to define his impulses and confine his identity in terms of sexuality was foreign to him. His drives toward men were consuming but I never felt loved any less. It wasn't easy for him to sever our physical ties, I knew that.

Robert and I still kept our vow. Neither would leave the other. I never saw him through the lens of his sexuality. My picture of him remained intact. He was the artist of my life.

Bobby Neuwirth rode into town like some easy rider. He would dismount, and the artists, musicians, and poets all came together, a gathering of the tribes. He was a catalyst for action. He would breeze in and take me places, exposing me to other artists and musicians. I was a colt, but he appreciated and encouraged my awkward attempts at writing songs. I wanted to do things that affirmed his belief in me. I developed long balladic oral poems inspired by storytellers like Blind Willie McTell and Hank Williams.

On June 5, 1970, he took me to the Fillmore East to see Crosby, Stills, Nash, and Young. It was really not my kind of band, but I was moved to see Neil Young, since his song "Ohio" had made a great impression on me. It seemed to crystallize the role of the artist as a responsible commentator, as it paid homage to the four young Kent State students who lost their lives in the name of peace.

Afterward we drove up to Woodstock, where the Band was

recording *Stage Fright*. Todd Rundgren was the engineer. Robbie Robertson was hard at work, concentrating on the song "Medicine Man." Mostly everyone else drifted off toward some hard-core partying. I sat up and talked with Todd until dawn and we found that we both had Upper Darby roots. My grandparents had lived close to where he was born and raised. We were also oddly similar—sober, work-driven, judgmental, idiosyncratic wallflowers.

Bobby continued to open up his world to me.

Through him I had met Todd, the artists Brice Marden and Larry Poons, and the musicians Billy Swan, Tom Paxton, Eric Andersen, Roger McGuinn, and Kris Kristofferson. Like a flock of geese, they veered toward the Chelsea Hotel, awaiting the arrival of Janis Joplin, affectionately known by all as Pearl. The only credential that gave me entrance to the private world of these people was Bobby's word, and his word was undisputable. He introduced me to Janis as the poet, and from then on that's what Janis always called me.

We all went to see Janis play in Central Park at the Wollman Rink. The concert was sold out, but great crowds were spread out over the surrounding rocks. I stood with Bobby on the side of the stage mesmerized by her electric energy. It suddenly began to pour, followed by thunder and lightning, and the stage was cleared. Unable to continue, the roadies began to break down the equipment. The people, refusing to leave, began to boo.

Janis was distraught. "They're booing me, man," she cried to Bobby.

Bobby brushed the hair out of her eyes. "They're not booing you, darling," he said. "They're booing the rain."

The intense community of musicians staying at the Chelsea then would often find their way into Janis's suite with their acoustic guitars. I was privy to the process as they worked on songs for her new album. Janis was the queen of the radiating wheel, sitting in her easy chair

with a bottle of Southern Comfort, even in the afternoon. Michael Pollard was usually by her side. They were like adoring twins, both with the same speech patterns, punctuating each sentence with *man*. I sat on the floor as Kris Kristofferson sang her "Me and Bobby McGee," Janis joining in the chorus. I was there for these moments, but so young and preoccupied with my own thoughts that I hardly recognized them as moments.

Robert got his nipple pierced. He had it done by a doctor in Sandy Daley's space while he nestled in the arms of David Croland. She filmed it in 16mm, an unholy ritual, Robert's *Chant d'Amour*. I had faith that under Sandy's impeccable direction it would be beautifully shot. But I found the procedure repellent and did not attend, certain it would get infected, which it did. When I asked Robert what it was like, he said it was both interesting and creepy. Then the three of us went off to Max's.

We were sitting in the back room with Donald Lyons. Like the leading male figures at the Factory, Donald was an Irish Catholic boy from the boroughs. He had been a brilliant classicist at Harvard, destined for great things in academia. But he was beguiled by Edie Sedgwick, who was studying art in Cambridge, and followed her to New York City, giving up everything. Donald could be extremely caustic when drinking, and all in his company were either abused or amused. In his best moments he expertly spouted on film and theater, quoted from arcane Latin and Greek texts, and lengthy passages of T. S. Eliot.

Donald asked us if we were going to see the Velvet Underground opening upstairs. It marked their reunion in New York City and the debut of live rock and roll at Max's. Donald was shocked to find I had never seen them, and insisted we go upstairs with him to catch their next set.

I immediately related to the music, which had a throbbing surfer beat. I had never listened closely to Lou Reed's lyrics, and recognized, especially through the ears of Donald, what strong poetry they contained. The upstairs room at Max's was small, perhaps holding fewer than a hundred people, and as the Velvets moved deeper into their set, we began to move as well.

Robert took the floor with David. He had a thin white shirt on, open to the waist, and I could see the impression of the gold nipple ring beneath it. Donald took my hand and we sort of danced. David and Robert definitely danced. Donald, in our various discussions, was right about Homer, Herodotus, and *Ulysses*, and he was more than right about the Velvet Underground. They were the best band in New York City.

On Independence Day, Todd Rundgren asked if I would go with him to Upper Darby to visit his mother. We set off fireworks in an abandoned lot and ate Carvel ice cream. Afterward I stood next to his mother in the backyard watching him play with his younger sister. She quizzically eyed his multicolored hair and velvet bell-bottoms. "I gave birth to an alien," she blurted, which surprised me since he seemed so down-to-earth, at least to me. When we drove back to the city, both of us agreed we had found kin, each as alien as the other.

Later that night at Max's, I ran into Tony Ingrassia, a playwright who worked out of La MaMa. He asked me to read for a role in his new play *Island*. I was a little skeptical, but as he handed me the script, he promised no pancake makeup and no glitter.

It seemed an easy role for me because I didn't have to relate to any of the characters in the play. My character, Leona, was totally self-involved, shot speed, and rambled incoherently about Brian Jones. I was never completely certain what the play was about, but it was Tony Ingrassia's epic. Like *The Manchurian Candidate*, everybody was in it.

I wore my frayed boatneck shirt and rubbed kohl around my

eyes as I had to appear at my worst. I guess I achieved a sort of junkie raccoon look. I had a vomit scene. That was no problem. I just held a sizable amount of crushed peas and wet cornmeal in my mouth for several minutes before I let it fly. But one night at rehearsal Tony brought me a syringe and said casually, "Just shoot water, you know, pull a little blood out of your arm and people will think you're shooting up."

I almost fainted. I couldn't even look at the syringe, let alone put it in my arm. "I'm not doing that," I said.

They were shocked. "You never shot up?"

Everyone took it for granted that I did drugs because of the way I looked. I refused to shoot up. Finally they slapped hot wax on my arm and Tony showed me what to do.

Robert thought it was hilarious that I should be in such a fix and teased me relentlessly about it. He knew well my needle phobia. He liked to see me onstage. He would attend all the rehearsals, so incredibly dressed he was worthy of a part himself. Tony Ingrassia would eye him and say, "He looks so fabulous, I wish he could act."

"Just sit him in a chair," Wayne County chimed. "He wouldn't have to do a thing."

Robert was sleeping alone. I went to knock on his door and it was unlocked. I stood and watched him sleep, as I had when I first met him. He was still that same boy with his tousled shepherd's hair. I sat on the bed and he awoke. He leaned on one elbow and smiled. "Want to get under the covers, China?" He began tickling me. We wrestled around and couldn't stop laughing. Then he jumped up. "Let's go to Coney Island," he said. "We'll get our picture taken again."

We did all the things we liked. We wrote our names in the sand, went to Nathan's, strolled through Astroland. We got our picture

taken by the same old guy, and at Robert's insistence I climbed aboard his stuffed pony.

We stayed until dusk and boarded the F train back. "We're still us," he said. He held my hand and I fell asleep on his shoulder on the subway home.

Sadly, the new picture of the two of us was lost, but the picture of myself astride the pony, alone and slightly defiant, remains.

Robert sat on an orange crate as I read him some of my new poems.

"You should let people hear you," he said, as he always did.

"You're hearing me. That's enough for me."

"I want everyone to hear you."

"No, you want me to read at one of those wretched teas."

But Robert, not to be denied, pressed me, and when Gerard Malanga told him about a Tuesday open mike moderated by the poet Jim Carroll, he made me promise I would read.

I agreed to try, choosing a couple of poems I thought suitable to perform. I can't remember what I read, but I certainly remember what Robert wore, a pair of gold lamé chaps he had designed. We had some discussion about the matching codpiece and decided against it. It was Bastille Day, and I jokingly predicted that heads would roll when those poets checked him out.

I instantly took a liking to Jim Carroll. He seemed a beautiful person, slim and sturdy with long red-gold hair, black Converse high-top sneakers, and a sweet disposition. I saw in him a mix of Arthur Rimbaud and Parsifal, the holy fool.

My writing was shifting from the formality of French prose poetry to the bravado of Blaise Cendrars, Mayakovsky, and Gregory Corso. Through them my work developed humor and a little swagger. Robert was always my first listener and I developed a lot of confidence simply

by reading to him. I listened to recordings of the beat poets and Oscar Brown Jr., and studied lyric poets like Vachel Lindsay and Art Carney.

One night after a terminally long rehearsal for *Island*, I bumped into Jim, who was hanging outside the Chelsea eating a water ice. I asked him if he wanted to come along and go for a bad coffee at the doughnut shop. He said sure. I told him I liked to write there. On the next night he took me for bad coffee at Bickford's on Forty-second Street. Jim told me that Jack Kerouac liked to write there.

It wasn't clear where Jim lived, but he spent a lot of time at the Chelsea Hotel. The following night he came home with me, and wound up staying in my side of the loft. It had been a long time since I really felt something for someone other than Robert.

Robert felt a part of the equation, because he had been instrumental in introducing me to Jim. They got along really well and happily nothing seemed unnatural about us staying next door to Robert. Often Robert stayed at David's, and he seemed happy that I was not alone.

In my own way, I devoted myself to Jim. I laid a blanket over him as he slept. In the mornings I got him his doughnuts and coffee. He didn't have much money and he was unapologetic that he had a modest heroin habit. Sometimes I would go with him when he scored. I didn't know anything about these kinds of drugs except from reading *Cain's Book*, Alexander Trocchi's account of a junkie writing on a barge plying the rivers of New York while junk plies the river of his soul. Jim shot stuff in his freckled hand, like the darker side of Huckleberry Finn. I looked away, and then asked him if it hurt. He said no, not to worry about him. Then I would sit by him as he recited Walt Whitman, kind of falling asleep sitting up.

While I was working during the day, Robert and Jim would take walks up to Times Square. They both shared an affection for Forty-second Street's netherworld and found in their wanderings they also shared an affinity for hustling, Jim for drug money and Robert for rent

money. Even at this point Robert was still asking questions about himself and his drives. He wasn't comfortable being identified in terms of his sexuality, and questioned whether he was hustling for money or pleasure. He could talk about these things with Jim because Jim wasn't judgmental. They both took money from men, but Jim had no problem with it. For him, it was just business.

"How do you know you're not gay?" Robert would ask him.

Jim said he was sure. "Because I always ask for money."

Toward the middle of July, I made my last payment on my first guitar. Held in layaway in a pawnshop on Eighth Avenue, it was a little Martin acoustic, a parlor model. It had a tiny bluebird decal on its top, and a strap made of multicolored braid. I bought a Bob Dylan songbook and learned a few simple chords. At first they didn't sound too bad, but the more I played, the worse it sounded. I didn't realize you had to tune a guitar. I took it over to Matthew, and he tuned it. Then it occurred to me that whenever it got out of tune, I could find a musician and ask them if they wanted to play it. There were plenty of musicians at the Chelsea.

I had written "Fire of Unknown Origin" as a poem, but after I met Bobby, I turned it into my first song. I struggled to find some chords to accompany it on guitar, and sang it for Robert and Sandy. She was especially elated. The dress sweeping down the hallway was hers.

> *Death comes sweeping down the hallway in a lady's dress*
> *Death comes riding up the highway in its Sunday best*
> *Death comes I can't do nothing*
> *Death goes there must be something that remains*
> *A fire of unknown origin took my baby away*

Being in *Island* gave me the notion that I had a knack for performing. I had no stage fright and liked to elicit a response from the audience. But I made a mental note that I wasn't acting material. It seemed being an actor was like being a soldier: you had to sacrifice yourself to the greater good. You had to believe in the cause. I just couldn't surrender enough of myself to be an actor.

Playing Leona sealed the unfounded perception of me as a speed freak. I don't know if I was much of an actress, but I was good enough to get a bad reputation. The play was a social success. Andy Warhol came every night and became genuinely interested in working with Tony Ingrassia. Tennessee Williams attended the final performance with Candy Darling on his arm. Candy, in her desired element, was ecstatic to be seen with the great playwright.

I may have had bravado, but I knew I lacked the warmth and tragic glamour of my fellow actors. Those involved with alternative theater were committed, slaving under mentors like Ellen Stewart, John Vaccaro, and the brilliant Charles Ludlam. Although I did not choose to pursue their direction I was grateful for what I learned. It would be a while before I put my experience in the theater into action.

When Janis Joplin returned in August for her rain date in Central Park, she seemed extremely happy. She was looking forward to recording, and came into town resplendent in magenta, pink, and purple feather boas. She wore them everywhere. The concert was a great success, and afterward we all went to the Remington, an artists' bar near lower Broadway. The tables were crowded with her entourage: Michael Pollard, Sally Grossman, who was the girl in the red dress on the cover of *Bringing It All Back Home*, Brice Marden, Emmett Grogan of the Diggers, and the actress Tuesday Weld. The jukebox was playing Charlie Pride. Janis spent most of the party with a good-looking guy she was attracted to,

but just before closing time he ducked out with one of the prettier hangers-on. Janis was devastated. "This always happens to me, man. Just another night alone," she sobbed on Bobby's shoulder.

Bobby asked me to get her to the Chelsea and to keep an eye on her. I took Janis back to her room, and sat with her while she bemoaned her fate. Before I left, I told her that I'd made a little song for her, and sang it to her.

*I was working real hard*
*To show the world what I could do*
*Oh I guess I never dreamed*
*I'd have to*
*World spins some photographs*
*How I love to laugh when the crowd laughs*
*While love slips through*
*A theatre that is full*
*But oh baby*
*When the crowd goes home*
*And I turn in and I realize I'm alone*
*I can't believe*
*I had to sacrifice you*

She said, "That's me, man. That's my song." As I was leaving, she looked in the mirror, adjusting her boas. "How do I look, man?"

"Like a pearl," I answered. "A pearl of a girl."

Jim and I spent a lot of time in Chinatown. Every outing with him was a floating adventure, riding the high summer clouds. I liked to watch him interact with strangers. We would go to Hong Fat because it was cheap and the dumplings were good, and he would talk to the old guys. You ate what they brought to the table or you pointed to someone's meal because the menu was in Chinese. They

cleaned the tables by pouring hot tea on them and wiping it up with a rag. The whole place had the fragrance of oolong. Sometimes Jim just picked up an abstract thread of conversation with one of these venerable-looking old men, who would then lead us through the labyrinth of their lives, through the Opium Wars and the opium dens of San Francisco. And then we would tramp from Mott to Mulberry to Twenty-third Street, back in our time, as if nothing had ever happened.

I gave him an autoharp for his birthday and wrote him long poems on my lunch break at Scribner's. I was hopeful he would be my boyfriend, but as it turned out, that was an improbable expectation. I would never serve as the source of his inspiration, though in attempting to articulate the drama of my feelings I became more prolific and I believe a better writer.

Jim and I had some very sweet times. I'm sure there were downs as well, but my memories are served with nostalgia and humor. Ours were ragtag days and nights, as quixotic as Keats and as rude as the lice we both came to suffer, each certain they originated from the other as we underwent a tedious regimen of Kwell lice shampooing in any one of the unmanned Chelsea Hotel bathrooms.

He was unreliable, evasive, and sometimes too stoned to speak, but he was also kind, ingenuous, and a true poet. I knew he didn't love me but I adored him anyway. Eventually he just drifted away, leaving me a long lock of his red-gold hair.

Robert and I went to see Harry. He and a friend were deciding who should be the new keeper of a special gray lamb pull toy. It was child-size, on wheels, with a long red ribbon: the Blakean lamb of Allen Ginsberg's companion, Peter Orlovsky. When they entrusted it to me I thought Robert would be mad, for I had promised I would harbor no

more sad refuse or broken toys. "You have to take it," he said, placing the ribbon in my hand. "It's a Smith classic."

A few evenings later, Matthew appeared out of nowhere with a boxful of 45s. He was obsessed with Phil Spector; it seemed like every single Phil had produced was in it. His eyes darted nervously across the room. "Do you have any singles?" he asked anxiously.

I got up and rummaged through the laundry and found my singles box, which was cream-colored and covered with musical notes. He immediately counted our combined collection. "I was right," he said. "We have just the right number."

"The right number for what?"

"For a night of one hundred records."

It made sense to me. We played them, one after another, starting with "I Sold My Heart to the Junkman." Each song was better than the next. I leapt up and started dancing. Matthew kept changing the sides like some deranged disc jockey. In the middle of it all, Robert came in. He looked at Matthew. He looked at me. He looked at the record player.

The Marvelettes were on. I said, "What are you waiting for?"

His coat dropped to the floor. There were thirty-three more to go.

It was an infamous address, having housed the Film Guild Cinema in the twenties, and a raucous country-western club hosted by Rudy Vallée in the thirties. The great abstract expressionist artist and teacher Hans Hoffman had a small school on the third floor through the forties and fifties, preaching to the likes of Jackson Pollock, Lee Krasner, and Willem de Kooning. In the sixties it housed the Generation Club, where Jimi Hendrix used to hang out, and when it closed he took over the space and built a state-of-the-art studio in the bowels of 52 Eighth Street.

On August 28 there was a party celebrating the opening. The

Wartoke Concern handled the press. It was a coveted invitation and I received mine through Wartoke's Jane Friedman. She had also done the publicity for the Woodstock festival. We had been introduced at the Chelsea by Bruce Rudow, and she showed interest in my work.

I was excited to go. I put on my straw hat and walked downtown, but when I got there, I couldn't bring myself to go in. By chance, Jimi Hendrix came up the stairs and found me sitting there like some hick wallflower and grinned. He had to catch a plane to London to do the Isle of Wight Festival. When I told him I was too chicken to go in, he laughed softly and said that contrary to what people might think, he was shy, and parties made him nervous. He spent a little time with me on the stairs and told me his vision of what he wanted to do with the studio. He dreamed of amassing musicians from all over the world in Woodstock and they would sit in a field in a circle and play and play. It didn't matter what key or tempo or what melody, they would keep on playing through their discordance until they found a common language. Eventually they would record this abstract universal language of music in his new studio.

"The language of peace. You dig?" I did.

I can't remember if I actually went into the studio, but Jimi never accomplished his dream. In September I went with my sister and Annie to Paris. Sandy Daley had an airline connection and helped us get cheap tickets. Paris had already changed in a year, as had I. It seemed as if the whole of the world was slowly being stripped of innocence. Or maybe I was seeing a little too clearly.

As we walked down the boulevard Montparnasse I saw a headline that filled me with sorrow: *Jimi Hendrix est mort. 27 ans.* I knew what the words meant.

Jimi Hendrix would never have the chance to return to Woodstock to create a universal language. He would never again record at Electric

Lady. I felt that we had all lost a friend. I pictured his back, the embroidered vest, and his long legs as he went up the stairs and out into the world for the last time.

Steve Paul sent a car for Robert and me to see Johnny Winter at the Fillmore East on October 3. Johnny was at the Chelsea for a few days. After his concert, we all met back in his room. He had played at Jimi Hendrix's wake, and together we mourned the loss of our guitar poet, finding comfort in talking of him together.

But the next night we would meet in Johnny's room to console one another again. I wrote but two words in my diary: Janis Joplin. For she had died of an overdose in room 105 of the Landmark Hotel in Los Angeles, twenty-seven years old.

Johnny plunged. Brian Jones. Jimi Hendrix, Janis Joplin. He immediately made the *J* connection, as fear and grief merged. He was highly superstitious and worried that he would be next. Robert tried to calm him but said to me, "I can't blame him. It's pretty freaky," and he suggested I read Johnny's cards, which I did. His tarot suggested a swirl of contradicting forces, but spoke of no imminent danger. Cards or no cards, Johnny didn't have death in his face. There was something about him. Johnny was mercurial. Even as he fretted over the deaths of the J-club, frenetically pacing the room, it was as if he could never sit still long enough to die.

★

I was both scattered and stymied, surrounded by unfinished songs and abandoned poems. I would go as far as I could and hit a wall, my own imagined limitations. And then I met a fellow who gave me his secret, and it was pretty simple. When you hit a wall, just kick it in.

Todd Rundgren took me to the Village Gate to hear a band called the Holy Modal Rounders. Todd had made his own album, *Runt*, and

was on the lookout for interesting things he could produce. Big acts like Nina Simone and Miles Davis would play upstairs at the Gate, while the more underground bands were booked in the basement. I had never heard the Holy Modal Rounders, whose "Bird Song" was featured in *Easy Rider*, but knew it would be interesting because Todd usually gravitated toward the unusual.

It was like being at an Arabian hoedown with a band of psychedelic hillbillies. I fixed on the drummer, who seemed as if he was on the lam and had slid behind the drums while the cops looked elsewhere. Toward the end of their set he sang a song called "Blind Rage," and as he slammed the drums, I thought, This guy truly embodies the heart and soul of rock and roll. He had beauty, energy, animal magnetism.

I was introduced to the drummer when we went backstage. He said his name was Slim Shadow. I said, "Glad to meet you, Slim." I mentioned to him that I wrote for a rock magazine called *Crawdaddy* and that I wanted to write an article about him. Slim seemed entertained by this idea. He just nodded while I started my pitch, telling him about his potential, how "rock and roll needs you."

"Well, I never really thought about that," was his laconic reply.

I was sure *Crawdaddy* would accept a piece on this future salvation of rock and roll, and Slim agreed to come over to Twenty-third Street for an interview. He was amused by my mess, and sprawled out on my mat and told me about himself. He said he was born in a trailer and spun quite a yarn for me. Slim was a good talker. In a happy role reversal, it was he who was the storyteller. It was possible his tales were even taller than mine. He had an infectious laugh and was rugged, smart, and intuitive. In my mind, he was the fellow with the cowboy mouth.

In the following evenings he would appear late at night at my door with his shy and appealing grin and I would grab my coat and

we would take a walk. We never strayed far from the Chelsea yet it seemed as if the city had dissolved into sagebrush and the stray debris rolling in the wind transformed as tumbleweeds.

A cold front passed over New York City in October. I developed a bad cough. The heating was erratic in our loft spaces. They were not meant to live in and were cold at night. Robert often stayed at David's, and I would pile up all our blankets and stay awake till quite late reading Little Lulu comics and listening to Bob Dylan. I had wisdom teeth trouble and was run down. My doctor said I was anemic and told me to have red meat and drink porter, advice given to Baudelaire when he trudged through a winter in Brussels sick and alone.

I was a bit more resourceful than poor Baudelaire. I donned an old plaid coat with deep pockets and lifted two small steaks from Gristede's, planning to fry them in my grandmother's cast-iron pan over my hot plate. I was surprised to run into Slim on the street and we took our first non-nocturnal walk. Worrying the meat would go bad, I finally had to admit to him I had two raw steaks in my pocket. He looked at me, trying to detect if I was telling the truth, then slid his hand in my pocket and pulled a steak out in the middle of Seventh Avenue. He shook his head in mock admonishment, saying, "Okay, sugar, let's eat."

We went upstairs and I fired up the hot plate. We ate the steaks out of the pan. After that, Slim was concerned whether I was eating enough. A few nights later he came by and asked me if I liked the lobster at Max's. I said I never tried it. He seemed shocked.

"You never had the lobster there?"

"No, I never had any meal there."

"What? Get your coat. We're getting some grub."

We got a cab to Max's. He had no qualms about sauntering into the back room, but we didn't sit at the round table. Then he ordered

for me. "Bring her the biggest lobster you have." I realized that every-
one was staring at us. It occurred to me that I had never been to Max's
with any fellow save Robert, and Slim was a really good-looking guy.
And when my giant lobster with drawn butter arrived, it also occurred
to me that this handsome hillbilly might not have the money to pay
the check.

While I was eating, I noticed Jackie Curtis giving me hand sig-
nals. I figured she wanted some of my lobster, which was fine with
me. I wrapped a meaty claw in a napkin and followed her into the
ladies' room. Jackie immediately started grilling me.

"What are you doing with Sam Shepard?" she blurted.

"Sam Shepard?" I said. "Oh, no, this guy's name is Slim."

"Honey, you don't know who he is?"

"He's the drummer for the Holy Modal Rounders."

She rummaged frantically in her purse, polluting the air with face
powder. "He's the biggest playwright off-Broadway. He had a play
at Lincoln Center. He won five Obies!" she rattled off, penciling her
eyebrows. I stared at her incredulously. The revelation seemed like a
plot twist in some Judy Garland and Mickey Rooney musical. "Well,
that doesn't mean much to me," I said.

"Don't be a fool," she said, gripping me dramatically. "He can
take you right to Broadway." Jackie had a way of transporting any
random interaction into a B movie scene.

Jackie passed on the lobster claw. "No, thanks, honey, I'm after
bigger game. Why don't you bring him over to my table, I'd love to
say hello."

Well, I didn't have my eyes on Broadway and I wasn't going to
drag him around like some male trophy, but I figured if nothing else
he was sure to have the money to pick up the check.

I went back to the table and looked at him hard. "Is your name
Sam?" I asked.

"Oh, yes, so it is," he drawled like W. C. Fields. But at that moment dessert arrived, a vanilla sundae with chocolate sauce.

"Sam is a good name," I said. "It will work."

He said, "Eat your ice cream, Patti Lee."

I felt increasingly out of place in Robert's social whirl. He escorted me to teas, dinners, and an occasional party. We sat at tables where a single setting had more forks and spoons than needed for a family of five. I could never understand why we had to separate at dinner, or why I had to engage in discussions with people I didn't know. I just sat in a state of internal misery waiting for the next course. No one seemed as impatient as I. Yet I had to admire Robert as I watched him interact with an ease I hadn't seen before, lighting another's cigarette and holding their eye as he spoke.

He was beginning to penetrate higher society. In some ways his social shift was harder to surmount than his sexual shift. I needed only to comprehend and accept the duality of his sexuality. But to stay in step with him socially I would have needed to change my ways.

Some of us are born rebellious. Reading the story of Zelda Fitzgerald by Nancy Milford, I identified with her mutinous spirit. I remember passing shopwindows with my mother and asking why people didn't just kick them in. She explained that there were unspoken rules of social behavior, and that's the way we coexist as people. I felt instantly confined by the notion that we are born into a world where everything was mapped out by those before us. I struggled to suppress destructive impulses and worked instead on creative ones. Still, the small rule-hating self within me did not die.

When I told Robert of my child-self's desire to shatter windows, he teased me about it.

"Patti! No. You're the bad seed," he said. But I wasn't.

Sam, on the other hand, identified with the little story. He had no problem imagining me in my little brown shoes itching to cause a ruckus. When I told him I sometimes had the impulse to put my foot through a window, he just said, "Kick it in, Patti Lee. I'll bail you out." With Sam I could be myself. He understood more than anyone how it felt to be trapped in one's skin.

Robert didn't warm up to Sam. He was encouraging me to be more refined and worried that Sam would only magnify my irreverent ways. Both of them were wary of each other, and they were never able to bridge this divide. A casual observer might have thought it was because they were different species, but to me, it was because they were both strong men who had my best interests at heart. Table manners aside, I recognized something of myself in both of them and accepted their locking horns with humor and pride.

Encouraged by David, Robert took his work from gallery to gallery without results. Undaunted, he sought an alternative and decided to show his collages on his birthday at Stanley Amos's gallery in the Chelsea Hotel.

The first thing Robert did was to go to Lamston's. It was smaller and cheaper than Woolworth's. He and I enjoyed any excuse to raid their outdated stock: yarn, patterns, buttons, drugstore items, *Redbook* and *Photoplay*, incense burners, holiday cards and family-size bags of candy, barrettes and ribbons. Robert bought stacks of their classic silver frames. They were very popular at a dollar apiece, and even the likes of Susan Sontag could be seen purchasing them.

Wanting to create a unique invitation, he took soft-porn playing cards that he got on Forty-second Street and printed the information on the back. Then he slipped them in a fake leather cowboy-style ID case that he found in Lamston's.

The show consisted of Robert's collages that centered on freaks, but he prepared one fairly large altarpiece for the event. He used several of my personal objects in this construction, including my wolf skin, an embroidered velvet scarf, and a French crucifix. We had a little sparring over his appropriating my things, but of course I gave in, and Robert pointed out that no one would buy it. He just wanted people to see it.

It was in suite 510 of the Chelsea Hotel. The room was packed. Robert arrived with David. As I looked around the room, I could trace our entire history at the hotel. Sandy Daley, one of Robert's greatest champions, beamed. Harry was so taken by the altarpiece that he decided to film it for his *Mahagonny* movie. Jerome Ragni, the co-creator of *Hair*, bought one of the collages. The collector Charles Coles made an appointment to discuss a future purchase. Gerard Malanga and Rene Ricard mingled with Donald Lyons and Bruce Rudow. David was an elegant host and spokesman for Robert's work.

Observing people taking in the work I had watched Robert create was an emotional experience. It had left our private world. It was what I had always wanted for him, but I felt a slight pang of possessiveness sharing it with others. Overriding that feeling was the joy of seeing Robert's face, suffused with confirmation, as he glimpsed the future he had so resolutely sought and had worked so hard to achieve.

Contrary to Robert's prediction, Charles Coles bought the altarpiece, and I never did get my wolf skin, my scarf, or my crucifix back.

★

"The lady's dead." Bobby called from California to tell me that Edie Sedgwick had died. I never knew her, but when I was a teenager I found a copy of *Vogue* with a photograph of her pirouetting on a bed in front of a drawing of a horse. She seemed entirely self-possessed, as if nobody in the world existed but her. I tore it out and put it on my wall.

Bobby seemed genuinely stricken by her untimely death. "Write the little lady a poem," he said, and I promised I would.

In writing an elegy to a girl like Edie, I had to access something of the girl in myself. Obliged to consider what it meant to be female, I entered the core of my being, led by the girl poised before a white horse.

I was in a Beat humor. The Bibles were piled in small stacks. The Holy Barbarians. The Angry Young Men. Rummaging around, I found some poems by Ray Bremser. He really got me going. Ray had that human saxophone thing. You could feel his improvisational ease the way language spilled out like linear notes. Inspired, I put on some Coltrane but nothing good happened. I was just jacking off. Truman Capote once accused Kerouac of typing, not writing. But Kerouac infused his being onto rolls of Teletype paper, banging on his machine. Me, I was typing. I leapt up frustrated.

I picked up the Beat anthology and found "The Beckoning Sea" by George Mandel. I read him softly, and then at the top of my voice, to get the sea he embedded in the words and the accelerating rhythm of the waves. I kept going, spitting out Corso and Mayakovsky and back to the sea, to be pushed off the edge by George.

Robert had entered on his cat feet and sat down nodding his head. He listened with his full being. My artist who would never read. Then he bent down and picked up a handful of poems off the floor.

"You have to take better care of your work," he said.

"I don't even know what I'm doing," I shrugged, "but I can't stop doing it. I'm like a blind sculptor hacking away."

"You need to show people what you can do. Why don't you do a reading?"

I was getting frustrated with writing; it wasn't physical enough.

He told me he had some ideas. "I'll get you a reading, Patti."

I didn't really have any expectations about having a poetry reading anytime soon, but the thought did intrigue me. I had been writing my poems to please myself and a handful of people. Maybe it was time to see if I could pass the Gregory test. Inside I knew I was ready.

I was also writing more pieces for rock magazines—*Crawdaddy*, *Circus*, *Rolling Stone*. This was a time when the vocation of a music journalist could be an elevated pursuit. Paul Williams, Nick Tosches, Richard Meltzer, and Sandy Pearlman were some of the writers I held in esteem. I modeled myself after Baudelaire, who wrote some of the great idiosyncratic critiques of nineteenth-century art and literature.

I received a Lotte Lenya double album amongst a pile of records to review. I was determined that this great artist should be acknowledged, and called Jann Wenner at *Rolling Stone*. I had never spoken with him, and he seemed perplexed by the request. But when I pointed out that Bob Dylan was holding a Lotte Lenya album on the cover of *Bringing It All Back Home*, he relented. Primed by writing my Edie Sedgwick poem, I tried to articulate Lotte Lenya's role as an artist and a strong feminine presence. The concentration on this piece bled into my poems, offering me another mode of self-expression. I didn't think they would publish it, but Jann called and said that although I talked like a truck driver, I had written an elegant piece.

Writing for rock magazines brought me in contact with the writers I admired. Sandy Pearlman gave me a copy of *The Age of Rock II*, an anthology edited by Jonathan Eisen that gathered some of the best writing on music from that past year. What most touched me was a warm yet knowledgeable piece on a cappella music by Lenny Kaye. It spoke to me of my own roots, recalling the street corners of my youth where the boys would gather singing R&B songs in three-part harmony. It also contrasted with some of the cynical, holier-than-thou tone of much criticism of the time. I decided to seek him out and thank him for such an inspiring article.

Lenny worked downtown as a clerk at Village Oldies on Bleecker Street, and I stopped by one Saturday night. The store had hubcaps on the wall and shelves of vintage 45s. Almost any song you could think of could be dug out of those dusty stacks. In future visits, if there were no customers, Lenny would put on our favorite singles, and we'd dance to the Dovells' "Bristol Stomp" or do the 81 to Maureen Gray singing "Today's the Day."

The scene was shifting at Max's. The summer residency of the Velvet Underground attracted the new guardians of rock and roll. The round table was often filled with musicians, the rock press, and Danny Goldberg, who conspired to revolutionize the music business. Lenny could be found alongside Lillian Roxon, Lisa Robinson, Danny Fields, and others who were slowly making the back room their own. One could still count on Holly Woodlawn sweeping in, Andrea Feldman dancing on the tabletops, and Jackie and Wayne spewing cavalier brilliance, but increasingly their days of being the focal point of Max's were numbered.

Robert and I spent less time there and pursued our own scenes. Yet Max's still reflected our destiny. Robert had begun to photograph the Warhol denizens even as they were departing. And I was slowly becoming enmeshed in the rock world, along with those who inhabited it, through writing and ultimately performing.

Sam got a room with a balcony at the Chelsea. I loved staying there, having a room back in the hotel. I could get a shower anytime I wanted. Sometimes we just sat on the bed and read. I was reading about Crazy Horse and he was reading Samuel Beckett.

Sam and I had a long discussion about our life together. By then he had revealed to me that he was married and had an infant son. Perhaps it was the carelessness of youth but I was not completely cognizant of how our irresponsible ways could affect others. I met

his wife, Olan, a young and gifted actress. I never expected him to leave her, and we all fell into an unspoken rhythm of coexistence. He was often gone and let me stay in his room by myself with remnants of him: his Indian blanket, typewriter, and a bottle of Ron del Barrilito three-star rum.

Robert was appalled by the thought that Sam was married. He'll leave you eventually, he would say, but I already knew that. He figured Sam to be an erratic cowboy.

"You wouldn't like Jackson Pollock, either," I retorted. Robert just shrugged.

I was writing a poem for Sam, an homage to his obsession with stock cars. It was a poem called "Ballad of a Bad Boy." I pulled it out of the typewriter, pacing the room, reading it aloud. It worked. It had the energy and the rhythm I was looking for. I knocked on Robert's door. "Want to hear something?" I said.

Although we were a bit estranged in this period, Robert off with David and me with Sam, we had our common ground. Our work. As he had promised, Robert was determined to get me a reading. He spoke on my behalf to Gerard Malanga, who was scheduled to read at St. Mark's Church in February. Gerard generously agreed to let me open for him.

The Poetry Project, shepherded by Anne Waldman, was a desirable forum for even the most accomplished poets. Everyone from Robert Creeley to Allen Ginsberg to Ted Berrigan had read there. If I was ever going to perform my poems, this was the place to do it. My goal was not simply to do well, or hold my own. It was to make a mark at St. Mark's. I did it for Poetry. I did it for Rimbaud, and I did it for Gregory. I wanted to infuse the written word with the immediacy and frontal attack of rock and roll.

Todd suggested that I be aggressive, and he gave me a pair of black snakeskin boots to wear. Sam suggested I add music. I thought

about all the musicians who had come through the Chelsea, but then I remembered Lenny Kaye had said he played electric guitar. I went to see him.

"You play guitar, right?"

"Yeah, I like to play guitar."

"Well, could you play a car crash with an electric guitar?"

"Yeah, I could do that," he said without hesitation, and agreed to accompany me. He came to Twenty-third Street with his Melody Maker and a little Fender amp, and while I recited my poems, he fell in.

The reading was scheduled for February 10, 1971. Judy Linn took a photo of Gerard and me smiling in front of the Chelsea for the flyer. I researched for any auspicious signs connected to the date: Full moon. Bertolt Brecht's birthday. Both favorable. With a nod to Brecht, I decided to open the reading singing "Mack the Knife." Lenny played along.

It was a night of nights. Gerard Malanga was a charismatic poet-performance artist and drew much of the crème of the Warhol world, everyone from Lou Reed to Rene Ricard to Brigid Berlin to Andy himself. Lenny's people came to cheer him on: Lillian Roxon, Richard and Lisa Robinson, Richard Meltzer, Roni Hoffman, Sandy Pearlman. There was a contingent from the Chelsea including Peggy, Harry, Matthew, and Sandy Daley. Poets like John Giorno, Joe Brainard, Annie Powell, and Bernadette Mayer. Todd Rundgren brought Miss Christine of the GTOs. Gregory was restlessly shifting in his aisle seat waiting to see what I'd come up with. Robert entered with David and they sat front and center. Sam hung over the balcony rail, urging me on. The atmosphere was charged.

Anne Waldman introduced us. I was totally wired. I dedicated the evening to criminals from Cain to Genet. I chose poems like "Oath," which began, "Christ died for somebody's sins / But not mine," and took a slow turn on "Fire of Unknown Origin." I read "The Devil

Has a Hangnail" for Robert, and "Cry Me a River" for Annie. "Picture Hanging Blues," written from the perspective of Jesse James's girlfriend, was, with its chorus, closer to a song than anything I'd written before.

We finished with "Ballad of a Bad Boy" accompanied by Lenny's strong rhythmic chords and electric feedback. It was the first time an electric guitar had been played in St. Mark's Church, provoking cheers and jeers. As this was hallowed ground for poetry, some objected, but Gregory was jubilant.

The reception had its thundering moments. I drew from all the submerged arrogance I may have possessed for the performance. But afterward I was so filled with adrenaline that I behaved like a young cock. I failed to thank Robert and Gerard. Nor did I socialize with their people. I just high-tailed it out with Sam and we had a couple of tequilas and lobster.

I had my night and it was exciting but I thought it best to take it in stride and forget about it. I had no idea how to process such an experience. Although I knew I hurt Robert's feelings, he still could not conceal his pride in me. Yet I had to take into account that I seemed to have a whole other side. What it had to do with art I wasn't certain.

I was bombarded with offers stemming from my poetry reading. *Creem* magazine agreed to publish a suite of my poems; there were proposed readings in London and Philadelphia; a chapbook of poems for Middle Earth Books; and a possible record contract with Steve Paul's Blue Sky Records. At first this was flattering, and then seemed embarrassing. It was a more extreme reaction than had greeted my haircut.

It came, I felt, too easy. Nothing had come to Robert so easily. Or for the poets I had embraced. I decided to back off. I turned down the record contract but left Scribner's to work for Steve Paul as his girl Friday. I had more freedom and made a little more money, but Steve

kept asking me why I chose to make his lunch and clean his birdcages instead of making a record. I didn't really believe I was destined to clean the cage, but I also knew it wasn't right to take the contract.

I thought of something I learned from reading *Crazy Horse: The Strange Man of the Oglalas* by Mari Sandoz. Crazy Horse believes that he will be victorious in battle, but if he stops to take spoils from the battlefield, he will be defeated. He tattoos lightning bolts on the ears of his horses so the sight of them will remind him of this as he rides. I tried to apply this lesson to the things at hand, careful not to take spoils that were not rightfully mine.

I decided I wanted a similar tattoo. I was sitting in the lobby drawing versions of lightning bolts in my notebook when a singular woman entered. She had wild red hair, a live fox on her shoulder, and her face was covered with delicate tattoos. I realized that if one erased the tattoos, they would reveal the face of Vali, the girl on the cover of *Love on the Left Bank*. Her picture had long ago found a place on my wall.

I asked her outright if she would tattoo my knee. She stared at me and nodded in assent, not saying anything. In the next few days we arranged that she would tattoo my knee in Sandy Daley's room, and that Sandy would film it, just as she had filmed Robert getting his nipple pierced, as if it were my turn to be initiated.

I wanted to go alone, but Sam wanted to be there. Vali's technique was primitive, a large sewing needle which she sucked in her mouth, a candle, and a well of indigo ink. I had resolved to be stoic, and sat quietly as she stabbed the lightning bolt into my knee. When it was over, Sam asked her to tattoo his left hand. She repeatedly pierced the web of skin between his thumb and forefinger until a crescent moon appeared.

One morning Sam asked me where my guitar had gone and I told him I had given it to my youngest sister, Kimberly. That afternoon he took me to a guitar shop in the Village. There were acoustic guitars hanging on the wall, like in a pawnshop, only the cantankerous owner

seemed not to want to part with any of them. Sam told me to choose any one I wanted. We looked at a lot of Martins, including some pretty ones with mother-of-pearl inlay, but what caught my eye was a battered black Gibson, a 1931 Depression model. The back had been cracked and repaired, and the gears of the tuning pegs were rusted. But something about it captured my heart. I thought by the looks of it that nobody would want it but me.

"Are you sure this is the one, Patti Lee?" Sam asked me.

"It's the only one," I said.

Sam paid two hundred dollars for it. I thought the owner would be glad, but he followed us down the street saying, "If you ever don't want it, I'll buy it back."

It was a beautiful gesture that Sam got me the guitar. It put me in mind of a movie I saw called *Beau Geste*, with Gary Cooper. He plays a soldier in the French Foreign Legion who, at the price of his own reputation, shields the woman who raised him. I decided to call the guitar Bo, a short form of Beau. It was to remind me of Sam, who in truth had fallen in love with the guitar himself.

Bo, which I still have and treasure, became my true guitar. On it, I have written the greater measure of my songs. The first was written for Sam, anticipating his leave-taking. Our conscience was closing in on us, in our work and life. We were as close as ever, but it was getting time for him to go and we both knew it.

One night we were sitting in silence, thinking the same thing. He leapt up and brought his typewriter onto the bed. "Let's write a play," he said.

"I don't know anything about writing plays," I answered.

"It's easy," he said. "I'll start." He described my room on Twenty-third Street: the license plates, the Hank Williams records, the toy lamb, the bed on the floor, and then introduced his own character, Slim Shadow.

Then he shoved the typewriter my way and said, "You're on, Patti Lee."

I decided to call my character Cavale. I got it from a French-Algerian writer named Albertine Sarrazin, who, like Genet, was a precocious orphan who moved seamlessly between literature and crime. My favorite of her books was called *La Cavale*, which is the French word for escape.

Sam was right. It wasn't hard at all to write the play. We just told each other stories. The characters were ourselves, and we encoded our love, imagination, and indiscretions in *Cowboy Mouth*. Perhaps it wasn't so much a play as a ritual. We ritualized the end of our adventure and created a portal of escape for Sam.

Cavale is the criminal in the story. She kidnaps Slim and holes him up in her lair. The two of them love and spar, and create a language of their own, improvising poetry. When we got to the part where we had to improvise an argument in a poetic language, I got cold feet. "I can't do this," I said. "I don't know what to say."

"Say anything," he said. "You can't make a mistake when you improvise."

"What if I mess it up? What if I screw up the rhythm?"

"You can't," he said. "It's like drumming. If you miss a beat, you create another."

In this simple exchange, Sam taught me the secret of improvisation, one that I have accessed my whole life.

*Cowboy Mouth* opened at the end of April at the American Place Theatre on West Forty-sixth Street. In the play, Cavale tries to re-create Slim into her image of a rock and roll savior. Slim, at first intoxicated with the idea and beguiled by Cavale, finally has to tell her that he can't realize her dream. Slim Shadow goes back into his own world, his family, his responsibilities, leaving Cavale alone, setting her free.

Sam was excited because the play was good, but the reality of exposing himself onstage was deeply stressful. Directed by Robert Glaudini, the rehearsals were uneven and high-spirited but unfettered by an audience. The first preview was for local schoolchildren, and it was liberating as the kids laughed and cheered and egged us on. It was if we were collaborating with them. But at the official preview, it was as if Sam woke up, having to confront real people with his real problems.

On the third night, Sam disappeared. We closed the play. And like Slim Shadow, Sam returned to his own world, his family, and his responsibilities.

Experiencing the play taught me things about myself as well. I couldn't imagine how Cavale's image of a "rock 'n' roll Jesus with a cowboy mouth" could apply to anything I was doing, but as we sang, sparred, and drew each other out, I found myself at home onstage. I was no actress; I drew no line between life and art. I was the same on- as offstage.

Before Sam left New York City for Nova Scotia, he gave me some money in an envelope. It was for me to take care of myself.

He looked at me, my cowboy with Indian ways. "You know, the dreams you had for me weren't my dreams," he said. "Maybe those dreams are meant for you."

I was at a crossroads, not sure of what to do. Robert did not gloat when Sam left. And when Steve Paul offered to take me to Mexico with some other musicians to write songs, Robert encouraged me to go. Mexico represented two things that I loved: coffee and Diego Rivera. We arrived in Acapulco in mid-June and stayed in a sprawling villa overlooking the sea. I didn't get much songwriting done, but I drank a lot of coffee.

A dangerous storm drove everyone home, but I stayed on, and eventually made my way back through Los Angeles. It was there I saw

a huge billboard for the Doors' new album, *L.A. Woman,* an image of a woman crucified on a telegraph pole. A car drove by and I heard the strains of their new single coming over the radio, "Riders on the Storm." I felt remorse that I had almost forgotten what an important influence Jim Morrison had been. He had led me on the path of merging poetry into rock and roll, and I resolved to buy the album and write a worthy piece on his behalf.

By the time I returned to New York, fragmented news of his passing in Paris filtered back from Europe. For a day or two, no one was certain what had happened. Jim had died in his bathtub from mysterious causes; on July 3, the same date as Brian Jones.

As I ascended the stairs I knew something was wrong. I could hear Robert crying out, "I love you! I hate you! I love you!" I flung open the door to Robert's studio. He was staring into an oval mirror, flanked by a black whip and a devil's mask he had spray-painted months before. He was having a bad trip, wrestling good and evil. The devil was gaining on him, morphing his features, which like the mask were distorted and blood red.

I had no experience with this kind of situation. Remembering how he had helped me when I was dosed at the Chelsea, I calmly talked him down as I removed the mask and mirror from his sight. At first he looked at me as if I were a stranger, but soon his labored breathing slowed down. Exhausted, he followed me to the bed and put his head in my lap and fell asleep.

His dual nature troubled me, mostly because I feared it troubled him. When we first met, his work reflected a belief in God as universal love. Somehow he got off track. His Catholic preoccupation with good and evil reasserted itself, as if he had to choose one over the other. He had broken from the Church, now it was breaking within

him. His trip magnified his fear that he had aligned himself irrevocably with darker forces, his Faustian pact.

Robert took to describing himself as evil, partially joking or just needing to be different. I sat and watched as he strapped on a leather codpiece. He was certainly more Dionysian than satanic, embracing freedom and heightened experience.

"You know you don't have to be evil to be different," I said. "You are different. Artists are their own breed."

He gave me a hug. The codpiece pressed against me. "Robert," I squealed, "you're so bad."

"I told you," he said, winking.

He went off and I went back to my side. I caught sight of him through my window as he hurried past the YMCA. The artist and hustler was also the good son and altar boy. I believed he would once again embrace the knowledge that there is no pure evil, nor pure good, only purity.

Not having the income to devote to one pursuit, Robert continued working in several media simultaneously. He shot film when he could afford it, made necklaces when he had the available components, and created constructions with found materials. But there was no question that he was gravitating toward photography.

I was Robert's first model and he was his second. He began by taking photographs of me incorporating my treasures or his ritual objects, and graduated to nudes and portraits. I was eventually relieved of some of my duties by David, who was the perfect muse for Robert. David was photogenic and flexible, open to some of Robert's unusual scenarios, such as lying clothed in nothing but socks, wrapped naked in black net, or gagged in a bow tie.

He was still using Sandy Daley's 360 Land Camera. The settings and options were limited but it was technically simple and he needed no light meter. Spreading a pink waxy coating over the image preserved the shots. If he forgot to coat it, the picture would slowly fade. He made use

of the whole Polaroid pack, the casing for frames, the pull tab, and occasionally even a semi-failure by manipulating the image with emulsion.

Because of the price of film he felt obliged to make every shot count. He did not like making mistakes or wasting film, and so developed his quick eye and decisive manner. He was precise and economical, first out of necessity, then out of habit. Observing his swift progress was rewarding, as I felt a part of his process. The creed we developed as artist and model was simple. I trust in you, I trust in myself.

★

An important new presence entered Robert's life. David had introduced Robert to the curator of photography at the Metropolitan Museum of Art. John McKendry was married to Maxime de la Falaise, a leading figure in New York's high society. John and Maxime provided Robert with an entrance into a world that was as glamorous as he could have wished for. Maxime was an accomplished cook and hosted elaborate dinner parties where she served obscure dishes taken from her knowledge of centuries of English cooking. For every sophisticated course presented, there was equally well-spiced repartee served up by her guests. Those typically seated at her table: Bianca Jagger, Marisa and Berry Berenson, Tony Perkins, George Plimpton, Henry Geldzahler, Diane and Prince Egon von Fürstenberg.

Robert wanted to expose me to this stratum of society: fascinating and cultured people he thought I could relate to and who he hoped might help us. As usual, this created more than humorous conflicts between Robert and me. I didn't dress properly, I was awkward in their company, if not bored, and I spent more time milling around in the kitchen than gossiping at the table. Maxime was patient with me, but John genuinely seemed to comprehend my feeling of being an outsider. Perhaps he too felt alienated. I really liked him, and he

made every effort to make me feel comfortable. We would sit together on their Napoleonic daybed, and he would read me passages from Rimbaud's *Illuminations* in the original French.

Due to his unique position at the Met, John had access to the vaults that housed the museum's entire photography collection, much of it never seen by the public. John's specialty was Victorian photography, which he knew I was partial to as well. He invited Robert and me to come and see the work firsthand. There were flat files from floor to ceiling, metal shelves and drawers containing vintage prints of the early masters of photography: Fox Talbot, Alfred Stieglitz, Paul Strand, and Thomas Eakins.

Being allowed to lift the tissues from these photographs, actually touch them and get a sense of the paper and the hand of the artist, made an enormous impact on Robert. He studied them intently—the paper, the process, the composition, and the intensity of the blacks. "It's really all about light," he said.

John saved the most breathtaking images for last. One by one, he shared photographs forbidden to the public, including Stieglitz's exquisite nudes of Georgia O'Keeffe. Taken at the height of their relationship, they revealed in their intimacy a mutual intelligence and O'Keeffe's masculine beauty. As Robert concentrated on technical aspects, I focused on Georgia O'Keeffe as she related to Stieglitz, without artifice. Robert was concerned with how to make the photograph, and I with how to be the photograph.

This clandestine viewing was one of the first steps in John's supportive though complex relationship with Robert. He bought him his own Polaroid camera and secured him a grant from Polaroid that provided Robert with all the film he needed. This gesture came in tandem with Robert's increasing interest in taking photographs. The only thing that had stopped him was the prohibitive cost of film.

John opened Robert's social circle not only in America, but internationally, for he would soon take him to Paris on a museum-related trip. This was Robert's first trip abroad. His window into Paris was opulent. Robert's friend Loulou was John's stepdaughter and they shared champagne with Yves Saint Laurent and his partner Pierre Bergé, as Robert wrote from the Café de Flore. On his postcard he said that he was taking photographs of statues, incorporating his love of sculpture into photography for the first time.

John's devotion to Robert's work spilled over to Robert himself. Robert accepted John's gifts and took advantage of opportunities that John opened up for him, but he was never interested in John as a romantic partner. John was sensitive, volatile, and physically fragile, qualities that would not attract Robert. He admired Maxime, who was strong and ambitious with an impeccable pedigree. Perhaps he may have been cavalier with John's feelings, for as time went on, he found himself entangled within a destructive romantic obsession.

When Robert was away, John would visit me. He sometimes brought me presents, like a tiny ring of twisted gold from Paris, or a special translation of Verlaine or Mallarmé. We talked about the photography of Lewis Carroll and Julia Margaret Cameron, but what he really wanted to talk about was Robert. On the surface, John's sorrow could be attributed to unrequited love, but the more time I spent with him, the deeper consideration seemed to be John's inexplicable self-loathing. John couldn't have been more ebullient, curious, and loving, so I couldn't imagine why he suffered such a low opinion of himself. I did my best to console him, but could not offer him any solace; Robert's view of him would never go beyond friend and mentor.

In *Peter Pan*, one of the Lost Boys is named John. Sometimes he seemed so to me, a pale and wispy Victorian boy ever chasing after Pan's shadow.

Yet John McKendry could not have given Robert a better gift than the tools he needed to devote himself to photography. Robert was thoroughly smitten, obsessed not only with the process, but also its place in the arts. He had endless discussions with John, whose complacent air frustrated him. He felt that John, using his position at the Met, should be working harder to lift the estimation of photography to the respected and critical level of painting and sculpture. But John, assembling a major Paul Strand exhibition, was wed to photography, not the potential duty to raise its place in the hierarchy of the arts.

I never anticipated Robert's complete surrender to its powers. I had encouraged him to take photographs to integrate into his collages and installations, hoping to see him assume the mantle of Duchamp. But Robert had shifted his focus. The photograph was not a means to an end, but the object itself. Hovering over all of this was Warhol, who seemed to both excite and paralyze him.

Robert was determined to do something Andy had not yet done. He had defaced Catholic images of the Madonna and Christ; he had introduced physical freaks and S&M imagery into his collages. But where Andy had seen himself as a passive observer, Robert would eventually insert himself into the action. He would participate in and document that which he had previously only been able to approximate through magazine imagery.

He began to branch out, photographing those he met through his complex social life, the infamous and the famous, from Marianne Faithfull to a young tattooed hustler. But he always returned to his muse. I no longer felt that I was the right model for him, but he would wave my objections away. He saw in me more than I could see in myself. Whenever he peeled the image from the Polaroid negative, he would say, "With you I can't miss."

*Twenty-third Street, 1972*

I loved his self-portraits and he took a lot of them. He regarded the Polaroid as the artist's photo booth, and John had provided him with all the quarters he needed.

We were invited to a fancy dress ball hosted by Fernando Sánchez, the great Spanish designer known for his provocative lingerie. Loulou and Maxime sent me a vintage gown of heavy crepe designed by Schiaparelli. The top was black, with poufed sleeves and a V-neck bodice, sweeping down into a red floor-length skirt. It looked suspiciously like the dress Snow White was wearing when she met the Seven Dwarfs. Robert was beside himself. "Are you going to wear it?" he said excitedly.

Lucky for me, it was too small. Instead, I dressed completely in black, finishing it off with pristine white Keds. David and Robert were in black tie.

This was one of the most glamorous parties of the season, attended by the upper echelon of art and fashion. I felt like a Buster Keaton character, leaning alone against a wall when Fernando came up. He took me in skeptically. "Darling, the ensemble is fabulous," he said, patting my hand, eyeing my black jacket, black tie, black silk shirt, and heavily pegged black satin pants, "but I'm not so sure about the white sneakers."

"But they're essential to my costume."

"Your costume? What are you dressed as?"

"A tennis player in mourning."

Fernando looked me up and down and began to laugh. "Perfect," he said, showing me off to the room. He took my hand and immediately led me to the dance floor. Being from South Jersey, I was now in my element. The dance floor was mine.

Fernando was so intrigued by our exchange that he gave me a slot in his upcoming fashion show. I was invited to join the lingerie

models. I wore the same black satin pants, a tattered T-shirt, the white sneakers, modeling his eight-foot-long black feather boa and singing "Annie Had a Baby." It was my catwalk debut, the beginning and end of my modeling career.

More important, Fernando was a champion of both Robert's and my work, often stopping by our loft to look at new pieces. He bought work at a time when both of us needed the money and the encouragement.

Robert took the photograph for my first small collection of poems, a chapbook called *Kodak* published by Middle Earth Books in Philadelphia. I had in mind that it should resemble the cover of Bob Dylan on *Tarantula*, a cover of a cover. I bought some film and a white tab-collar shirt, which I wore with a black jacket and Wayfarers.

Robert didn't want me to wear the dark glasses but he indulged me anyway and took the picture that would become the cover. "Now," he said, "take the glasses and jacket off," and he took more pictures with just the white shirt. He chose four, and laid them in a row. Then he picked up the Polaroid film casing. He slipped one of the pictures in the black metal frame. It wasn't quite the look he wanted so he spray-painted it white. Robert was able to modify materials and make unexpected use of them. He fished out three or four from the trash and spray-painted them.

He rifled through the refuse from the Polaroid, the black tab of paper that said, "DON'T Touch Here," and slid it into one of the spent casings. Robert on a roll was like David Hemmings in *Blow-Up*. The obsessive concentration, images tacked on a wall, a cat detective stalking the terrain of his work. The trail of blood, his footprint,

his mark. Even Hemmings's words from the film seemed a subtext, Robert's private mantra: *I wish I had tons of money. / Then I'd be free. / Free to do what? / Everything.*

★

As Rimbaud said, "New scenery, new noise." Everything accelerated after Lenny Kaye and I performed at St. Mark's. My ties with the rock community strengthened. Many notable writers, such as Dave Marsh, Tony Glover, Danny Goldberg, and Sandy Pearlman, had attended, and I was offered more writing assignments. The poems in *Creem* would mark the first major publication of my poetry.

Sandy Pearlman, in particular, had a vision of what I should be doing. Although I wasn't ready to fulfill his particular take on my future, I was always interested in his perception of things, for Sandy's mind contained a repertoire of references from Pythagorean mathematics to St. Cecilia, the patron saint of music. His opinions were backed with considerable knowledge on any imaginable subject. In the center of his arcane sensibility was a fervor for Jim Morrison, who placed so high in his mythos that he modeled himself after him, wearing a black leather shirt and leather pants fastened by a large silver concho belt, the signature raiment of the lizard king. Sandy had a sense of humor and a speedy way of talking, and he always wore dark glasses, shielding his ice blue eyes.

He saw me as fronting a rock and roll band, something that had not occurred to me, or that I had even thought possible. But after writing and performing songs with Sam in *Cowboy Mouth*, I felt the desire to explore songwriting.

Sam had introduced me to Lee Crabtree, a composer and key-

board player who had worked with the Fugs and the Holy Modal Rounders. He had a room at the Chelsea with a bureau full of compositions, thick piles of music no one had ever heard. He always seemed vaguely uncomfortable. He was freckled, with red hair tucked under a watch cap, glasses, and a slight red beard. It was impossible to tell whether he was young or old.

We began with the song I wrote for Janis, the song she would never sing. His approach to this song was to play the music as if it were a calliope. I was kind of shy, but he was shyer, and we were mutually patient with each other.

As he grew to trust me, he told me a little about himself. He was devoted to his grandfather, and when his grandfather died, he left him a modest but meaningful inheritance, which included the home in New Jersey they had shared. He confided in me that his mother objected to the will, used his fragile emotional state to block it, and attempted to have him committed. When he took me to the house, he sat on his grandfather's chair and cried.

We had a good practice after that. We worked on three songs. He had some ideas for the melodies of "Dylan's Dog" and "Fire of Unknown Origin," and we ended with "Work Song," the song I had written for Janis. I was amazed at how good it sounded, for he had found me a key I could sing in.

One day he came to see me at Twenty-third Street. It was pouring rain outside, and he was distraught. His mother had successfully blocked the will and denied him access to his grandfather's house. He was soaking wet, and I offered him a T-shirt that Sandy Pearlman had given me, a prototype for a new rock and roll band he was managing.

I did my best to console him, and we agreed to meet again. But he never showed up for practice the following week. I went over to the Chelsea. After several days I asked around for him, and Anne

Waldman told me that, facing the loss of his inheritance and the threat of institutionalization, he had leapt to his death from the roof of the Chelsea.

I was stunned. I combed my memory for signs. I wondered if I could have helped him, but we were just learning to communicate and share our trust. "Why didn't anyone tell me?" I asked.

"We didn't want to upset you," said Anne. "He was wearing the T-shirt you gave him."

I felt strange singing after that. I went back to my writing, but singing found me. Sandy Pearlman was convinced that's what I should be doing, and he introduced me to Allen Lanier, the keyboard player of the band he was managing. They had begun as the Soft White Underbelly, recording an album for Elektra that was never to be released. They were now known as the Stalk-Forrest Group, but would soon become Blue Öyster Cult.

He had two motivations for introducing us. He felt Allen might help frame the songs I was writing for myself, and that possibly I could write lyrics for the band. Allen came from strong Southern stock, which included the Civil War poet Sidney Lanier and the playwright Tennessee Lanier Williams. He was soft-spoken, encouraging, and shared my affection for the poems of William Blake, which he could recite from memory.

While our musical collaboration progressed slowly, our friendship deepened, and soon we chose a romantic relationship over a working one. Unlike Robert, he liked to keep these things separate.

Robert was fond of Allen. They had mutual respect for each other, and each other's relationship with me. Allen fit our equation as David did with Robert, and we all coexisted amicably. Allen's duties with the band often took him out of town, but increasingly, when he was home, he would stay with me.

Allen contributed to our expenses as Robert made every advance

toward financial independence. He dragged his portfolio from gallery to gallery, but most often he had the same response. The work was good, but dangerous. Occasionally he would sell a collage, or be encouraged by the likes of Leo Castelli, but on the whole he was in a position similar to that of the young Jean Genet showing his work to Cocteau and Gide. They knew he was great, but they feared the intensity of his gift, and also what his subject matter might reveal about themselves.

Robert took areas of dark human consent and made them into art. He worked without apology, investing the homosexual with grandeur, masculinity, and enviable nobility. Without affectation, he created a presence that was wholly male without sacrificing feminine grace. He was not looking to make a political statement or an announcement of his evolving sexual persuasion. He was presenting something new, something not seen or explored as he saw and explored it. Robert sought to elevate aspects of male experience, to imbue homosexuality with mysticism. As Cocteau said of a Genet poem, "His obscenity is never obscene."

Robert would never compromise, but oddly enough, he kept a censorious eye on me. He worried that my confrontational manner would hamper my chances of success. But the success he wished for me was my least concern. When Telegraph Books, a revolutionary small press spearheaded by Andrew Wylie, offered to publish a small book of poems, I concentrated on work that skirted the edge of sex, broads, and blasphemy.

The girls interested me: Marianne Faithfull, Anita Pallenberg, Amelia Earhart, Mary Magdalene. I would go to parties with Robert just to check out the dames. They were good material and knew how to dress. Ponytails and silk shirtwaist dresses. Some of them found their way into my work. People took my interest the wrong way. They figured I was a latent homosexual, or maybe just acting like

one, but I was merely a Mickey Spillane type, exercising my hard, ironic edge.

I thought it was funny that Robert was so concerned about the content of my work. He was worried that I wouldn't be successful if my work was too provocative. He always wanted me to write a song he could dance to. In the end I would point out that he was a bit like his father, wanting me to take a commercial path. But I had no interest, and I was always too crude. This was cause for him to brood, but he still thought he was right.

When *Seventh Heaven* was published, Robert arranged a book party for me with John and Maxime. It was an informal affair held in their elegant Central Park West apartment. They graciously invited many of their friends from the worlds of art, fashion, and publishing. I entertained them with poems and stories, and then sold copies of my book from a large shopping bag for a dollar a piece. Robert lightly scolded me for soliciting in the McKendry drawing room, but George Plimpton, who particularly liked the Edie Sedgwick poem, found my sales pitch charming.

Our social differences, however exasperating, were tinged with love and humor. In the end, we were more alike than not, and gravitated toward each other, however wide the breach. We weathered all things, large and small, with the same vigor. To me, Robert and I were irrevocably entwined, like Paul and Elisabeth, the sister and brother in Cocteau's *Les Enfants Terribles*. We played similar games, declared the most obscure object treasure, and often puzzled friends and acquaintances by our indefinable devotion.

He had been chided for denying his homosexuality; we were accused of not being a real couple. In being open about his homo-sexuality, he feared our relationship would be destroyed.

We needed time to figure out what all of this meant, how we were going to come to terms and redefine what our love was called. I learned from him that often contradiction is the clearest way to truth.

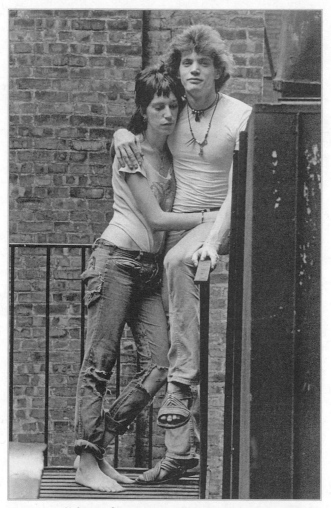

*West Twenty-third Street, fire escape*

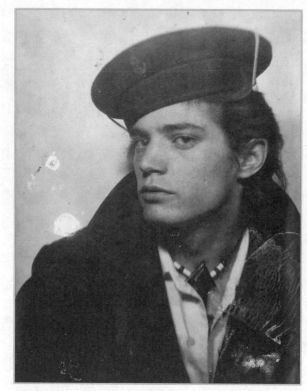

*Photo booth, Forty-second Street, 1970*

-<-<->->-

I f Robert was the sailor, Sam Wagstaff was the ship coming in.
An image of a young man in a naval cap, his head turned three-quar-
ters, insolent and alluring, had its place on David Croland's mantel.

Sam Wagstaff picked it up and looked at it. "Who's this?" he asked.

*This is it*, thought David, as he answered.

Samuel Jones Wagstaff Jr. was intelligent, handsome, and rich. He
was a collector, patron, and the former curator of the Detroit Institute
of Arts. He was at a crossroads in his life, having inherited a large sum
of money, and was at the center of a philosophical standoff, equidis-
tant between the spiritual and the material. The question of whether
he should give up everything to pursue a Sufi's path or invest in an
aspect of art that he had yet to experience seemed suddenly answered
by Robert's defiant gaze.

Scattered about David's apartment was Robert's work. Sam saw
all he needed.

Quite unconsciously, David had orchestrated the trajectory of
Robert's life. From my perspective, he was a puppet master, bring-
ing new characters into the play of our lives, shifting Robert's path
and the history that resulted. He gave Robert John McKendry, who
opened for him the vaults of photography. And he was about to send
him Sam Wagstaff, who would give him love, wealth, companionship,
and a small amount of misery.

A few days later, Robert received a phone call. "Is this the shy
pornographer?" were Sam's first words.

Robert was highly sought after by both men and women. Often
acquaintances would knock on my door asking me if he was fair game
and seeking tips for the way into his heart. "Love his work," I would
say. But few listened.

I was asked by Ruth Kligman if I minded if she made a play for Robert. Ruth, who wrote the book titled *Love Affair: A Memoir of Jackson Pollock* and was the sole survivor of the car crash that took his life, was attractive in an Elizabeth Taylor kind of way. She dressed to the hilt, and I could smell her perfume as she mounted the stairs. She tapped on my door, having made an appointment with Robert, and winked to me. "Wish me luck," she said.

A few hours later, she was back. As she slipped off her slingback heels and rubbed her ankles, she said, "Boy, when he says, 'Come up and see my etchings,' he means 'Come up and see my etchings.'"

Love his work. That was the way to Robert's heart. But the only one who truly grasped this, who had the capacity to love his work completely, was the man who was to become his lover, his patron, and his lifelong friend.

I was out the first time Sam came to visit, but by Robert's account Sam and he spent the evening studying his work. Sam's reactions were insightful, stimulating, and tinged with playful innuendo, and he promised he would return. Robert was like a teenage girl, waiting for Sam to call.

He entered our life with a breathtaking swiftness. Sam Wagstaff had a sculptural presence, as if he were carved from granite, a tall and rugged version of Gary Cooper with a Gregory Peck voice. He was affectionate and spontaneous. Sam was attractive to Robert for more than his looks. He had a positive and curious nature and, unlike others Robert had met in the art world, did not seem tormented about the complexity of being a homosexual. He was less open, as was typical of his generation, but not ashamed, or divided, and seemed delighted to share Robert's willingness to be open.

Sam was physically virile, healthy, and mentally lucid in a time when the rampant use of drugs made sober communication about art or process challenging. He was rich yet unimpressed with wealth.

Knowledgeable and enthusiastically open to provocative concepts, he was the perfect advocate and provider for Robert and his work.

Sam appealed to us both; his maverick side to me, his privileged to Robert. He was studying Sufism and dressed simply in white linen and sandals. He was unpretentious and seemed thoroughly unconscious of his effect on others. He was a Yale graduate, had been an ensign in the Navy who took part in the D-Day invasion on Omaha Beach, and had served as curator at the Wadsworth Atheneum. He could discourse in an educated and humorous fashion on everything from free-market economics to Peggy Guggenheim's love life.

Sealing their seemingly predestined union was the fact that Robert and Sam shared the same birthday, twenty-five years apart. On November fourth, we celebrated at the Pink Tea Cup, a true soul food kitchen on Christopher Street. Sam, with all his money, liked the same places we did. That evening, Robert gave Sam a photograph, and Sam gave Robert a Hasselblad camera. This early exchange was symbolic of their roles as artist and patron.

The Hasselblad was a medium-format camera fitted with a Polaroid back. Its complexity required the use of a light meter, and the interchangeable lens gave Robert a greater depth of field. It allowed him more choices and flexibility, more control over his use of light. Robert had already defined his visual vocabulary. The new camera taught him nothing, just allowed him to get exactly what he was looking for. Robert and Sam could not have chosen more significant gifts for one another.

★

In late summer, two Double Bubble Cadillacs could be found parked at any hour outside the Chelsea. One was pink, the other yellow, and the pimps wore suits and wide-brimmed hats matching the cars. The dresses on their women matched their suits. The Chelsea was

sleepless 66

thunderstruck. nightmare at 4 o clock.saying look im gonna
die. gonna be dead. gonna go off the earth. world gonna go
without me. someone gonna fill the space I filled. someone
is gonna dance on the floor i used to rock n roll to. rock
n roll slow to. someone will fill my slot. put the i under
my dot. get off on my rocks. gotta take a leak gotta take
a shit. no i cant get up i got a cramp and god its hot after
a rainstorm when you wake alone at 4 am then its 4:10. you
know when. pacing linoleum. when the tiles on the floor fill
you with anxiety. gotta pee pee. gotta pretend Im speeding
like highway 61. motorcycle sunglass. mexican whorelass.
correo aereo my darling. coldeye cleat boot. now look how
well im hung dung. watch me snort a crystal ball. ooga mooga
mirror iceskate. me surrealist beatnik:

I sport my shades/ i dig bob dylan/ I like food/ thats not
to filling/ the bible/ is too heavy for me.

end of theme song im heading for a fall. im a fall guy im
a fall gown. im a fallen arm im a fallen elm. timber ta yoga.
little brown boys chant chant: baby your so beautiful but
you got to die someday. oh no is it really possible rainstorm?
am i really gonna die. everything fades/ evaporates like genii.
already the first word thunderstruck is gone. dead. how can
I keep WORDS moving insect? Quick! ill record everything. its
dark no im wrong its dawn i have my shades on. its cool its
ok theyre prescription. keep the light dart lame arrow out.
so i can get the moment get the movement. spread it all out
full house mayonaise. record player on. dylan sings queen jane.
the words a bandana and complain. oops record skips. good i
heard that song enough keep moving. was that a throw of the
dice? no baby its sugar teeth crumbling. spit them out everyone
of them. got a controll headache just keep on pushing ecedrin.
jumpy bean queen see me slug another quart of coffee. blood
count maybe 2/3. me go to lab get coffee count. nurse says ummm
your xx right java head. open my lips to kiss the flavor bursts
like chicary. oh dont turn away honey. a bud is not a false
flower. ya gotta give it time time. gotta beat time. gotta
kiss cowardice. oh correction: howard ice. hes the real cream
bomb in my life. ice is nice and hes cold exposed crystal
pill pill. beter to slip that speed in better to keep time
within. better to record the speech of phantoms.

jim morrison. our leather lamb. how we betrayed him. turned
our back on him. this is the end our beautiful friend. no wait
I had a dream Mr. King. jim morrison is alive and racing with
time. he who hesitates is fates. he sits erect. typing tran
latings his final stolen sensations into language. into the
~~yard he gotta edge when black windows. popping pills kissing~~

"Sleepless 66," winter 1971

changing, and the atmosphere on Twenty-third Street had a manic feel, as if something had gone awry. There was no sense of logic, even in a summer where everyone's attention was riveted on a chess match in which Bobby Fischer, a young American, was about to topple the great Russian bear. One of the pimps was murdered; homeless women shifted aggressively in front of our door, shouting obscenities, rifling our mail. The ritualistic sparring between Bard and our friends had come to a head and many were being evicted.

Robert was often traveling with Sam, and Allen was on the road with the band. Neither of them liked leaving me alone.

When our loft was broken into, Robert's Hasselblad and motorcycle jacket were stolen. We had never been robbed before, and Robert was upset not only about the expensive camera, but about what it indicated: a lack of safety and invasion of privacy. I mourned the loss of the motorcycle jacket because we had used it in installations. Later, we found it hanging from the fire escape. The thief had dropped it as he fled, but he kept the camera. The thief was possibly daunted by my mess but did steal the outfit I had worn to Coney Island on our anniversary in 1969. It was my favorite outfit, the one in the picture. It was on a hook on the inside of my door, freshly dry-cleaned. Why he took that I'll never know.

It was time to go. The three men in my life—Robert, Allen, and Sam—hashed it out. Sam gave Robert the money to buy a loft on Bond Street, down the block from him. Allen found a first-floor apartment on East Tenth Street, within walking distance of Robert and Sam. He assured Robert he was earning enough from the band to take care of me.

We decided to leave on October 20, 1972. It was Arthur Rimbaud's birthday. As far as Robert and I were concerned, we had upheld our vow.

Everything would change, I thought, packing my things, the madness of my mess. I tied a string around a stationery box that had once been filled with fresh onionskin. Now it held a stack of coffee-

stained typed pages rescued by Robert, picked up from the floor and smoothed by his Michelangelo hands.

Robert and I stood together alone in my section of the loft. I had left some things behind—the lamb pull toy, an old white jacket made of parachute silk, *PATTI SMITH 1946*—stenciled on the back wall— in homage to the room like one leaves a portion of wine to the gods. I know we were thinking the same thing, how much we had been through, good and bad, but also a sense of relief. Robert squeezed my hand. "Do you feel sad?" he asked.

"I feel ready," I answered.

We were leaving the swirl of our post-Brooklyn existence, which had been dominated by the vibrating arena of the Chelsea Hotel.

The merry-go-round was slowing down. As I packed even the most insignificant of things accumulated in the past few years, they were accompanied by a slide show of faces, some of which I would never see again.

There was the copy of *Hamlet* from Gerome Ragni, who imag- ined me playing the sad and arrogant Danish prince. Ragni, who co- wrote and starred in *Hair*, and I were not to cross paths again, but his belief in me bolstered my sense of self. Energetic and muscular with a wide grin and masses of curly hair, he could be so excited about some crazy prospect he would leap onto a chair and raise his arms as if he had to share his vision with the ceiling or, better yet, the universe.

My blue satin sack with gold stars that Janet Hamill had made to hold my tarot cards, and the cards themselves, which divined the for- tunes of Annie, Sandy Daley, Harry, and Peggy.

A rag doll with hair of Spanish lace given to me by Elsa Peretti. Matthew's harmonica holder. Notes from Rene Ricard scolding me to keep drawing. David's black leather Mexican belt studded with rhinestones. John McKendry's boatneck shirt. Jackie Curtis's angora sweater.

As I folded the sweater, I could picture her under the filmy red light of Max's back room. The scene there was changing with the same speed as the Chelsea, and those who had attempted to imbue it with a *Photoplay* glamour would find the new guard was leaving them behind.

Many would not make it. Candy Darling died of cancer. Tinkerbelle and Andrea Whips took their lives. Others sacrificed themselves to drugs and misadventure. Taken down, the stardom they so desired just out of reach, tarnished stars falling from the sky.

I feel no sense of vindication as one of the handfuls of survivors. I would rather have seen them all succeed, catch the brass ring. As it turned out, it was I who got one of the best horses.

Separate Ways
Together

W E WENT OUR SEPARATE WAYS, BUT WITHIN WALKING distance of one another. The loft that Sam bought Robert was a raw space at 24 Bond. It was a cobblestone side street with garages, post–Civil War architecture, and small warehouses that was now coming to life, as these industrial streets will, when pioneer artists scrub, clear out, and scrape the years from wide windows and let in the light.

John Lennon and Yoko Ono had a place across the way; Brice Marden worked next door, his studio mystically clean with shimmering vats of pigment and small silent photographs he later distilled into panels of smoke and light. Robert's loft needed a lot of work. Steam erupted from the pipes as the plumbing was erratic. Much of the original brick was concealed with moldy drywall, which he removed. Robert cleaned and covered the brick with several layers of white paint and set it up, part studio, part installation, all his.

It seemed like Allen was always on the road with Blue Öyster Cult, leaving me on my own. Our apartment on East Tenth Street was

just a block away from St. Mark's Church. It was small and pretty, with French doors opening onto a view of a garden. And from our new digs, Robert and I resumed our lives as before, eating together, searching for assemblage components, taking photographs, and monitoring the progress of each other's work.

Although Robert now had his own space, he still seemed tense and worried about money. He didn't want to be entirely dependent on Sam and was more determined than ever to make it on his own. I was in limbo when I left Twenty-third Street. My sister Linda got me a part-time job at the Strand Book Store. I bought stacks of books, but I didn't read them. I taped sheets of paper to the wall, but I didn't draw. I slid my guitar under the bed. At night, alone, I just sat and waited. Once again I found myself contemplating what I should be doing to do something of worth. Everything I came up with seemed irreverent or irrelevant.

On New Year's Day, I lit a candle for Roberto Clemente, my brother's favorite ballplayer. He had perished while on a humanitarian mission to aid Nicaragua in the aftermath of a terrible earthquake. I chided myself for inactivity and self-indulgence, and resolved to rededicate myself to my work.

Later that evening I sat on the floor of St. Mark's for the annual marathon reading. It benefited the church and went on from early afternoon to well into the night, with everyone contributing to the perpetuation of the Poetry Project. I sat through much of it sizing up the poets. I wanted to be a poet but I knew I would never fit into their incestuous community. The last thing I wanted was to negotiate the social politics of another scene. I thought of my mother's saying, that what you do on New Year's Day will foretell what you'll be doing the rest of the year. I felt the spirit of my own Saint Gregory, and resolved that 1973 would be my year of poetry.

Providence is sometimes kind, for Andy Brown soon offered to

publish a book of my poems. The prospect of being published by Gotham Book Mart inspired me. Andy Brown had long tolerated me hanging around Diamond Row's historic bookstore, allowing me to place my broadsides and flyers on the counter. Now, with the prospect of being a Gotham author, I harbored a secret pride when I saw the shop's motto, *Wise men fish here*.

I dragged my Hermes 2000 from under the bed. (My Remington had bit the dust.) Sandy Pearlman pointed out that Hermes was the winged messenger, the patron of shepherds and thieves, so I was hoping the gods would channel me some lingo. I had a lot of time to kill. It was the first time I hadn't had a steady job in almost seven years. Allen paid our rent and I made pocket money at the Strand. Sam and Robert took me to eat every afternoon, and in the evening I made couscous in my pretty little kitchen, so I wanted for nothing.

Robert had been preparing for his first solo show of Polaroids. The invitation arrived in a cream Tiffany envelope: a self-portrait, his naked midsection in the mirror, his Land 360 above his crotch. There was no mistaking the raised veins above his wrist. He had applied a large white paper dot to the front to conceal his cock and hand-stamped his name on the lower right corner. Robert believed the show began with the invitation and each one was meant to be a seductive gift.

The opening at the Light Gallery fell on January 6, Joan of Arc's birthday. Robert gave me a silver medal with her likeness crowned with the French fleur-de-lis. There was a good crowd, a perfect New York City mix of leather boys, drag queens, socialites, rock and roll kids, and art collectors. It was an optimistic gathering, with perhaps an undercurrent of envy. His bold, elegant show mixed classic motifs with sex, flowers, and portraits, all equivalent in their presentation: unapologetic images of cock rings beside an arrangement of flowers. To him one was the other.

★

Marvin Gaye's *Trouble Man* played over and over while I tried to write about Arthur Rimbaud. I taped a picture of him with his defiant Dylan face above the writing desk that I seldom used. Instead, I sprawled on the floor writing nothing but fragments, poems, and the beginning of a play, an imagined dialogue between the poet Paul Verlaine and myself, sparring for Arthur's unattainable love.

One afternoon I fell asleep on the floor amid my piles of books and papers, reentering the familiar terrain of a recurring apocalyptic dream. Tanks were draped in spangled cloth and hung with camel bells. Muslim and Christian angels were at one another's throats, their feathers littering the surface of the shifting dunes. I plowed through revolution and despair and found, rooted in the treachery of the withered trees, a rolled leather case. And in that deteriorating case, in his own hand, the great lost work of Arthur Rimbaud.

One could imagine him strolling the banana gardens, ruminating in the language of science. In the hellhole of Harar, he manned the coffee fields and scaled the high Abyssinian plateau on horseback. In the deep night he lay beneath a moon perfectly ringed, like a majestic eye that saw him and presided over his sleep.

I awoke with a sudden revelation. I would go to Ethiopia and find this valise that seemed more like a sign than a dream. I would return with the contents preserved in Abyssinian dust, and give them to the world. I presented my dream to publishers, to travel magazines and literary foundations. But I found the imagined secret papers of Rimbaud were not a fashionable cause in 1973. Far from letting it go, I felt the idea had grown to the extent that I truly believed I was destined to find them. When I dreamed of a frankincense tree on a hill throwing no shadow, I believed the valise to be buried there.

I decided to ask Sam to sponsor my trip to Ethiopia. He was adventurous and sympathetic and was intrigued by my proposition. Robert was appalled at the idea. He succeeded in convincing Sam that I would get lost, kidnapped, or be eaten alive by wild hyenas. We sat in a café on Christopher Street and, as our laughter mingled with the steam of many espressos, I bade farewell to the coffee fields of Harar, resigned that the treasure's resting place would not be disturbed in this century.

I really wanted to leave the Strand. I hated being stuck in the basement unpacking overstock. Tony Ingrassia, who had directed me in *Island*, asked me to be in a one-act play called *Identity*. I read the script and I just didn't get it. It was a dialogue between me and another girl. After a few lackluster rehearsals he asked me to show more tenderness toward the girl. "You're too stiff, too distant," he said, exasperated. I was openly affectionate with my sister Linda and applied that in my interpretation of tender. "These girls are lovers. You have to get that across." He threw his arms up. I was taken aback. There was nothing in the script that intimated this. "Just pretend she's one of your girlfriends." Tony and I had a heated exchange that ended with him incredulous with laughter. "You don't shoot up and you're not a lesbian. What do you actually do?"

I did my best to feel up the other girl, but I decided this would be my last play. I didn't have the stuff to be an actor.

Robert had Sam bail me out of the Strand, hiring me to catalog his vast collection of books and kachina dolls that he was donating to a university. Without realizing it, I had said goodbye to traditional employment. I never punched a clock again. I made my own time and my own money.

After failing as a believable lesbian in *Identity*, I decided that if I took the stage again, it would be as myself. I joined forces with Jane Friedman, who found me an occasional job reading poetry in bars.

Jane had a successful publicity firm and enjoyed a reputation for supporting the efforts of fringe artists. Although I was not enthusiastically received, it sharpened my abilities to spar with a hostile audience with some amount of humor. She arranged for me to have a series of slots opening for bands like the New York Dolls at the Mercer Arts Center, located in the decaying Broadway Central Hotel, a once-opulent nineteenth-century edifice where Diamond Jim Brady and Lillian Russell dined, where Jubilee Jim Fisk was shot on the marble staircase. If there were few remnants of its former grandeur, it now housed a culturally rich community, including theater, poetry, and rock and roll.

Performing poetry night after night to an unreceptive and unruly crowd who were primed to see the New York Dolls proved a challenging education. I had no musicians or crew, but the soul of my sibling army, Linda, acted as roadie, foil, and guardian angel. She had an unaffected simplicity, yet could be fearless. It was she who took on the unenviable task of passing the hat when our troupe had sung and performed on the streets of Paris. At the Mercer, Linda manned my bag of tricks, which included a small tape recorder, a megaphone, and a toy piano. I read my poems, fielded insults, and sometimes sang songs accompanied by bits of music on my cassette player.

At the end of each performance, Jane would take a five-dollar bill out of her back pocket, saying that was our cut of the take. It took me a while to understand that I had gotten no pay at all, and that Jane was paying me, literally, out of her own pocket. It was a tough and spirited run, and by summer I was starting to hit my stride, with people calling out for poems and genuinely seeming to be in my corner. I took to ending each performance with "Piss Factory," a prose poem I had improvised, framing my escape from a nonunion assembly line to the freedom of New York City. It seemed to bring the audience and me together.

On Friday, the thirteenth of July, I gave a reading in memory of Jim Morrison on the roof of underground filmmaker Jack Smith's loft at Greene Street and Canal. It was my own bill, and anyone who was there had come to celebrate Jim Morrison with me. Among them was Lenny Kaye, and although we would not perform together that night, it would soon come to pass that I would not perform without him.

The strong attendance for a self-produced poetry reading fired up Jane. She felt that, together with Lenny, we could find a way to bring my poetry to a wider audience. We even spoke of adding a real piano, which Linda jokingly said would put her out of business. In this she was not wrong. Jane was undaunted. She came from old Broadway stock; her father, Sam Friedman, was a legendary press agent, working with Gypsy Rose Lee, Lotte Lenya, and Josephine Baker, among others. He had seen all the openings and closings Broadway had to offer. Jane had his vision and stubborn determination; she would find another way for us to break on through.

I went back to the typewriter.

"Patti, no!" Robert gasped. "You're smoking pot." I looked up sheepishly. Busted.

I had seen *The Harder They Come*, and was stirred by the music. When I began listening to the soundtrack, following its trail to Big Youth and the Roys, U and I, it led me back to Ethiopia. I found irresistible the Rastafarian connection to Solomon and Sheba, and the Abyssinia of Rimbaud, and somewhere along the line I decided to try their sacred herb.

That was my secret pleasure until Robert caught me sitting alone, trying to stuff some pot in an empty Kool cigarette wrapper. I had no idea how to roll a joint. I was a little embarrassed, but he sat down on

the floor, picked the seeds out of my small stash of Mexican pot, and rolled me a couple of skinny joints. He just grinned at me and we had a smoke, our first together.

With Robert, I was not transported into the Abyssinian plain, but into the valley of uncontrollable laughter. I told him that pot was supposed to be for writing poetry, not fooling around. But all we did was laugh. "Come on," he said. "Let's go to the B&H." It was my first entrance into the outside world stoned on pot. It took an extralong time for me to lace my boots, find my gloves, my cap. Robert stood grinning, watching me moving in circles. I now saw why it took so much time for Harry and Robert to get ready to go to Horn and Hardart.

After that, as fun as it was, I kept my pot smoking to myself, listening to *Screaming Target*, writing impossible prose. I never thought of pot as a social drug. I liked to use it to work, to think, and eventually for improvising with Lenny Kaye and Richard Sohl as the three of us would gather under a frankincense tree dreaming of Haile Selassie.

Sam Wagstaff lived on the fifth floor of a classic imposing white structure on the corner of Bowery and Bond. As I climbed the stairs, I always knew that there would be something new and wonderful for me to look at, to touch, to catalog: glass negatives, salt prints of forgotten poets, gravures of the tepees of Hopi Indians. Sam, with Robert's urging, had begun collecting photographs, first slowly, with an amused curiosity, and then obsessively, like a lepidopterist in a tropical forest. Sam bought what he wanted and sometimes it seemed he wanted everything.

The first photograph Sam bought was an exquisite daguerreotype

in a red velvet case with a soft gold clasp. It was in impeccable condition, and Robert's own daguerreotypes, found in secondhand stores buried among piles of old family photographs, paled in comparison. This at times bothered Robert, who was the first to begin collecting photographs. "I can't compete with him," he said somewhat ruefully. "I've created a monster."

The three of us would scour Book Row, the dusty secondhand bookstores that once lined Fourth Avenue. Robert would go through boxes of old postcards, stereo cards, and tintypes carefully to find a gem. Sam, impatient, and not impeded by cost, would simply buy the whole box. I would stand aside listening to them argue. It sounded very familiar.

Scouting bookstores was one of my specialties. In rare instances, I would root out a desirable Victorian cabinet card, or an important portfolio of turn-of-the-century cathedrals, and on one lucky excursion, an overlooked Cameron. It was on the cusp of collecting photography, the last period where one could find a bargain. It was still possible to come upon gravure prints of large-format field photographs by Edward Curtis. Sam was taken with the beauty and the historical value of these photographs of the North American Indian, and acquired several volumes. Later, as we sat on the floor looking at them, in his large empty apartment flooded with natural light, we were impressed not only by the images but by the process. Sam would feel the edge of the photograph between his thumb and forefingers. "There's something about the paper," he would say.

Consumed by his new passion, Sam haunted auction houses, often traveling across the sea to acquire a specific photograph. Robert accompanied him on these expeditions, and was sometimes able to influence Sam's choice of images. In this way, Robert could person-

ally examine the photographs of artists he admired, from Nadar to Irving Penn.

Robert urged Sam just as he had John McKendry to use his position to elevate photography's place in the art world. In turn, both men encouraged Robert to commit to photography as his primary form of expression. Sam, at first curious, if not skeptical, had now fully embraced the concept and was spending a small fortune building what would become one of the most important photography collections in America.

Robert's uncomplicated Polaroid Land 360 did not require a light meter and the settings were rudimentary: darker, lighter. Small icons indicated distance: close, near, far. His early use of the unfettered Polaroid was perfect for his impatient nature. He had moved seamlessly into the larger-format Hasselblad, which was stolen from Twenty-third Street. At Bond Street, Robert bought a Graphic camera fitted with a Polaroid back. The 4x5 format suited him. Polaroid was now producing positive/negative film, making it possible to produce first-generation prints. With Sam's backing, he finally had the resources to realize his vision for each photograph and was able to commission a carpenter, Robert Fosdick, to construct elaborate frame designs. In this way he went much further than simply incorporating his photographs into collages. Fosdick understood Robert's sensibilities and meticulously translated Robert's sketches into sculptural frames, a synthesis of geometric designs, planes, and images for the presentation of his photographs.

The frames greatly resembled the drawings that Robert had done in the sketchbook he had given me in 1968. As in the past, he saw the completed thing almost immediately. This was the first time he was able to fully realize these visions. This was largely due to Sam, who had come into even more money with the death of his beloved

mother. Robert sold some work, but he still wanted nothing more than to make it on his own.

Robert and I took a lot of photographs at Bond Street. I liked the atmosphere there and I thought we took really good pictures. They were easily taken against the backdrop of the whitewashed brick walls and were bathed in beautiful New York light. One of the reasons we took such good pictures there is that I was out of my element. There were none of my things to clutter the picture, for me to identify with, or hide behind. Even as Robert and I parted as a couple, our photographs became more intimate, for they spoke of nothing but our common trust.

Sometimes I would sit and watch him photograph himself in his striped robe, and then slowly removing it, and then naked, suffused with light.

When we shot the cover for *Witt*, my new book of poems, I had it in my mind that the cover would have a saintly look, like a holy card. Although Robert did not like direction, he was sure he could satisfy us both. I went to Robert's loft and washed in his shower so I would be freshly clean. I combed my hair away from my face and wrapped an old Tibetan robe made of tea-colored linen around me. Robert took a handful of pictures and said he had the photograph he needed for the cover, but he was so pleased with the pictures that he kept shooting.

On September 17 Andy Brown hosted a party to celebrate the release of my book, as well as the first exhibition of my drawings. Robert had gone through my drawings, selecting the ones to be shown. Sam paid to frame them, and Jane Friedman's friend Dennis Florio framed them in his gallery. Everyone pitched in to help make it a good show. I felt that I had found my niche, my drawings and poems appreciated. It meant a great deal to see my work hung in the very bookshop that in 1967 hadn't a slot open to hire me.

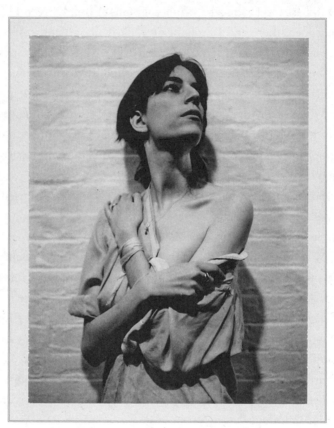

Witt, *Bond Street, 1973*

*Witt* was very different from *Seventh Heaven*. Where the poems in *Seventh Heaven* were lighter, rhythmic, and oral, *Witt* made use of the prose poem, reflecting the influence of French Symbolists. Andy was impressed with my growth, and he promised me that if I wrote a monograph on Rimbaud he would publish it.

A new scheme burrowed in my veins, which I presented to Robert and Sam. Since my Ethiopia excursion had been scrapped, I thought I could at least make a pilgrimage to Charleville, France, where Rimbaud was born and buried. Unable to resist my enthusiasm, Sam met me halfway and agreed to help finance the trip. Robert had no objection since there were no hyenas in France. I decided to go in October, the month of Rimbaud's birth. Robert took me shopping for a proper hat, and we chose one of soft brown felt with a grosgrain ribbon. Sam sent me to an optometrist where I was fitted for National Health–style spectacles, in honor of John Lennon. Sam gave me enough money for two pairs, considering my penchant for leaving things behind, but instead I chose an impractical pair of Italian sunglasses that only Ava Gardner could pull off. They were white cat's-eyes, nestled in a gray tweed case stamped *Milan*.

On the Bowery I found an unconstructed raincoat of kelly green rubberized silk, a Dior blouse of gray houndstooth linen, brown trousers, and an oatmeal cardigan: an entire wardrobe for thirty dollars, just needing a bit of washing and mending. In my plaid suitcase I placed my Baudelaire cravat, my notebook; Robert added a postcard of a statue of Joan of Arc. Sam gave me a silver Coptic cross from Ethiopia, and Judy Linn loaded up her small half-frame camera and showed me how to use it. Janet Hamill, who had returned from her own journey to Africa, where she passed through the region of my dreams, had brought me back a handful of blue glass beads—scarred trade beads from Harar—the same beads that

Rimbaud had traded—as a cherished souvenir. I slipped them in my pocket as a good-luck talisman.

Thus armed, I was ready for my journey.

★

My impractical raincoat barely protected me from the chilly autumn drizzle in Paris. I retraced some steps my sister and I had made in the summer of 1969, though without her bright presence, the quai Victor Hugo, La Coupole, and the enchanted streets and cafés seemed very lonely. I walked, as we had walked, up and down the boulevard Raspail. I located our street where we resided at 9 rue Campagne-Première. I stood there in the rain for some time. I had been drawn to this street in 1969 as so many artists had lived here. Verlaine and Rimbaud. Duchamp and Man Ray. It was here, on this street, where Yves Klein contemplated his famous blue and where Jean-Luc Godard shot precious bits of *Breathless*. I walked another block to the Montparnasse cemetery and paid my respects to Brancusi and Baudelaire.

Guided by Enid Starkie, Rimbaud's biographer, I found the Hôtel des Etrangers on the rue Racine. Here, according to her text, Arthur slept in the room of the composer Cabaner. He also was found sleeping in the lobby, in an oversized overcoat and crushed felt hat, shaking off the residue of a hashish dream. The desk clerk treated me with gentle humor. I explained, in my terrible French, the nature of my mission and why I yearned to stay the night in this particular hotel. He was sympathetic, but all the rooms were occupied. I sat on the musty couch in the lobby, unable to bear the rain again. Then, as the angels winked, he motioned me to follow him. He led me upstairs to a door, which opened upon a small winding staircase. He searched through his keys and, after a few false starts,

triumphantly opened an attic room. It was empty save for a wooden chest with carved maple leaves and a horsehair mattress. Rays of filthy light filtered through the slanted skylight.

—*Ici?*

—*Oui.*

He gave me the room for a small price and for a few francs extra added a candle and some sheets. I draped the sheets on the lumpy mattress that seemed to contain the impression of a long, rugged body. I quickly set up camp. Night was falling and I arranged my things around the candle—the picture of Joan of Arc, a copy of *Paris Spleen*, my pen and a bottle of ink. But I could not write. I could only lie upon the horsehair and stretch into its ancient impression of sleep. The candle was a pool in a dish. I slipped into unconsciousness. I did not even dream.

At dawn the gentleman brought me a cup of hot chocolate and a brioche. I partook of it gratefully. I packed my few belongings, dressed, and headed to Gare de l'Est. I sat on a leather seat across from a governess and a small boy who slept. I had no idea what I'd find or where I'd stay, but I trusted in fate. Arriving at Charleville at twilight, I searched for a hotel. I was a bit uneasy walking alone with my little suitcase without a soul around but I somehow found one. Two women were folding linens. They seemed surprised, suspicious of my presence, and spoke no English. After some awkward moments, I was led upstairs into a pretty room. Everything, even the canopy of the four-poster bed, was covered in flowered chintz. I was very hungry, and was given some hearty soup with country bread.

But once again, in the silence of my room, I found I could not write. I fell asleep early and awoke early. Filled with new resolve, I threw on my raincoat and hit the Charleville streets. To my dismay, the Musée Rimbaud was closed, so I walked in an atmosphere of silence down unknown streets and found my way to the cemetery. Behind a

*Musée Rimbaud, Charleville, 1973*

garden of huge cabbages lay the resting place of Rimbaud. I stood there for a long time looking at the gravestone, with the words *Priez pour lui*—Pray for him—etched over his name. His grave had been neglected, and I brushed away the fallen leaves and bits of debris. I said a small prayer as I buried the blue glass beads from Harar in a stone urn before his headstone. I felt, since he had been unable to return to Harar, that I should bring a bit of Harar to him. I took a photograph and said goodbye.

I went back to the museum and sat on the steps. Here Rimbaud had stood, in contempt for all he saw, the stone mill, the river rushing beneath a limestone bridge, that I now revered just as he despised it. The museum was still closed. I was feeling a bit woebegone when an old man, a caretaker perhaps, took pity on me and unlocked the heavy door. While he performed his duties, he allowed me to spend time with the humble belongings of my Rimbaud: his geography book, his valise, his tin drinking cup, spoon, and kilim. I saw the places he had mended within the folds of his scarf of striped silk. There was a small scrap of paper with his drawing of the litter that he would lie upon as the bearers walked across the rocky terrain to the shore where a ship would take him dying to Marseille.

That night, I had a simple meal of stew, wine, and bread. I went back to my room, but I could not bear to stay there alone. I washed and changed clothes, slipped on my raincoat, and ventured into the Charleville night. It was quite dark and I walked the wide and empty quai Rimbaud. I felt a little afraid, and then, in the distance, I saw a tiny light, a neon sign—Rimbaud Bar. I stopped and took a breath, unable to believe my good fortune. I advanced slowly, afraid it might disappear like a mirage in the desert. It was a white stucco bar with one small window. There was no one around. I entered tentatively. It was dimly lit and mainly inhabited by boys, angry-faced fellows, leaning against

the jukebox. A few faded pictures of Arthur were tacked on the walls. I ordered a Pernod and water, as it seemed the closest to absinthe. The jukebox played a crazy mix of Charles Aznavour, country tunes, and Cat Stevens.

After a time, I left, and returned to the warmth of my hotel room and its provincial flowers. *Tiny flowers spattering the walls, just as the sky had been spattered with budding stars.* This was the solitary entry in my notebook. I had imagined that I would write the words that would shatter nerves, honoring Rimbaud and proving everyone's faith in me, but I didn't.

The following morning I paid my bill and left my bag in the lobby. It was Sunday morning and the bells were tolling. I wore my white shirt and black Baudelaire ribbon. My shirt was a bit rumpled, but so was I. I returned to the museum, which was thankfully open, and bought my ticket. I sat on the floor and made a small pencil drawing— *St. Rimbaud, Charleville, Octobre 1973.*

I wanted a souvenir, and found a little flea market on the place Ducale. There was a simple ring of gold wire, but I could not afford it. John McKendry had given me a similar ring when he returned from a trip to Paris. I remembered him lying on his elegant daybed while I sat at his feet and he read me passages from *A Season in Hell.* I imagined Robert here by my side. He would have gotten me the ring and slipped it on my finger.

The train ride to Paris was uneventful. I realized at one point I was crying. Once in Paris, I boarded the Métro to the station Père-Lachaise, for I had one more thing to do before returning to New York. It was raining again. I stopped at a florist just outside the cemetery walls and bought a small bundle of hyacinths and proceeded to search for Jim Morrison's grave. At that time there was no marker, and it was not easy to find, but I followed messages scrawled by well-wishers on neighboring headstones. It was completely silent, save the

rustling of autumn leaves and the rain, which was becoming more pronounced. On the unmarked grave were gifts from pilgrims before me: plastic flowers, cigarette butts, half-empty whiskey bottles, broken rosaries, and strange charms. The graffiti surrounding him were words in French from his own songs: *C'est la fin, mon merveilleux ami.* This is the end, beautiful friend.

I felt an uncommon lightheartedness, not sad at all. I felt that he might silently step from the mist and tap me on my shoulder. It seemed right for him to be buried in Paris. The rain began in earnest. I wanted to leave because I was so wet, but I felt rooted. I had the uneasy feeling that if I did not flee I would turn into stone, a statue armed with hyacinths.

In the distance I saw an old woman dressed in a heavy coat, holding a long pointed stick and dragging a large leather bag behind her. She was cleaning the gravesites. When she saw me, she began to shout at me in French. I begged her forgiveness for not speaking the lan-

guage, yet I knew what she must be thinking. She looked at the grave, and at me, in disgust. All the pitiful treasures and the surrounding graffiti were to her nothing but desecration. She shook her head, muttering. I was amazed at her disregard for the torrential rain. Suddenly she turned and gruffly cried in English: "American! Why do you not honor your poets?"

I was very tired. I was twenty-six years old. All around me the messages written in chalk were dissolving like tears in the rain. Streams formed beneath the charms, cigarettes, guitar picks. Petals of flowers left on the plot of earth above Jim Morrison floated like bits of Ophelia's bouquet.

"*Ehh!*" she cried again. "Answer me, *Américaine!* Why do you young people not honor your poets?"

"*Je ne sais pas, madame,*" I answered, bowing my head.

"I do not know."

<div align="center">⤙⟶</div>

On the anniversary of the death of Rimbaud, I gave the first of my "Rock and Rimbaud" performances, reuniting me with Lenny Kaye. It was held on the roof of Le Jardin, in the Hotel Diplomat off Times Square. The evening began with the Kurt Weill classic "Speak Low," saluting Ava Gardner's depiction of the goddess of love in *One Touch of Venus*, accompanied by the pianist Bill Elliott. The balance of the program consisted of poems and songs revolving around my love of Rimbaud. Lenny and I reprised the pieces we had done at St. Mark's, and added the Hank Ballard song "Annie Had a Baby." We looked out at the crowd and were amazed to see people ranging from Steve Paul to Susan Sontag. For the first time it occurred to me that, instead of this being a onetime event, we had the potential of something to build on.

We weren't quite certain where we could take this, since the Broadway Central had collapsed. What we were doing was so undefined and there seemed to be no suitable venues. But the people were there, and I believed we had something to give them, and I wanted Lenny to be a permanent part of the equation.

Jane did her best to find us places to play, which was no easy task. Occasionally I read poetry at a bar, but would spend most of my allotted time sparring with drunken patrons. These experiences did much to sharpen my Johnny Carson repartee but little to advance the communication of poetry. Lenny joined me the first time I played at the West End Bar, where Jack Kerouac and his buddies had once written and drunk, but not necessarily in that order. We made no money, but at the end of the night Jane rewarded us with a great piece of news. We had been asked to open for Phil Ochs at Max's Kansas City in the last days of the year. Lenny Kaye and I would spend both of our December birthdays and New Year's Eve merging poetry and rock and roll.

It was our first extended job, a six-day stint, two sets a night and three on the weekends. Through broken strings and a sometimes hostile crowd, we prevailed with the support of a colorful cast of friends: Allen Ginsberg, Robert and Sam, Todd Rundgren and Bebe Buell, Danny Fields and Steve Paul. By New Year's Eve, we were ready for anything.

Several minutes after midnight, Lenny and I were performing on the stage of Max's. The people were raucous, divided, the electricity in the air tangible. It was the first hour of the New Year and as I looked out into the crowd, I remembered again what my mother always said. I turned to Lenny. "So as today, the rest of the year."

I took the microphone. He struck the chord.

Soon after, I moved with Allen to MacDougal Street, across from the Kettle of Fish in the heart of the Village. Allen went off again on tour and we saw little of each other, but I loved living there and

immersed myself in a new course of study. I was drawn to the Middle East: the mosques, the prayer rugs, and the Koran of Muhammad. I read Nerval's *Women of Cairo*, and the stories of Bowles, Mrabet, Albert Cossery, and Isabelle Eberhardt. Since hashish permeated the atmosphere of these stories I had it in my mind to partake of it. Under its influence I listened to *The Pipes of Pan at Joujouka*; Brian Jones produced the album in 1968. I was happy to write to the music he loved. From the baying dogs to the ecstatic horns, it was for a time the sound track of my nights.

★

Sam loved Robert's work, loved it like no other.

I stood with him looking at an image of white tulips that Robert had shot against a black background.

"What's the blackest thing you've ever seen?" asked Sam.

"An eclipse?" I said, as if in answer to a riddle.

"No." He pointed at the photograph. "It's this. A black you can get lost in."

Later Robert was inscribing the photograph to Sam. "He's the only one who really gets it," he said.

Robert and Sam were as close to blood as two men could be. The father sought the heir, the son the father. Sam, as the quintessential patron, had the resources, the vision, and the desire to magnify the artist. Robert was the artist he sought.

The undying affection between Robert and Sam has been prodded, misshapen, and spat out in a twisted version, perhaps interesting in a novel, but one cannot judge their relationship without an understanding of their consensual code.

Robert liked Sam's money, and Sam liked that Robert liked his

money. Were that all that motivated them, they could have easily found it elsewhere. Instead, each possessed something the other wanted and, in that way, complemented the other. Sam secretly yearned to be an artist, but he was not. Robert wanted to be rich and powerful, but he was not. By association, each tasted the other's attributes. They were a package, so to speak. They needed each other. The patron to be magnified by the creation. The artist to create.

I saw them as two men who had a bond that could not be severed. The affirmation that came from each strengthened them. Both had stoic natures, but together they could reveal their vulnerabilities without shame, and trust each other with that knowledge. With Sam, Robert could be himself, and Sam did not judge him. Sam never tried to have Robert tone his work down, or dress differently, or pander to institutions. Shedding all else, what I felt between them was mutual tenderness.

Robert was not a voyeur. He always said that he had to be authentically involved with the work that came out of his S&M pursuits, that he wasn't taking pictures for the sake of sensationalism, or making it his mission to help the S&M scene become more socially acceptable. He didn't think it should be accepted, and he never felt that his underground world was for everybody.

There is no question that he enjoyed, even needed, its attractions. "It's intoxicating," he would say. "The power that you can have. There's a truck line of guys that all want you, and no matter how repulsive they are, feeling that collective desire for oneself is powerful."

Robert's subsequent excursions into the world of S&M were sometimes bewildering and frightening to me. He couldn't share things with me, because it was so outside our realm. Perhaps he would

have if I'd wanted him to, but I really didn't want to know. It wasn't so much denial as it was squeamishness. His pursuits were too hard-core for me and he often did work that shocked me: the invitation with the whip shoved up his ass, a series of photographs of cords binding genitals. He was no longer using magazine images, just models and himself to produce visuals of self-inflicted pain. I admired him for it, but I could not comprehend the brutality. It was hard for me to match it with the boy I had met.

And yet when I look at Robert's work, his subjects are not saying, Sorry, I have my cock hanging out. He's not sorry and doesn't want anybody else to be. He wanted his subjects to be pleased with his photographs, whether it was an S&M guy shoving nails in his dick or a glamorous socialite. He wanted all his subjects to feel confident about their exchange.

He didn't think the work was for everybody. When he first exhibited his most hard-core photographs, they were in a portfolio marked X, in a glass case, for people over eighteen. He didn't feel that it was important to shove those pictures in people's faces, except mine, if he was teasing me.

When I asked him what drove him to take such pictures, he said that someone had to do it, and it might as well be him. He had a privileged position for seeing acts of extreme consensual sex and his subjects trusted him. His mission was not to reveal, but to document an aspect of sexuality as art, as it had never been done before. What excited Robert the most as an artist was to produce something that no one else had done.

It didn't change the way he was with me. But I worried about him, as at times he seemed to be driving himself into a darker, more dangerous place. At its best, our friendship was a refuge from everything, where he could hide or coil like an exhausted baby snake.

*Long Island Rail Road, 1974*

"You should sing more songs," Robert would say when I sang him Piaf or one of the old songs we both liked. Lenny and I had a few songs and were developing a repertoire, but we felt confined. We envisioned using the poems to segue into a rhythmic pattern we could both riff on. Although we had yet to find the right person, we thought a piano would suit our style, being both percussive and melodic.

Jane Friedman gave us one of the small rooms on the floor she rented above the Victoria Theatre on Forty-fifth Street and Broadway. There was an old upright piano, and on St. Joseph's Day, we invited a few keyboard players to see if we could find the third man. All the players were talented but didn't fit in with our idiosyncratic ways. The best, as Scripture says, was saved for last. Richard Sohl, sent by Danny Fields, walked in the room wearing a striped boatneck shirt, rumpled linen trousers, his face half concealed behind a mane of golden curls. His beauty and laconic manner did not betray the fact that he was a gifted pianist. As he readied himself at the piano, Lenny and I looked at each other, thinking the same thing. His presence brought to mind the character of Tadzio in *Death in Venice*.

"Whaddya want?" he asked casually, and proceeded to play a medley that went from Mendelssohn to Marvin Gaye to "MacArthur Park." Richard Sohl was nineteen, classically trained, yet he possessed the simplicity of a truly confident musician who did not need to show off his knowledge. He was as happy playing a repetitive three-chord sequence as a Beethoven sonata. With Richard we were able to move seamlessly between improvisation and song. He was intuitive and inventive, able to give us a field upon which Lenny and I had the freedom to explore in a language of our own. We dubbed it "three chords merged with the power of the word."

On the first day of spring we rehearsed with Richard for our premiere as a trio. Reno Sweeney's had a lively, pseudo-elegant air that did not mesh with our unruly and impious performances, but it was

a place to play: we were undefined and could not be defined by others. But each time we played, we found people came to see us, and their growing numbers encouraged us to keep going. Although we exasperated the manager, he was good enough to give us five nights running with Holly Woodlawn and Peter Allen.

By the end of the week, which was Palm Sunday, we two had become three, and Richard Sohl had become DNV. *Death in Venice*, our golden-haired boy.

The stars were lining up to enter the Ziegfeld Theatre for the glittering premiere of the film *Ladies & Gentlemen, the Rolling Stones*. I was excited to be there. I remember it was Easter and I was wearing a black velvet Victorian dress with a white lace collar. Afterward, Lenny and I headed downtown, our coach a pumpkin, our finery tattered. We pulled in front of a little bar on the Bowery called CBGB. We had promised the poet Richard Hell that we would come to see the band in which he played bass, Television. We had no idea what to expect, but I wondered how another poet would approach performing rock and roll.

I had often come to this area of the Bowery to visit William Burroughs, who lived a few blocks south of the club, in a place called the Bunker. It was the street of winos and they would often have fires going in large cylindrical trash cans to keep warm, to cook, or light their cigarettes. You could look down the Bowery and see these fires glowing right to William's door, just as we did on that chilly but beautiful Easter night.

CBGB was a deep and narrow room with a bar along the right side, lit by overhanging neon signs advertising various brands of beer. The stage was low, on the left-hand side, flanked by photographic murals of turn-of-the-century bathing belles. Past the stage was a pool table,

and in back was a greasy kitchen and a room where the owner, Hilly Krystal, worked and slept with his saluki, Jonathan.

The band had a ragged edge, the music erratic, angular and emotional. I liked everything about them, their spasmodic movements, the drummer's jazz flourishes, their disjointed, orgasmic musical structures. I felt a kinship with the alien guitarist on the right. He was tall, with straw-colored hair, and his long graceful fingers wrapped around the neck of his guitar as if to strangle it. Tom Verlaine had definitely read *A Season in Hell*.

In between sets Tom and I did not talk of poetry but of the woods of New Jersey, the deserted beaches of Delaware, and flying saucers hovering in the western skies. It turned out that we were raised twenty minutes from one another, listened to the same records, watched the same cartoons, and both loved the *Arabian Nights*. The break over, Television returned to the stage. Richard Lloyd picked up his guitar and fingered the opening phrase of "Marquee Moon."

It was a world away from the Ziegfeld. The absence of glamour made it seem all the more familiar, a place that we could call our own. As the band played on, you could hear the whack of the pool cue hitting the balls, the saluki barking, bottles clinking, the sounds of a scene emerging. Though no one knew it, the stars were aligning, the angels were calling.

The Patty Hearst kidnapping dominated the news that spring. She had been abducted from her Berkeley apartment and held hostage by an urban guerrilla group tagged the Symbionese Liberation Army. I found myself drawn to this story partially due to my mother's fixation on the Lindbergh kidnapping and consequent fear of her children being snatched. The images of the grief-stricken aviator and the bloodstained pajamas of his golden-haired son haunted my mother throughout her life.

On April 15, Patty Hearst was caught on a security camera wielding a gun, joining her captors in robbing a San Francisco bank. Subsequently a tape was released, in which she declared allegiance to the SLA and issued this statement: "Tell everybody that I feel free and strong and I send my greetings and love to all the sisters and brothers out there." Something in these words, magnified by our shared first name, drew me to respond to her complicated plight. Lenny, Richard, and I merged my meditation on her situation with Jimi Hendrix's version of "Hey Joe." The connection between Patty Hearst and "Hey Joe" lay within the lyrics, a fugitive crying out "I feel so free."

We had been thinking of doing a single, to see how the effect we were having live could be translated to a record. Lenny was knowledgeable in producing and pressing a single, and when Robert offered to put up the money, we booked time at Jimi Hendrix's studio, Electric Lady. In homage to Jimi, we decided to record "Hey Joe."

Wishing to add a guitar line that could represent the desperate desire to be free, we chose Tom Verlaine to join us. Divining how to appeal to Tom's sensibilities, I dressed in a manner that I thought a boy from Delaware would understand: black ballet flats, pink shantung capris, my kelly green silk raincoat, and a violet parasol, and entered Cinemabilia, where he worked part-time. The shop specialized in vintage film stills, scripts, and biographies representing everyone from Fatty Arbuckle to Hedy Lamarr to Jean Vigo. Whether or not my getup impressed Tom, I'll never know, but he enthusiastically agreed to record with us.

We recorded in studio B with a small eight-track setup in the back of Electric Lady. Before we started, I whispered "Hi, Jimi" into the microphone. After a false start or two, Richard, Lenny, and I, playing together, got our take, and Tom overdubbed two tracks of a solo guitar. Lenny mixed these two into one spiraling lead, and then added a bass drum. It was our first use of percussion.

Robert, our executive producer, came by and watched anxiously from the control room. He gave Lenny a silver skull ring to commemorate the occasion.

At the end of recording "Hey Joe," we had fifteen minutes left. I decided to attempt "Piss Factory." I still had the original typescripts of the poem that Robert had rescued from the floor of Twenty-third Street. It was at the time a personal anthem of extricating myself from the tedium of being a factory girl, escaping to New York City. Lenny improvised over Richard's sound track, and I riffed off the poem. We got our take at exactly midnight.

Robert and I stood in front of one of the space-alien murals that lined the hall of Electric Lady. He seemed more than satisfied, but could not resist pouting just a little. "Patti," he said, "you didn't make anything we could dance to."

I said I'd leave that to the Marvelettes.

Lenny and I designed the record. We called our label Mer. We pressed 1,500 copies at a small plant on Ridge Avenue in Philadelphia and distributed them to book and record stores, where they sold for two dollars apiece. Jane Friedman could be found at the entrance to our shows, selling them from a shopping bag. Of all the places, our greatest source of pride was to hear it on the Max's jukebox. We were surprised to discover that our B-side, "Piss Factory," was more popular than "Hey Joe," inspiring us to focus more on our own work.

Poetry would still be my guiding principle, but I had it in my mind to one day give Robert his wish.

Now that I had experienced hashish, Robert, always protective, felt it was all right for me to take a trip with him. It was my first time and while we waited for the drug to come on we sat on my fire escape, which overlooked MacDougal Street.

"Do you want to have sex?" he asked me. I was surprised and pleased he still desired to be with me. Before I answered, Robert took my hand and said, "I'm sorry."

That night we walked down Christopher Street to the river. It was two in the morning, there was a garbage strike, and you could see the rats scurrying in the lamplight. As we moved toward the water, we were met with a frenzy of queens, beards in tutus, leather saints and angels. I felt like the traveling preacher in *The Night of the Hunter*. Everything took on a sinister air, the smell of patchouli oil, poppers, and ammonia. I became progressively more agitated.

Robert seemed amused. "Patti, you're supposed to feel love for everybody." But I couldn't relax. Everything seemed so out of hand, silhouetted by orange and pink and acid green auras. It was a hot steamy night. No moon or stars, real or imagined.

He put his arm around my shoulders and walked me home. It was nearly dawn. It took me a while to comprehend the nature of that trip, the demon vision of the city. Random sex. Trails of glitter shaking from muscled arms. Catholic medals torn from shaved throats. The fabulous festival I could not embrace. I did not create that night, but the images of racing Cockettes and Wild Boys would soon be transmuted into the vision of a boy in a hallway, drinking a glass of tea.

William Burroughs was simultaneously old and young. Part sheriff, part gumshoe. All writer. He had a medicine chest he kept locked, but if you were in pain he would open it. He did not like to see his loved ones suffer. If you were infirm he would feed you. He'd appear at your door with a fish wrapped in newsprint and fry it up. He was inaccessible to a girl but I loved him anyway.

He camped in the Bunker with his typewriter, his shotgun, and his overcoat. From time to time he'd slip on his coat, saunter our way,

and take his place at the table we reserved for him in front of the stage. Robert, in his leather jacket, often sat with him. Johnny and the horse.

We were in the midst of a several-week stand at CBGB that had begun in February and stretched into spring. We shared the bill with Television, as we had at Max's the previous summer, doing two alternating sets from Thursday through Sunday. It was the first time we had played regularly as a band, and it helped us define the inner narrative that connected the varied streams of our work.

In November we had gone with Jane Friedman to Los Angeles for our first shows at the Whisky a Go Go, where the Doors had played, and then to San Francisco. We played upstairs at Rather Ripped Records in Berkeley, and at an audition night at the Fillmore West with Jonathan Richman on drums. It was my first time in San Francisco, and we made a pilgrimage to City Lights bookstore, where the window was filled with the books of our friends. It was during this first excursion outside of New York that we decided we needed another guitarist to expand our sound. We were hearing music in our heads that we couldn't realize in our trio configuration.

When we returned to New York, we put an ad in the *Village Voice* for a guitarist. Most of those who showed up already seemed to know what they wanted to do, or what they wanted to sound like, and almost to a man, none of them warmed up to the idea of a girl being the leader. I found my third man in an appealing Czechoslovakian. In his appearance and musical style, Ivan Kral upheld the tradition and promise of rock much as the Rolling Stones celebrated the blues. He had been an emerging pop star in Prague, but his dreams were shattered when his home country was invaded by Russia in 1968. Escaping with his family, he was obliged to start anew. He was energetic and open-minded, ready to magnify our swiftly developing concept of what rock and roll could be.

We imagined ourselves as the Sons of Liberty with a mission to preserve, protect, and project the revolutionary spirit of rock and roll. We feared that the music which had given us sustenance was in danger of spiritual starvation. We feared it losing its sense of purpose, we feared it falling into fattened hands, we feared it floundering in a mire of spectacle, finance, and vapid technical complexity. We would call forth in our minds the image of Paul Revere, riding through the American night, petitioning the people to wake up, to take up arms. We too would take up arms, the arms of our generation, the electric guitar and the microphone.

CBGB was the ideal place to sound a clarion call. It was a club on the street of the downtrodden that drew a strange breed who welcomed artists yet unsung. The only thing Hilly Krystal required from those who played there was to be new.

From the dead of winter through the renewal of spring, we grappled and prevailed until we found our stride. As we played, the songs took on a life of their own, often reflecting the energy of the people, the atmosphere, our growing confidence, and events that occurred in our immediate terrain.

There are many things I remember of this time. The smell of piss and beer. The entwining guitar lines of Richard Lloyd and Tom Verlaine as they elevated "Kingdom Come." Performing a version of "Land" that Lenny called "a blazing zone," with Johnny blazing a trail of his own, racing toward me from the acid night where the wild boys reigned, from the locker room to the sea of possibilities, as if channeled from the third and fourth minds of Robert and William sitting before us. The presence of Lou Reed, whose exploration of poetry and rock and roll had served us all. The thin line between the stage and the people and the faces of all those who supported us. Jane Friedman, beaming as she introduced us to Clive Davis, the president of Arista Records. She had rightly perceived a connection between him, his label,

and us. And at the end of every night, standing in front of the awning emblazoned with the letters CBGB & OMFUG and watching the boys load our humble equipment into the back of Lenny's '64 Impala.

At the time, Allen toured so heavily with Blue Öyster Cult that some questioned how I could stay loyal to one who was almost never home. The truth was I really cared for him, and believed our communication was strong enough to overcome his long absences. These extended periods on my own afforded me the time and freedom to pursue my artistic growth, but as time passed, it was revealed that the trust I believed we shared was repeatedly violated, endangering us both and compromising his health. This gentle, intelligent, and seemingly modest man had a lifestyle on the road that was inconsistent with what I believed was our quiet bond. Ultimately it destroyed our relationship, but not the respect I had for him, nor the gratitude I felt for the good he had done, as I stepped into uncharted territory.

★

WBAI was an important transmitter of the last vestiges of revolution on the radio. On May 28, 1975, my band supported them by doing a benefit in a church on the Upper East Side. We were perfectly suited for the uncensored possibilities of a live broadcast, not only ideologically but aesthetically. Not having to adhere to any formatting strictures, we were free to improvise, something rare on even the most progressive FM stations. We were well aware of the multitude we were reaching—our first time on the radio.

Our set ended with a version of "Gloria" that had taken shape over the past several months, merging my poem "Oath" with the great

Van Morrison classic. It had begun with Richard Hell's copper-toned Danelectro bass, which we bought from him for forty dollars. I had it in mind to play it, and since it was small, I thought I could handle it. Lenny showed me how to play an E, and as I struck the note, I spoke the line: "Jesus died for somebody's sins but not mine." I had written the line some years before as a declaration of existence, as a vow to take responsibility for my own actions. Christ was a man worthy to rebel against, for he was rebellion itself.

Lenny started strumming the classic rock chords, E to D to A, and the marriage of the chords with this poem excited me. Three chords merged with the power of the word. "Are those chords to a real song?"

"Only the most glorious," he answered, going into "Gloria," and Richard followed.

Over the weeks we spent at CBGB, it had become apparent to us all that we were evolving under own terms into a rock and roll band. On May Day, Clive Davis offered me a recording contract with Arista Records, and on the seventh I signed. We hadn't really put it in words, but during the course of the WBAI broadcast, we could feel a momentum gathering. By the improvised end of "Gloria," we had unfurled ourselves.

Lenny and I combined rhythm and language, Richard provided the bed, and Ivan had strengthened our sound. It was time for the next step. We needed to find another of our own kind, who would not alter but propel, who would be one of us. We ended our high-spirited set with a collective plea: "We need a drummer and we know you're out there."

He was more out there than we could imagine. Jay Dee Daugherty had done our sound at CBGB, using components from his home stereo system. He had originally come to New York from Santa Barbara with Lance Loud's Mumps. Hardworking, somewhat shy, he revered Keith Moon, and within two weeks of our WBAI broadcast he became part of our generation.

When I now entered our practice room, I could not help but feel, looking at our mounting equipment, our Fender amps, Richard's RMI keyboard, and now Jay Dee's silver Ludwig kit, the pride of being the leader of a rock and roll band.

Our first job with a drummer was at the Other End, around the corner from where I lived on MacDougal Street. I merely had to lace up my boots, throw on my jacket, and walk to work. The focus of this job was our melding with Jay Dee, but for others it was the moment to see how we would navigate the expectations surrounding us. Clive Davis's presence lent an air of excitement on the opening night of our four-day stint. When we threaded our way through the crowd to take the stage, the atmosphere intensified, charged as if before a storm.

The night, as the saying goes, was a jewel in our crown. We played as one, and the pulse and pitch of the band spiraled us into another dimension. Yet with all that swirling around me, I could feel another presence as surely as the rabbit senses the hound. He was there. I suddenly understood the nature of the electric air. Bob Dylan had entered the club. This knowledge had a strange effect on me. Instead of humbled, I felt a power, perhaps his; but I also felt my own worth and the worth of my band. It seemed for me a night of initiation, where I had to become fully myself in the presence of the one I had modeled myself after.

On September 2, 1975, I opened the doors of Electric Lady studio. As I descended the stairs, I could not help but recall the time Jimi Hendrix stopped for a moment to talk to a shy young girl. I walked into Studio A. John Cale, our producer, was at the helm, and Lenny, Richard, Ivan, and Jay Dee were inside the recording room, setting up their equipment.

For the next five weeks we recorded and mixed my first album,

*Horses*. Jimi Hendrix never came back to create his new musical language, but he left behind a studio that resonated all his hopes for the future of our cultural voice. These things were in my mind from the first moment I entered the vocal booth. The gratitude I had for rock and roll as it pulled me through a difficult adolescence. The joy I experienced when I danced. The moral power I gleaned in taking responsibility for one's actions.

These things were encoded in *Horses* as well as a salute to those who paved the way before us. In "Birdland," we embarked with young Peter Reich as he waited for his father, Wilhelm Reich, to descend from the sky and deliver him. In "Break It Up," Tom Verlaine and I wrote of a dream in which Jim Morrison, bound like Prometheus, suddenly broke free. In "Land," wild-boy imagery fused with the stages of Hendrix's death. In "Elegie," remembering them all, past, present, and future, those we had lost, were losing, and would ultimately lose.

There was never any question that Robert would take the portrait for the cover of *Horses*, my aural sword sheathed with Robert's image. I had no sense of how it would look, just that it should be true. The only thing I promised Robert was that I would wear a clean shirt with no stains on it.

I went to the Salvation Army on the Bowery and bought a stack of white shirts. Some were too big for me, but the one I really liked was neatly pressed with a monogram below the breast pocket. It reminded me of a Brassaï shot of Jean Genet wearing a white monogrammed shirt with rolled-up sleeves. There was an RV stitched on my shirt. I imagined it belonging to Roger Vadim, who had directed *Barbarella*. I cut the cuffs off the sleeves to wear under my black jacket adorned with the horse pin that Allen Lanier had given me.

Robert wanted to shoot it at Sam Wagstaff's, since his One Fifth Avenue penthouse was bathed in natural light. The corner window

cast a shadow creating a triangle of light, and Robert wanted to use it in the photograph.

I rolled out of bed and noticed it was late. I raced through my morning ritual, going around the corner to the Moroccan bakery, grabbing a crusty roll, a sprig of fresh mint, and some anchovies. I came back and boiled water, stuffing the pot with mint. I poured olive oil in the open roll, rinsed the anchovies, and laid them inside, sprinkling in some cayenne pepper. I poured a glass of tea and thought better of wearing my shirt, knowing that I'd get olive oil on the front of it.

Robert came to fetch me. He was worried because it was very overcast. I finished getting dressed: black pegged pants, white lisle socks, black Capezios. I added my favorite ribbon, and Robert brushed the crumbs off my black jacket.

We hit the street. He was hungry but he refused to eat my anchovy sandwiches, so we ended up having grits and eggs at the Pink Tea Cup. Somehow the day slipped away. It was cloudy and dark and Robert kept watching for the sun. Finally, in late afternoon, it started to clear. We crossed Washington Square just as the sky threatened to darken again. Robert became worried that we were going to miss the light, and we ran the rest of the way to One Fifth Avenue.

The light was already fading. He had no assistant. We never talked about what we would do, or what it would look like. He would shoot it. I would be shot.

I had my look in mind. He had his light in mind. That is all.

Sam's apartment was spartan, all white and nearly empty, with a tall avocado tree by the window overlooking Fifth Avenue. There was a massive prism that refracted the light, breaking it into rainbows cascading on the wall across from a white radiator. Robert placed me by the triangle. His hands trembled slightly as he readied to shoot. I stood.

The clouds kept moving back and forth. Something happened with his light meter and he became slightly agitated. He took a few

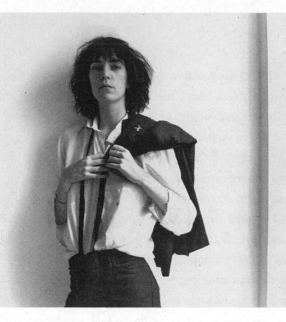

shots. He abandoned the light meter. A cloud went by and the triangle disappeared. He said, "You know, I really like the whiteness of the shirt. Can you take the jacket off?"

I flung my jacket over my shoulder, Frank Sinatra style. I was full of references. He was full of light and shadow.

"It's back," he said.

He took a few more shots.

"I got it."

"How do you know?"

"I just know."

He took twelve pictures that day.

Within a few days he showed me the contact sheet. "This one has the magic," he said.

When I look at it now, I never see me. I see us.

‑‑<‑►‑

Robert Miller championed the likes of Joan Mitchell, Lee Krasner, and Alice Neel, and after seeing my drawings on the second floor of Gotham Bookmart, he invited me to show my work in his gallery. Andy Brown had been supportive of my work for years and was delighted for me to have this opportunity.

When I visited the expansive and sophisticated gallery on Fifty-seventh and Fifth Avenue, I wasn't certain I merited such a space. I also felt I couldn't have a show at a gallery of this scope without Robert. I asked if we could show together.

In 1978 Robert was immersed in photography. His elaborate framing mirrored his relationship with geometric forms. He had produced classical portraits, uniquely sexual flowers, and had pushed pornography into the realm of art. His present task was mastering light and achieving the densest blacks.

Robert was connected with Holly Solomon's gallery at the time, and asked permission to show with me. I knew nothing of the politics of the art world; I only knew that we should show together. We chose to present a body of work that emphasized our relationship: artist and muse, a role that for both of us was interchangeable.

Robert wanted us to create something unique for the Robert Miller Gallery. He began by choosing his best portraits of me, printing them larger than life, and blew up the picture of us at Coney Island on a six-foot length of canvas. I drew a suite of portraits of him, and decided to do a series of drawings based on his erotic photographs. We chose a young man urinating in another's mouth, bloodied testicles, and a subject crouching in a black rubber suit. The photographs were printed relatively small and I surrounded some images with poetry and complemented others with pencil drawings.

We thought about doing a short film, but our resources were limited. We pooled our money, and Robert recruited a film student, Lisa Rinzler, to shoot.

We didn't have a storyboard. We just took for granted that each of us would do our part. When Robert asked me to come over to shoot the film on Bond Street, he said he had a surprise for me. I laid a cloth on the floor, placing the fragile white dress Robert had given me, my white ballet shoes, Indian ankle bells, silk ribbons, and the family Bible, and tied it all in a bundle. I felt ready for our task and walked to his loft.

I was elated to see what Robert had prepared for me. It was like coming home to Brooklyn when he would transform a room into a living installation. He had created a mythic environment, draping the walls with white netting with nothing before it but a statue of Mephistopheles.

I set my bundle down and Robert suggested that we take MDA. I was not really sure what MDA was but wholly trusted Robert so I agreed. As we entered the film, I wasn't really conscious of whether it had an effect or not. I was too focused on my role in the project. I put on the white dress and the ankle bells, leaving the bundle open on the floor. These things were on my mind: the Revelations. Communication. Angels. William Blake. Lucifer. Birth. As I talked, Lisa rolled film and Robert took stills. He wordlessly guided me. I was an oar in the water and his the steady hand.

At one point, I decided to pull down the netting, in effect destroying what he created. I reached up and gripped the edge of the net and froze, physically paralyzed, unable to move, unable to speak. Robert rushed toward me and put his hand on my wrist, holding it there until he felt me relax. He knew me so well that without saying a word he communicated that everything was all right.

Robert with Lily, *1978*

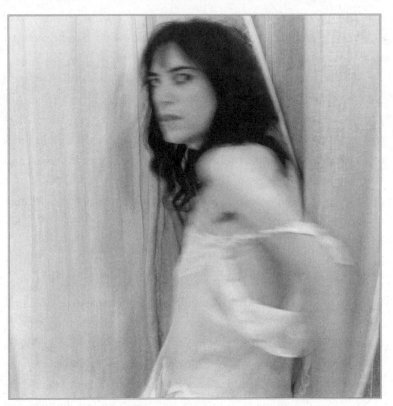

*Patti*, Still Moving, *1978*

The moment passed. I wrapped the net around me, and looked at him, and he shot that moment in motion. I took off the fragile dress and the bells from my ankles. I put on my dungarees, field marshal boots, my old black sweatshirt—my work clothes—and gathered everything else in the cloth, and threw the bundle over my shoulder.

In the narration of the film, I had explored ideas that Robert and I often discussed. The artist seeks contact with his intuitive sense of the gods, but in order to create his work, he cannot stay in this seductive and incorporeal realm. He must return to the material world in order to do his work. It's the artist's responsibility to balance mystical communication and the labor of creation.

I left Mephistopheles, the angels, and the remnants of our hand-made world, saying, "I choose Earth."

I went on the road with my band. Robert called me daily. "Are you working on the show? Are you doing any drawings?" He called me from hotel to hotel. "Patti, what are you doing? Are you drawing?" He worried so much that when I had three days off in Chicago, I went to an art supply store and bought several sheets of Arches sateen, my paper of choice, and covered the walls of my hotel room. I tacked the photograph of a young man urinating in the mouth of another, and did several drawings based on it. I've always worked in spurts. When I brought them back to New York, Robert, at first irritated at my pro-crastination, was very pleased with them. "Patti," he said, "what took you so long?"

Robert showed me the work he had been concentrating on for the show while I was gone. He had printed a series of stills from the film. I had been so engrossed in my part that I had not realized he had taken so many pictures. They were among the best photographs

we had done together. He decided to call the film *Still Moving*, as he incorporated the stills in the final edit of the film, and we built a sound track with my commentary mixed with me playing electric guitar and excerpts from "Gloria." In doing so, he represented the many facets of our work—photography, poetry, improvisation, and performance.

*Still Moving* reflected his view of the future of visual expression and music, a type of music video that could stand on its own as art. Robert Miller was supportive of the film, giving us a small room to loop it continuously. He suggested we do a poster and we each chose an image of the other to reinforce our belief in ourselves as artist and muse.

We dressed for the opening at Sam Wagstaff's. Robert wore a white shirt with the sleeves rolled up, a leather vest, jeans, and pointed-toe shoes. I wore a silk windbreaker and pegged pants. Miraculously, Robert liked my outfit. People from all the worlds that we had been part of since the Chelsea Hotel were there. Rene Ricard, the poet and art critic, reviewed the show and wrote a beautiful piece calling our work "The Diary of a Friendship." I owed no small debt to Rene, who had often chided and urged me on when I would decide to quit drawing. When I stood with Robert and Rene looking at the work hung in gilded frames, I was grateful that both of them had not let me give up.

It was our first and last show together. My work with my band and crew in the seventies would take me far from Robert and our universe. And as I toured the world I had time to reflect that Robert and I had never traveled together. We never saw beyond New York save in books and never sat in an airplane holding each other's hand to ascend into a new sky and descend onto a new earth.

Yet Robert and I had explored the frontier of our work and created space for each other. When I walked on the stages of the

world without him I would close my eyes and picture him taking off his leather jacket, entering with me the infinite land of a thousand dances.

★

One late afternoon, we were walking down Eighth Street when we heard "Because the Night" blasting from one storefront after another. It was my collaboration with Bruce Springsteen, the single from the album *Easter*. Robert was our first listener after we had recorded the song. I had a reason for that. It was what he always wanted for me. In the summer of 1978, it rose to number 13 on the Top 40 chart, fulfilling Robert's dream that I would one day have a hit record.

Robert was smiling and walking in rhythm with the song. He took out a cigarette and lit it. We had been through a lot since he first rescued me from the science-fiction writer and shared an egg cream on a stoop near Tompkins Square.

Robert was unabashedly proud of my success. What he wanted for himself, he wanted for us both. He exhaled a perfect stream of smoke, and spoke in a tone he only used with me—a bemused scolding—admiration without envy, our brother-sister language.

"Patti," he drawled, "you got famous before me."

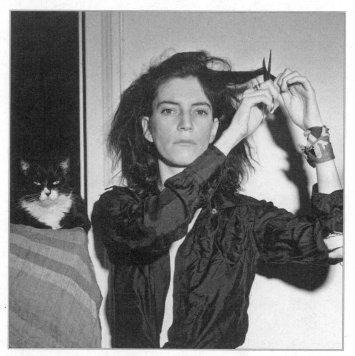

*1 Fifth Avenue, 1978*

Holding Hands
with God

❰❮❯❱

*In the spring of 1979, I left New York City to begin a new life with Fred Sonic Smith. For a time we lived in a small room in the Book Cadillac, a historic albeit empty hotel in downtown Detroit. We had no possessions save his guitars and my most precious books and clarinet. Thus I was living as I did with my first love, with the man I had chosen for my last. Of the man who was to become my husband, I wish only to say that he was a king among men and men knew him.*

*Leave-taking was difficult, but it was time for me to embark on my own. "What about us?" Robert said suddenly. "My mother still thinks we're married."*

*I really hadn't thought about it. "I guess you will have to tell her we got a divorce."*

*"I can't say that," he said, eyeing me steadily. "Catholics don't divorce."*

*In Detroit, I sat on the floor to write a poem for Robert's Y portfolio. He had given me a handful of flowers, a bouquet of photographs that I tacked to the wall. I wrote him of the process of creation, the divining rod and the forgotten vowel. I resumed the life of a citizen. It took me far from the world I had known, yet Robert was ever in my consciousness; the blue star in the constellation of my personal cosmology.*

ROBERT WAS DIAGNOSED WITH AIDS AT THE SAME time I found I was carrying my second child. It was 1986, late September, and the trees were heavy with pears. I felt ill with flulike symptoms, but my intuitive Armenian doctor told me that I wasn't sick but in the early stages of pregnancy. "What you have dreamed for has come true," he told me. Later, I sat amazed in my kitchen and thought that it was an auspicious time to call Robert.

Fred and I had begun work on the album that would become *Dream of Life*, and he suggested that I ask Robert to photograph me for the cover. I hadn't seen or spoken with him for some time. I sat to ready myself, contemplating the call I was about to make, when the phone rang. I was so focused on Robert that for an instant I felt it could be him. But it was my friend and legal counselor Ina Meibach. She told me she had some bad news and I sensed immediately that it was about Robert. He had been hospitalized with AIDS-related pneumonia. I was stunned. I drew my hand instinctively to my belly and began to cry.

Every fear I had once harbored seemed to materialize with the suddenness of a bright sail bursting into flames. My youthful premonition of Robert crumbling into dust returned with pitiless clarity. I saw his impatience to achieve recognition in another light, as if he had the predisposed lifeline of a young pharaoh.

I manically busied myself with small tasks, thinking of what to say, when, instead of calling him at home to speak of working together again, I had to phone him at a hospital. To pull myself together, I decided to first call Sam Wagstaff. Though I hadn't talked to Sam in some years, it was as if no time had passed, and he was happy to hear from me. I asked after Robert. "He's very sick, poor baby," Sam said, "but he's not as bad off as me." This was another shock, especially because Sam, though older than us, was always the more virile one, immune to physical insult. In his typical Sam way, he said he found the disease that was mercilessly attacking him on all fronts "most annoying."

Though I was heartbroken that Sam too was suffering, just hearing his voice gave me the courage to make the second call. When Robert answered the phone he sounded weak, but his voice strengthened as he heard the sound of mine. Even though so much time had passed, we were as we had always been, breathlessly finishing one another's sentences. "I'm going to beat this thing," he told me. I believed him with all my heart.

"I will see you soon," I promised.

"You made my day, Patti," he said as he hung up the phone. I can hear him saying that. I can hear it now.

★

As soon as Robert was well enough to leave the hospital, we made plans to meet. Fred packed up his guitars and we drove with our son, Jackson, from Detroit to New York City. We checked into the

Mayflower Hotel and Robert came to greet us. He was wearing his long leather coat, and he looked extremely handsome though a bit flushed. He pulled my long braids, calling me Pocahontas. The energy between us was so intense that it seemed to atomize the room, manifesting an incandescence that was our own.

Robert and I went to see Sam, who was in the AIDS ward at St. Vincent's Hospital. Sam of the hyperalert mind, glowing skin, and hard body lay there more or less helpless, slipping in and out of consciousness. He was suffering with carcinoma and his body was covered with sores. Robert reached to hold his hand and Sam drew it away. "Don't be silly," Robert admonished him, and gently took it in his. I sang Sam the lullaby that Fred and I had written for our son.

I walked with Robert to his new loft. He was no longer on Bond Street but lived in a spacious studio in an Art Deco building on Twenty-third Street, only two blocks from the Chelsea. He was optimistic and certain that he would survive, satisfied with his work, his success, and his possessions. "I did all right, didn't I?" he said with pride. I panned the room with my eyes: an ivory Christ, a white marble figure of the sleeping Cupid; Stickley armchairs and cabinet; a collection of rare Gustavsberg vases. His desk, for me, was the crown of his possessions. Designed by Gio Ponti, it was crafted of blond burl walnut with a cantilevered writing surface. Compartments lined in zebra wood were outfitted like an altar with small talismans and fountain pens.

Above the desk was a gold-and-silver triptych with the photograph he had taken of me in 1973 for the cover of *Witt*. He had chosen the one with the purest expression, reversing the negative and creating a mirror image, with a violet panel in the center. Violet had been our color, the color of the Persian necklace.

"Yes, "I said. "You did well."

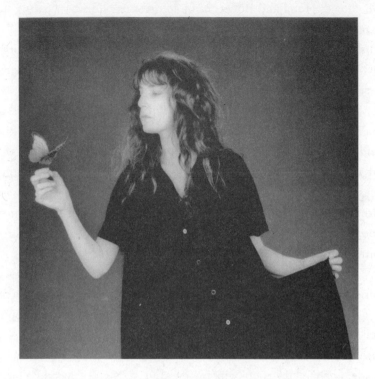

In the weeks to come, Robert photographed me several times. In one of our last sessions I wore my favorite black dress. He handed me a blue morpho butterfly mounted on a glass-headed dressmaker's pin. He took a color Polaroid. Everything read black and white offset by the iridescent blue butterfly, a symbol of immortality.

As he always had been, Robert was excited to show me his new work. Large platinum prints on canvas, color dye transfers of spiking lilies. The image of Thomas and Dovanna, a nude black man in a dance-embrace with a woman in a white gown flanked by panels of white moiré satin. We stood before a work that had just arrived, in the frame he had designed: Thomas in an Olympic bend within a black circle, above a leopard skin panel. "It's genius, isn't it?" he said.

The tone of his voice, the familiarity of the words of that particular exchange, took my breath away. "Yes, it's genius."

As I resumed the pattern of my daily life in Michigan, I found myself yearning for Robert's presence; I missed us. The phone, which I normally shunned, became our lifeline and we spoke often, though at times the calls were dominated by Robert's mounting cough. On my birthday he expressed concern for Sam.

On New Year's Day, I called Sam. He had just received a blood transfusion and seemed remarkably self-assured. He said he felt transformed into a man who was going to make it. Ever the collector, he wished to return to Japan, where he and Robert had traveled, as there was a tea set in a cerulean lacquer box that he greatly coveted. He asked me to sing the lullaby to him again and I obliged.

Just as we were about to say goodbye, Sam gave me the gift of one more of his infamous stories. Knowing my affection for the great sculptor, he said, "Peggy Guggenheim once told me that when you made love with Brancusi, you absolutely were not allowed to touch his beard."

"I'll remember that," I replied, "when I bump into him in heaven."

On the fourteenth of January, I received a distraught call from Robert. Sam, his sturdy love and patron, had died. They had weathered painful shifts in their relationship, and also the critical tongues and envy of others, but they could not stem the tide of the terrible fortune that befell them. Robert was devastated by the loss of Sam, the bulwark of his life.

Sam's death also cast a shadow on Robert's hopes for his own recovery. To comfort him I wrote the lyrics and Fred the music to "Paths That Cross," a sort of Sufi song in memory of Sam. Though Robert was grateful for the song, I knew one day I might seek out these same words for myself. *Paths that cross will cross again.*

We returned to New York on Valentine's Day. Robert was occasionally feverish and experiencing recurring stomach disorders, yet he was extremely active.

I spent much of the following days recording with Fred at the Hit Factory. We were on a tight schedule as my pregnancy was becoming more pronounced, and it was getting difficult to sing. I was due at the studio when Robert called in great distress to tell me that Andy Warhol was dead.

"He wasn't supposed to die," he cried out, somewhat desperately, petulantly, like a spoiled child. But I could hear other thoughts racing between us.

Neither are you.

Neither am I.

We didn't say anything. We hung up reluctantly.

It was snowing as I passed a churchyard closed with an iron gate. I noticed I was praying to the beat of my feet. I hurried on. It was a beautiful evening. The snow, which had been falling lightly, now fell with great force. I wrapped my coat about me. I was in my fifth month and the baby moved inside me.

It was warm and glowing in the studio. Richard Sohl, my beloved pianist, left his post to make me coffee. The musicians assembled. It was our last night in New York until the baby came. Fred spoke a few words concerning Warhol's passing. We recorded "Up There Down There." In the center of the performance I held the image of a trumpeter swan, the swan of my childhood.

I slipped outside into the night. The snow had ceased falling and it seemed like the whole of the city, in remembrance of Andy, had been covered in an undisturbed layer of snow—white and fleeting as Warhol's hair.

★

We were all reunited in Los Angeles. Robert, who was visiting his youngest brother, Edward, decided to shoot the cover there, while Fred and I worked to complete the album with our co-producer, Jimmy Iovine.

Robert was pale and his hands shook as he set up to take the portrait before a cluster of drying palms in the full sun. When he dropped his light meter, Edward knelt to pick it up. Robert was not feeling well, but somehow he marshaled his energies and took the picture. Within that moment was trust, compassion, and our mutual sense of irony. He was carrying death within him and I was carrying life. We were both aware of that, I know.

It was a simple photograph. My hair is braided like Frida Kahlo's. The sun is in my eyes. And I am looking at Robert and he is alive.

Later that evening, Robert attended the recording of the lullaby Fred and I had written for our son, Jackson. It was the song I had sung to Sam Wagstaff. There was a nod to Robert in the second verse: *Little blue star that offers light*. He sat on a couch in the control room. I would always remember the date. It was the nineteenth of March, the birthday of my mother.

Richard Sohl was at the piano. I was facing him. We were recording it live. The baby moved within me. Richard asked Fred if he had any special orders. "Make them cry, Richard," was all he said. We had one false start, then put everything we had into the second take. As I finished, Richard repeated the final chords. I looked through the glass window into the control room. Robert had fallen asleep on the couch and Fred was standing alone, weeping.

*Last Polaroid, 1988*

-<←→>-

On June 27, 1987, our daughter, Jesse Paris Smith, was born in Detroit. A double rainbow appeared in the sky and I felt optimistic. On All Souls' Day, ready to finish our postponed album, we once again packed up the car and with our two children drove to New York. On the long drive, I thought of seeing Robert and pictured him holding my daughter.

Robert was celebrating his forty-first birthday in his loft with champagne, caviar, and white orchids. That morning I sat at the desk in the Mayflower Hotel and wrote him the song "Wild Leaves," but I did not give it to him. Though I was trying to write him an immortal lyric, it seemed all too mortal.

Some days later, Robert photographed me wearing Fred's flight jacket for the cover of our projected single, "People Have the Power." When Fred looked at the photograph, he said, "I don't know how he does it, but all his photographs of you look like him."

Robert was eager to take our family portrait. On the afternoon we arrived, he was well dressed and gracious, though he often left the room, overtaken by a wave of nausea. I watched helplessly as he, always stoic, minimized his suffering.

He only took a handful of photographs, but then again, that's all he ever needed. Animated portraits of Jackson, Fred, and me together, the four of us, and then, right before we left, he stopped us. "Wait a minute. Let me take one of you and Jesse."

I held Jesse in my arms, and she reached out to him, smiling. "Patti," he said, pressing the shutter. "She's perfect."

It was our last photograph.

★

On the surface, Robert seemed to have everything he had wished for. One afternoon we sat in his loft, surrounded by the proofs of his burgeoning success. The perfect studio, exquisite possessions, and the resources to realize anything he envisioned. He was now a man; yet in his presence I still felt like a girl. He gave me a length of Indian linen, a notebook, and a papier-mâché crow. The small things he had gathered during our long separation. We tried to fill in the spaces: "I played Tim Hardin songs for my lovers and told them of you. I took photographs for a translation of *Season in Hell* for you." I told him he had always been with me, part of who I am, just as he is at this moment.

Ever the protector, he promised, as he once did in our own portion of Twenty-third Street, that if need be we could share a real home. "If anything happens to Fred, please don't worry. I'm getting a town house, a brownstone like Warhol had. You can come live with me. I'll help you raise the kids."

"Nothing will happen to Fred," I assured him. He just looked away.

"We never had any children," he said ruefully.

"Our work was our children."

I no longer remember the exact chronology of those last months. I stopped keeping a diary, perhaps losing heart. Fred and I drove back and forth from Detroit to New York, for our work and for Robert. He was rallying. He was working. He was in the hospital again. And eventually his loft became his sick bay.

Parting was always wrenching. I felt haunted by the idea that if I

stayed with him he would live. Yet I also struggled with a mounting sense of resignation. I was ashamed of that, for Robert had fought as if he could be cured by his will alone. He had tried everything from science to voodoo, everything but prayer. That, at least, I could give him in abundance. I prayed ceaselessly for him, a desperate human prayer. Not for his life, no one could take that cup from him, but for the strength to endure the unendurable.

In mid-February, driven by a sense of urgency, we flew to New York. I went to see Robert by myself. It seemed so quiet. I realized it was the absence of his terrible cough. I lingered by his empty wheelchair. Lynn Davis's image of an iceberg, rising like a torso turned by nature, dominated the wall. He had a white cat, a white snake, and there was a brochure of white stereo systems lying on the white table he had designed. I noticed he had added a white square in the blackness surrounding his image of a sleeping Cupid.

There was no one present save his nurse and she left us to ourselves. I stood by his bed and took his hand. We stayed like that for a long time, not saying anything. Suddenly he looked up and said, "Patti, did art get us?"

I looked away, not really wanting to think about it. "I don't know, Robert. I don't know."

Perhaps it did, but no one could regret that. Only a fool would regret being had by art; or a saint. Robert beckoned me to help him stand, and he faltered. "Patti," he said, "I'm dying. It's so painful."

He looked at me, his look of love and reproach. My love for him could not save him. His love for life could not save him. It was the first time that I truly knew he was going to die. He was suffering physical torment no man should endure. He looked at me with such deep apology that it was unbearable and I burst into tears. He

admonished me for that, but he put his arms around me. I tried to brighten, but it was too late. I had nothing more to give him but love. I helped him to the couch. Mercifully, he did not cough, and he fell asleep with his head on my shoulder.

The light poured through the windows upon his photographs and the poem of us sitting together a last time. Robert dying: creating silence. Myself, destined to live, listening closely to a silence that would take a lifetime to express.

*Dear Robert,*

*Often as I lie awake I wonder if you are also lying awake. Are you in pain or feeling alone? You drew me from the darkest period of my young life, sharing with me the sacred mystery of what it is to be an artist. I learned to see through you and never compose a line or draw a curve that does not come from the knowledge I derived in our precious time together. Your work, coming from a fluid source, can be traced to the naked song of your youth. You spoke then of holding hands with God. Remember, through everything, you have always held that hand, grip it hard, Robert, and don't let go.*

*The other afternoon, when you fell asleep on my shoulder, I drifted off, too. But before I did, it occurred to me looking around at all of your things and your work and going through years of work in my mind, that of all your work, you are still your most beautiful. The most beautiful work of all.*

*Patti*

-◄-►-

H E WOULD BE A SMOTHERING CLOAK, A VELVET PETAL. It was not the thought but the shape of the thought that tormented him. It suspended above him, then mutely dropped, causing his heart to pound so hard, so irregularly, that his skin vibrated and he felt as if he were beneath a lurid mask, sensual yet suffocating.

I thought I would be with him when he died, but I was not. I followed the stages of his passage until close to eleven, when I heard him for the last time, breathing with such force that it obscured the voice of his brother on the phone. For some reason, this sound filled me with a strange happiness as I climbed the stairs to go to sleep. He is still alive, I was thinking. He is still alive.

★

Robert died on March 9, 1989. When his brother called me in the morning, I was calm, for I knew it was coming, almost to the hour. I sat and listened to the aria from *Tosca* with an open book on my knees. Suddenly I realized I was shuddering. I was overwhelmed by a sense of excitement, acceleration, as if, because of the closeness I experienced with Robert, I was to be privy to his new adventure, the miracle of his death.

This wild sensation stayed with me for some days. I was certain it couldn't be detected. But perhaps my grief was more apparent than I knew, for my husband packed us all up and we drove south. We found a motel by the sea and camped there for the Easter holiday. Up and down the deserted beach I walked in my black wind coat. I felt within its asymmetrical roomy folds like a princess or a monk. I know Robert would have appreciated this picture: a white sky, a gray sea, and this singular black coat.

Finally, by the sea, where God is everywhere, I gradually calmed. I stood looking at the sky. The clouds were the colors of a Raphael. A wounded rose. I had the sensation he had painted it himself. You will see him. You will know him. You will know his hand. These words came to me and I knew I would one day see a sky drawn by Robert's hand.

Words came and then a melody. I carried my moccasins and waded the water's edge. I had transfigured the twisted aspects of my grief and spread them out as a shining cloth, a memorial song for Robert.

It was a wistful little song that conjured the color of his eyes. I sang the words over and over to myself so I wouldn't forget them. Within weeks I would sing it at his memorial service in the Whitney Museum of Art, where we had dreamed one day of showing our work and where I watched him pensively smoke a cigarette from its trapezoidal window.

Flocks of gulls gathered above me. The blue hour was fast approaching.

In the distance I heard a call, the voices of my children. They ran toward me. In this stretch of timelessness, I stopped. I suddenly saw him, his green eyes, his dark locks. I heard his voice above the gulls, the childish laughter, and the roar of the waves.

*Smile for me, Patti, as I am smiling for you.*

★

After Robert died, I agonized over his belongings, some of which had once been ours. I dreamed of his slippers. He wore them at the end of his life, black Belgian slippers with his initials stitched in burnished gold. I agonized over his desk and chair. They would be auctioned off with his other valuables at Christie's. I lay awake thinking of

them, so obsessed I became ill. I could have bid on them but I couldn't bear to; his desk and chair passed to strange hands. I kept thinking of something Robert would say when he was obsessed with something he couldn't have. "I'm a selfish bastard. If I can't have it I don't want anyone else to."

Why can't I write something that would awake the dead? That pursuit is what burns most deeply. I got over the loss of his desk and chair, but never the desire to produce a string of words more precious than the emeralds of Cortés. Yet I have a lock of his hair, a handful of his ashes, a box of his letters, a goatskin tambourine. And in the folds of faded violet tissue a necklace, two violet plaques etched in Arabic, strung with black and silver threads, given to me by the boy who loved Michelangelo.

→→ *fin* ←←

*We said farewell and I left his room. But something drew me back. He had fallen into a light sleep. I stood there and looked at him. So peaceful, like an ancient child. He opened his eyes and smiled. "Back so soon?" And then again to sleep.*

*So my last image was as the first. A sleeping youth cloaked in light, who opened his eyes with a smile of recognition for someone who had never been a stranger.*

# A note to the reader

O N MARCH 8, 1989, ROBERT AND I HAD OUR LAST CON-
versation. The last, that is, in the human form. He knew he
was dying and yet there was still a note of hope, a singular and obdu-
rate thread, woven in the timber of his voice. I asked him what he
wanted me to do for him and he said take care of my flowers. He asked
me to write an introduction to his flower book. They are color flowers
and I know you prefer the black and white ones so perhaps you won't
like them. I will like them I said and I will do it. I told him that I would
continue our work, our collaboration, for as long as I lived. Will you
write our story? Do you want me to? You have to he said no one but
you can write it. I will do it, I promised, though I knew it would be a
vow difficult to keep. I love you Patti. I love you Robert. And he was
wheeled away for tests and I never heard him speak again. Save for his
breath, which seemed to fill his hospital room as he lay dying.

I wrote the poem for his memorial card as I had done for Sam
Wagstaff. On the twenty-second of May, Fred and I attended the ser-
vice at the Whitney Museum. Fred wore a suit of indigo gabardine

with a burgundy tie. I wore my Easter dress of black silk velvet with a white lace collar. There were two grand vases with white lilies flanking the podium. His flowers hung on the walls. As I sang his memorial song I held the image of him from two decades before, smoking a cigarette outside the museum, waiting for me to emerge. Robert's entire family was present. His father, Harry, greeted me with warmth and compassion. His mother, Joan, was in a wheelchair fitted with a small oxygen tank. When I knelt to kiss her goodbye she pressed my hand. You're a writer, she whispered with some effort. Write me a line. I imagined she meant a letter, but Joan passed away three days later and was buried at Our Lady of the Snows.

I wrote the piece for *Flowers* and honored Joan's request. I wrote *The Coral Sea* and made drawings in remembrance of him but our story was obliged to wait until I could find the right voice. There are many stories I could yet write about Robert, about us. But this is the story I have told. It is the one he wished me to tell and I have kept my promise. We were as Hansel and Gretel and we ventured out into the black forest of the world. There were temptations and witches and demons we never dreamed of and there was splendor we only partially imagined. No one could speak for these two young people nor tell with any truth of their days and nights together. Only Robert and I could tell it. Our story, as he called it. And, having gone, he left the task to me to tell it to you.

*May 22, 2010*

# MEMORIAL SONG

*Little emerald bird*
*Wants to fly away*
*If I cup my hand*
*Could I make him stay*

*Little emerald soul*
*Little emerald eye*
*Little emerald soul*
*Must you say good-bye*

*All the things*
*That we pursue*
*All that we dream*
*Are composed*
*As nature knew*
*In a feather green*

*Little emerald bird*
*As you light afar*
*It is true I heard*
*God is where you are*
*Little emerald soul*
*Little emerald eye*
*Little emerald bird*
*We must say good-bye*

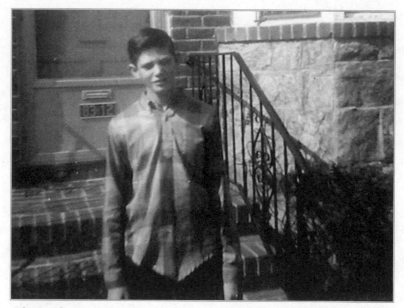

*Robert, age fourteen, 1961*

*A flower that grew from years of flowers.*
*Shot by one who caused a modern shudder.*
*And was favored by his mother.*

*A wall of flowers concealing all the tears of a relatively*
*young man with nothing but glory in his grasp.*
*And what he would be grasping is the hand of God*
*drawing him into another garden.*

*—from* Flowers, *1989*

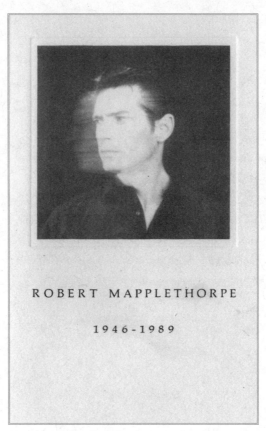

ROBERT MAPPLETHORPE

1946-1989

*Memorial card, May 22, 1989*

## MEMORIAL POEM

*As there is strength
in blackness
a deep control
a calla flare
trumpets
grace corporeal
there is a steady hand
adjusting child lace
and bravery's face
in veil inviolate
there is a steady hand
adept in heavens skin
spending into black
where pure hearts
are kin.*

*The Hotel Chelsea*

*Nathan's, Coney Island*

*Target / Letter, Paris. 7.7.69*

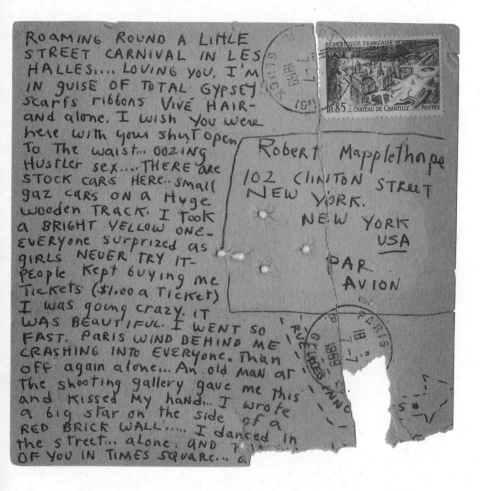

ROAMING ROUND A LITTLE
STREET CARNIVAL IN LES
HALLES..... LOVING YOU. I'M
IN GUISE OF TOTAL GYPSEY.
Scarfs ribbons VIVÉ HAIR-
and alone. I wish You were
here with your shirt open
To The waist... OOZING
Hustler sex.... THERE are
STOCK CARS HERE.. small
gaz cars ON a Hyge
Wooden TRACK. I Took
a BRIGHT YELLOW ONE-
EVERYone surprized as
girls NEVER TRY IT-
People Kept buying me
Tickets ($1.00 a Ticket)
I was going crazy. IT
WAS BEAUTIFUL. I WENT SO
FAST. PARIS WIND BEHIND ME
CRASHING INTO EVERYone. Than
off again alone... An old Man at
The shooting gallery gave me this
and kissed My hand... I wrote
a big star on the side of a
RED BRICK WALL..... I danced in
the street... alone. and 7 [...]
OF YOU IN TIMES SQUARE... a

Robert Mapplethorpe
102 CLINTON STREET
NEW YORK.
NEW YORK
USA

PAR
AVION

RÉPUBLIQUE FRANÇAISE
10.85 CHÂTEAU DE CHANTILLY POSTES

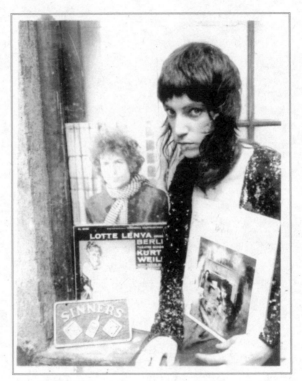

*Early Polaroid, 1970*

*Robert's last camera, 1988*

## WILD LEAVES

*Wild leaves are falling*
*Falling to the ground*
*Every leaf a moment*
*A light upon the crown*
*That we'll all be wearing*
*In a time unbound*
*And wild leaves are falling*
*Falling to the ground*

*Every word that's spoken*
*Every word decreed*
*Every spell that's broken*
*Every golden deed*
*All the parts we're playing*
*Binding as the reed*
*And wild leaves are falling*
*Wild wild leaves*

*The spirits that are mentioned*
*The myths that have been shorn*
*Everything we've been through*
*And the colors worn*
*Every chasm entered*
*Every story wound*
*And wild leaves are falling*
*Falling to the ground*

*As the campfire's burning*
*As the fire ignites*
*All the moments turning*
*In the stormy bright*
*Well enough the churning*
*Well enough believe*
*The coming and the going*
*Wild wild leaves*

*View from the window of the Hotel Chelsea, room 206*

In all the world one may always hope to recapture something lost. But sometimes we are obliged to set the memory of certain things in a dresser of small regrets. Yet occasionally we discover in the folds of an old handkerchief a shell or insignificant stone that had once embodied our happiest of afternoons. We experience a moment of respite when all sense of bad luck vanishes. As when the corrected proofs of *Finnegans Wake*, left on a backseat within a maze of taxicabs, were magically returned to the hands of an astonished and grateful James Joyce.

In mid-July, as I was assembling these pages, I received a message from my friend the photographer Lynn Goldsmith. She had met a young girl of fifteen named Delilah, who read my book and had given it to her mother to read. Her mother told her that years ago, after the birth of her first child, she took a trip with him on the Concord. Robert was sitting next to her and had a loving connection with the infant. This did not surprise me, as Robert was always tender and caring with children.

When Robert passed away, remembering his kindness, Delilah's mother obtained his desk at auction. Lynn assured me that if it was the desk that I had written of, that it was in good hands. When I opened the attachment I burst into tears. It was indeed his desk, as glowing as I remembered.

Seeing the photograph of Delilah, working so diligently, as I had dreamed I might, filled me with great happiness. I used to close my eyes and picture Robert showing it to me, saying, I thought of you when I got it because you always loved desks. Now I am at peace. I imagine Delilah writing at the desk, perhaps stopping for a moment, to give us both a good thought.

*Delilah at Robert's desk, 2010*

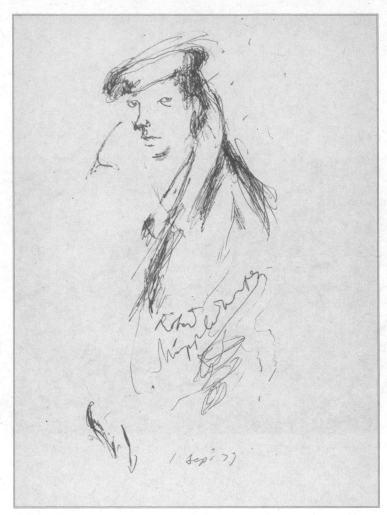

*Robert, 1979*

Just Kids

The air was filled w/ sweetness
incredible and bright
like a gleaming sari
in the Indian wind
fish were in the net
and the salt ran thru our fingers
and tears were swept away
by lover bony hand
and fair companions
fenced their prayers
sketches and linguistics
that glowed like eerie aroma
and none could know the price
no soul had ever bid
and underfoot the clover
crushed in carelessness
and rows were ript
upon the solemn banks
smiles drawn from blood
etched upon a window
pierced with dreams of god
was we ever asked for
all we ever knew
was such incredible
sweetness
that from the well
we drew

20 Dec 88.

*MacDougal Street, 1974*

# Photographs and Illustrations

*Designed and composed by Mary Austin Speaker*